Tl
be
do

Culture
& Spor

THE RING
AND
THE CROWN

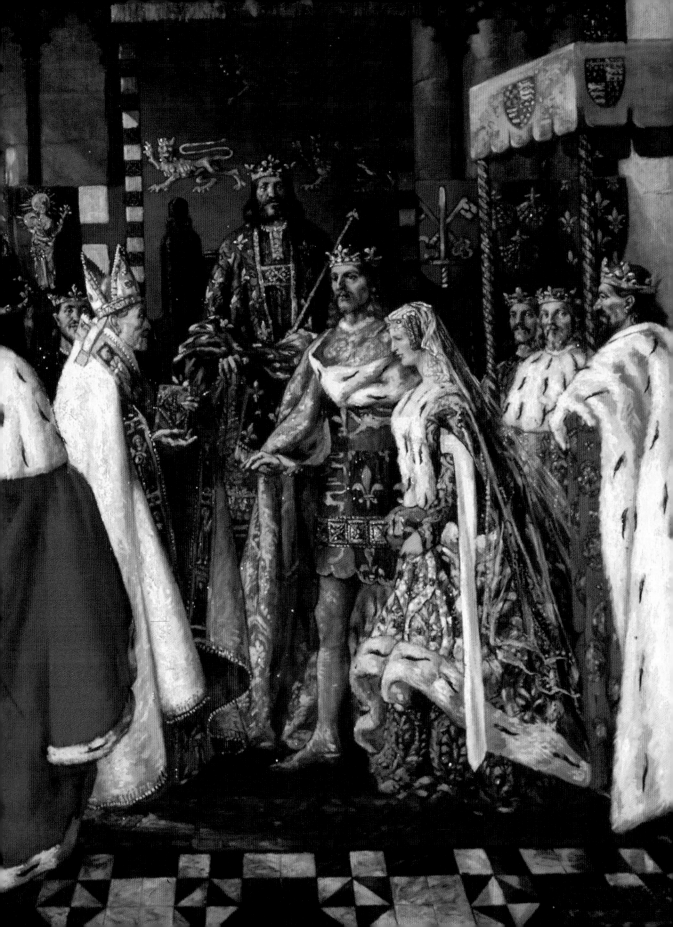

THE RING

AND

THE CROWN

ALISON WEIR

KATE WILLIAMS

SARAH GRISTWOOD

TRACY BORMAN

HUTCHINSON
LONDON

Published by Hutchinson 2011

2 4 6 8 10 9 7 5 3 1

Copyright © Alison Weir, Kate Williams, Sarah Gristwood and Tracy Borman 2011

Alison Weir, Kate Williams, Sarah Gristwood and Tracy Borman have asserted their right under the
Copyright, Designs and Patents Act 1988 to be identified as the authors of this work

This book is a work of non-fiction

First published in Great Britain in 2011 by
Hutchinson
Random House, 20 Vauxhall Bridge Road,
London SW1V 2SA

www.rbooks.co.uk

Addresses for companies within The Random House Group Limited can be found at:
www.randomhouse.co.uk/offices.htm

The Random House Group Limited Reg. No. 954009

A CIP catalogue record for this book is available from the British Library

ISBN 9780091943776

The Random House Group Limited supports The Forest Stewardship Council (FSC),
the leading international forest certification organisation. All our titles that are printed on
Greenpeace approved FSC certified paper carry the FSC logo.
Our paper procurement policy can be found at www.rbooks.co.uk/environment

of Edward III's son, John of Gaunt, and Blanche of Lancaster, Reading Abbey, 1359

Designed and typeset by Peter Ward

Printed and bound in Italy by
L.E.G.O. S.p.A.

CONTENTS

This book is affectionately dedicated to

Olivia and Neve Ellis,

Eleanor Weir,

Bethan Williams

and Florence Eastoe

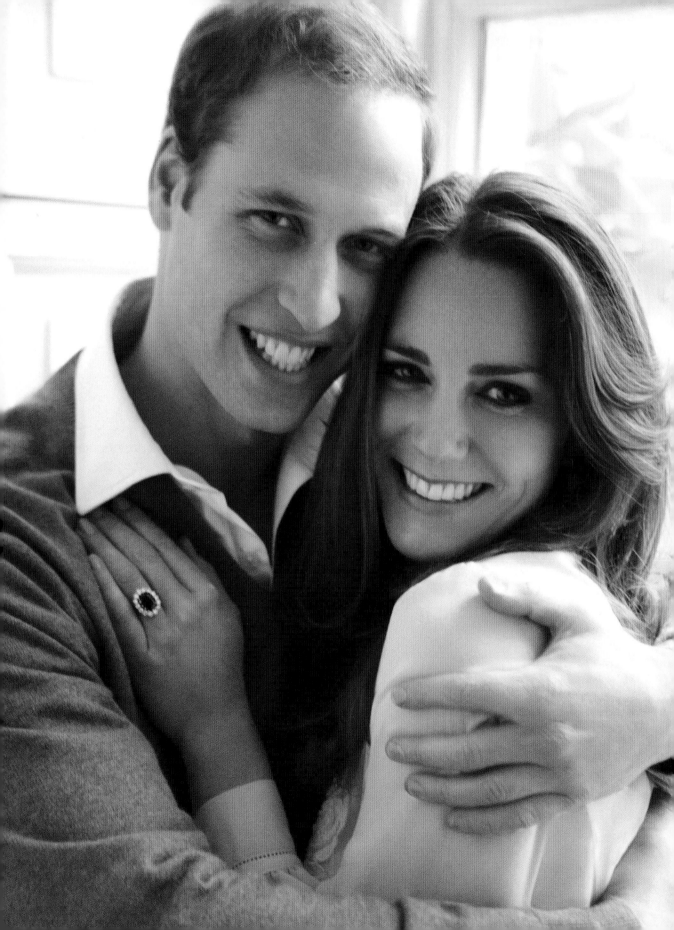

ALISON WEIR

'PRINCELY MARRIAGE'

ROYAL WEDDINGS FROM 1066 TO 1714

When the engagement of Prince William and Kate Middleton was announced, it was received with great public acclaim and rejoicing. Here was the heir presumptive to the British throne affirming his commitment to the charming young woman with whom he had enjoyed a romantic association for no less than eight years, an incredibly long courtship by traditional royal standards. But William and Kate are a refreshingly modern couple, a living example of how the monarchy constantly evolves to keep up with the times, while maintaining its integral traditions.

Lessons can be learned from the past. The choice of a royal bride has always been crucial, and Prince William himself and the royal family have more reason to be aware of that than most, and that it is important for the future of the monarchy that this marriage is given every chance to succeed.

Royal marriages these days are made in the blazing glare of a worldwide media. Public interest in the last wedding of an heir to the throne – that of Charles, Prince of Wales, to Lady Diana Spencer in 1981 – was unprecedented, and traumatic for the young and inexperienced bride, who had been instantly catapulted to international fame and scrutiny. Predictably, the marriage ended in divorce after just twelve years.

The tragic precedent of Diana, Princess of Wales, who was killed in a car crash in 1997, has no doubt informed official thinking on the wedding of her son. The royal family have remained very much in the background during Prince William's courtship of Kate Middleton, and allowed them the time and space to get to know each other, and the freedom to live together, as many

'There was something very special about her.' Prince William and Catherine Middleton: the official engagement photograph.

modern couples do. That is a sure indication of their resolve that William and Kate should be able to enjoy as normal a private life as possible. There is a general awareness, indeed a consensus, that the pressures that blighted Diana's life should be kept to a minimum. Kate Middleton is destined to be a queen, but her apprenticeship is being served in a softer glare of publicity than her late mother-in-law was forced to endure. The Queen, who did her best to curb media interest in Diana, may well feel strongly that a degree of privacy is essential for William and Kate in the years ahead.

That may not be asking for the moon, because public interest in what has been termed 'the royal soap opera' is not what it was in the days of Diana. She burst on to a rather staid royal scene like a breath of fresh air, with her beauty, her accessibility, her youth and her fashion sense. No detail about her was considered too insignificant to be reported. The media circus lasted until well after her marriage to Charles had gone sour, by which time she had learned to manipulate it to her advantage in the very public 'War of the Waleses'. By then, the public was glutted.

Although we have continued to expect our royals to observe the traditional morality of their Victorian forebears, despite our having long since rejected it ourselves, as a society we have become more egalitarian, less willing – in the light of too many divorces – to subscribe to the royal fairy tale, and a long way from the mass hysteria that attended Diana's untimely death. We've also become more cynical. There has been a sense that we should perhaps not invest so much in a royal marriage that might go the way of the others. We have come to look back on the great royal weddings of the Eighties with less starry eyes, because we know what came afterwards.

Yet this is not the materialistic, excessive 1980s, but a difficult time of recession into which this royal marriage comes as a ray of light and an article of faith for the future. The obvious love and chemistry between Prince William and Kate Middleton have mellowed the cynics and revived the romantic mystique of the monarchy. All the world loves a lover, and it loves a royal wedding even more. We are ready to celebrate, as Prince William marries the lady he loves.

Unlike many of his predecessors, he has chosen her himself. He has had time to get to know her before committing them both to marriage. He has not had to defy a feudal overlord, fight a war or circumvent witchcraft before he can lead her to the altar. Nor is it likely that his bride will feel the need to hide

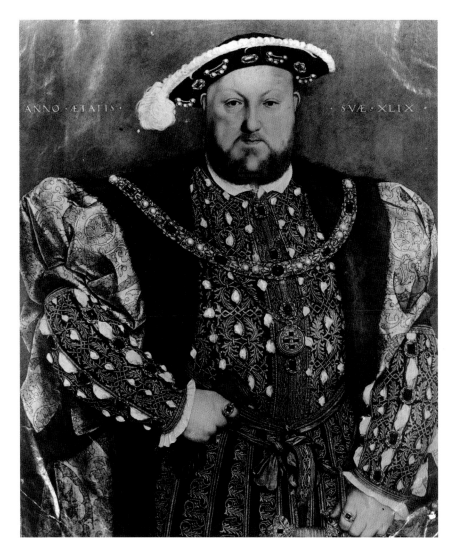

 Henry VIII in 1540, at the time of his marriage to Anne of Cleves. He married six times in his quest for an heir and conjugal bliss – a triumph of hope over experience, considering that he executed two of his wives and divorced three of them.

in a cupboard on her wedding night, as one terrified princess did. Yet even this most modern of royal weddings will take place in a historical context, informed by the traditions of a thousand years of monarchy.

When it came to marriage, Henry VIII lamented, 'Princes take as is brought them by others, while poor men be commonly at their own choice.' Rarely in past centuries has royalty been associated with romance:

until comparatively recently, most royal marriages were the subject of treaties and alliances, arranged for political or dynastic reasons, and love was rarely a consideration. Where, nowadays, we are shocked at the implications of Prince Charles's answer, 'Whatever "in love" means', when asked if he and Diana were in love, in earlier times marrying for love would have been regarded as an aberration and irresponsible – and equally shocking. Royal marriages were made to benefit kingdoms by ensuring the succession and forging alliances that averted war and brought prosperity. 'When love buds between great princes, it drives away bitter sobs from their subjects', went a political song of the thirteenth century.

Therefore, from earliest times, royal weddings have been seen as a cause for great celebrations. Every wedding should be, of course, with its promise of a happy and fruitful partnership, but royal nuptials have always signified something far more momentous for society at large. Traditionally, anointed kings and queens have been regarded as set apart from ordinary mortals, called by God to rule over their subjects, and invested with a mysterious sanctity. Securing the royal succession has therefore been a matter of prime concern, which is why the weddings of monarchs and heirs to the throne have always been of crucial importance to the welfare and common weal of the realm. They are a symbol of the Crown's ancient responsibility to its subjects, and a promise that the ancient sanctified bloodline will be continued and its purity maintained.

Because so much was at stake, it was rare for young people to be consulted on the spouses chosen for them by their elders. Future queens were always selected for their high lineage, their virtue and their aptness to bear heirs; it's a myth that virginity testing was routine, but even in 1981 it was thought desirable that Lady Diana Spencer was a virgin without a 'past'. The worth of a royal bride was calculated not so much from her looks or status, but from the size of the dowry she brought with her and the magnificence of her trousseau.

But the outward trappings of royal nuptials are only half the story – the velvet glove, rather than the iron first inside – and belie the fact that the splendour of such weddings has often been no more than the ceremonial cover for an unholy and sometimes brutal alliance. Often, a young princess would endure a difficult journey to Britain, having said goodbye for ever to her country and family, and find herself married to a stranger almost as soon

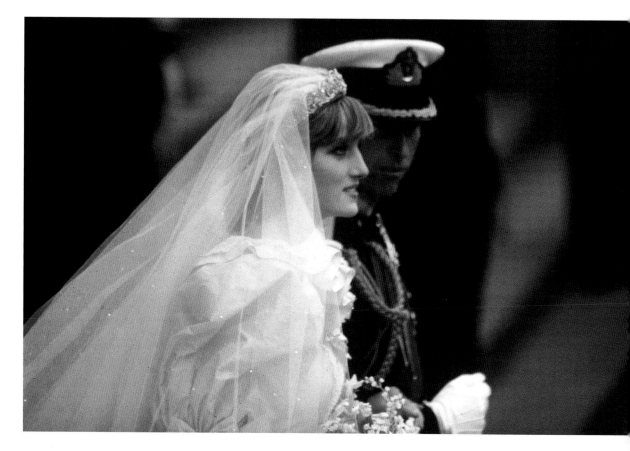

as she arrived; immediately, she was expected to produce children to secure the succession. Arguably, she was as much a sacrificial victim as any chained virgin in classical mythology.

Some royal couples did come to love each other; others were hopelessly mismatched, with disastrous consequences; most simply made the best of it. Arranged marriages were not generally conducive to romance.

The eyes of the world were watching: the wedding of the Prince of Wales and Lady Diana Spencer, St Paul's Cathedral, 1981.

The concept of a public royal wedding is an ancient one, although until recent times the most the public could expect to see was a bridal procession. A public wedding usually meant a court wedding followed by feasting and other celebrations, while many royal nuptials were quite private, low-key affairs. Only with the advent of newsreels and television

in the twentieth century were people able to witness the ceremony itself. Nowadays, we all expect to be guests at a royal wedding.

Paradoxically, as the monarchy has lost its political power and become ever more constitutional, and the succession has become a less crucial issue, the royal wedding has become an increasingly publicised event in which the world can share. There is in this an element of 'bread and circuses' – give the public a good show and it will take their minds off the ills of society – but it is certainly a boost to tourism and trade. Yet few other events have such power to unite us as a nation, and give us a sense of being part of a wider family. The role of the media in this should not be underestimated.

That is not to say, however, that there was less interest in royal weddings in the past. For many centuries, the media did not exist; even after the advent of broadsides and the press, electronic communications were far in the future. Society was more localised, and the crowds who watched royal wedding processions mostly lived nearby. Who is to say that, had our modern media existed then, there would have been just as widespread an interest in, say, the weddings of Henry VII and Elizabeth of York, or Mary Tudor and Philip of Spain? As Walter Bagehot famously wrote, 'A princely marriage is the brilliant edition of a universal fact, and as such rivets mankind.'

Royal marriages have not always come about in such a civilised manner as Prince William's. It is said that, when the future William the Conqueror proposed marriage to the 'very beautiful' Matilda of Flanders around 1050, she summarily rejected him on account of his bastardy. Soon, she would discover that you offended the Duke at your peril. William was so infuriated by the scorn with which Matilda had dismissed him that he waylaid her in the streets of Bruges, or in her father's palace at Lille, as she was returning with her ladies from Mass, 'beat her, rolled her in the mud, spoiled her rich array, and then rode off at full speed'. Apparently, this macho behaviour impressed Matilda, and she immediately changed her mind and accepted his suit.

The tale may be apocryphal, but they were married soon afterwards at the Cathedral of Notre Dame d'Eu in Normandy, William arriving first, followed by Matilda, escorted by her parents, the Count and Countess of Flanders,

 Matilda of Flanders, who married William I in c.1050–52, at Eu, Normandy. This nineteenth-century engraving showing her wearing a mantle of the type she wore for her wedding.

and attended by a great train of nobles and ladies; 'her father gave her joyfully to Duke William with a very large store of wealth'. Later, after conquering England in 1066, William would make her a queen.

One aspect of modern royal weddings that always captivates public interest is 'the dress'. The tradition of brides marrying in white was popularised by Queen Victoria, and although there are earlier examples of white being worn, most royal brides of earlier centuries wore their most splendid and colourful

attire to their weddings, aware of the desirability of outward display. If you were to be a queen, you were expected to look the part. Matilda of Flanders went to her wedding decked out in 'very rich apparelment', notably a rich, cope-like mantle garnished with jewels, which was preserved in the treasury of Bayeux Cathedral until at least 1476.

After their marriage, William and Matilda repaired with their guests to the castle of Augi for the wedding feast. Then William took his bride to Rouen, making a ceremonial entry into his capital city so that the new Duchess could be seen and received by his subjects. This sequence – the cathedral ceremony attended by important guests, the marriage feast and the state entry into the capital – established the pattern for many medieval royal weddings, with royal brides invariably being afforded a ceremonial welcome into London. For such occasions, the City would be cleansed and decorated, pageants would be performed, the conduits would run with free wine and huge crowds would gather.

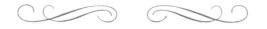

Nowadays, we tend to associate Westminster Abbey with royal weddings, but in the Middle Ages it was not the automatic church of choice, and only two kings – Henry I and Henry VII – are known for certain to have married there.

Westminster Abbey was built by Edward the Confessor and consecrated in 1066. The first royal wedding to take place there after the Norman Conquest was that of Henry I, who married Matilda of Scotland in 1100. As still happens today, the Archbishop of Canterbury – in this case, St Anselm – officiated, with 'all the nobility of the realm and the people of lesser degree crowding around the King and the maid in front of the doors of the church'. Matilda 'was given to the King in marriage with great ceremony' while demonstrating – as was thought entirely proper – 'a maidenly reluctance to marry; with blushes redder than the crimson of her royal robe, she stood at the altar, a virgin queen and bride, whom England's hopes hailed as its future mother of a mighty line of kings'.

Unusually, Henry had long 'ardently desired' this beautiful, devout girl, but their marriage nevertheless made good political sense. For Matilda was of the old Anglo-Saxon royal descent, and Henry married her to set an example

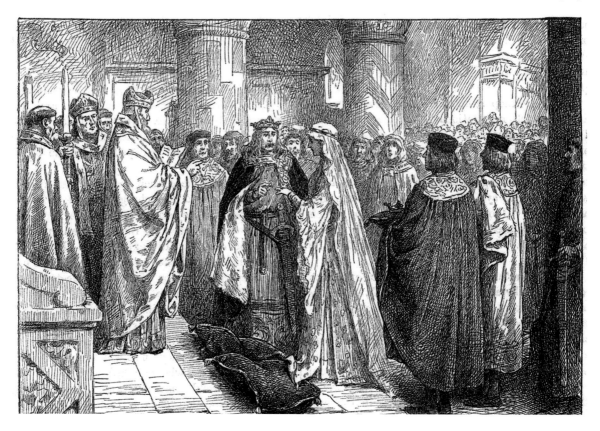

to his barons, hoping to unite his Norman and Saxon subjects; the ploy failed, however, for the barons looked askance at the union, and sneeringly bestowed on the couple the Saxon names of Godric and Godgifu.

Only one other royal wedding is known to have taken place in the old abbey church, that of King John's younger son, Richard, Earl of Cornwall, to Sanchia of Provence in 1243. Soon after that, the Abbey was magnificently rebuilt by Richard's brother, Henry III, and the first royal wedding to be celebrated in the newly consecrated church was that of the King's younger son, Edmund 'Crouchback', Earl of Lancaster, who married Aveline de Forz in 1269; both are buried in the Abbey. Some decades later, four daughters of Edward I were married in Westminster Abbey.

St George's Chapel, Windsor, begun by Edward IV in the 1470s and completed by Henry VIII almost fifty years later, has been a popular setting for royal weddings since Victorian times, yet the only previous royal wedding to take place at Windsor had been that of Henry I to his second

Fanciful illustration of the nuptials of Henry I to Matilda of Scotland, the first major royal wedding to take place after the Norman Conquest, and the first to be celebrated in Westminster Abbey.

17

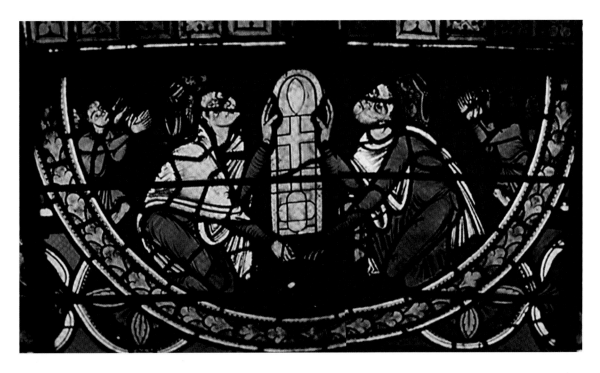

Eleanor of Aquitaine and Henry II: stained-glass window in Poitiers Cathedral donated by the couple to commemorate their wedding in 1152, which had to be celebrated stealthily, 'without the pomp and ceremony befitting their rank'.

wife, Adeliza of Louvain, in 1121. This took place in the private chapel in the domestic range of apartments built by Henry around 1110, with Archbishop Anselm again presiding (after an unseemly row with the Bishop of Salisbury, who also claimed the honour), and there was much comment on Adeliza's beauty, which 'dazzled her diadem'. Unusually, her bridegroom had travelled abroad to escort her to England. It was said that he had married her not only to forge an alliance but to have more children and keep himself from disgraceful conduct, which was perhaps wise as he had already begotten more than twenty bastards, yet had no surviving legitimate son.

From the Conquest to the sixteenth century, England's monarchs held territories in in France, and no fewer than eight medieval kings, including the Conqueror, were married abroad. Henry II, the first Plantagenet ruler, married the beautiful and notorious Eleanor of Aquitaine in 1152 at Poitiers Cathedral, where a contemporary stained-glass window donated by the couple marks the event. The hastily arranged wedding was conducted 'without the

pomp and ceremony befitting their rank', not only because they were marrying in defiance of their overlord, Louis VII, King of France (whom Eleanor had just divorced), but also because Eleanor, the heiress to half of what is now France, was being hotly pursued by other suitors. The couple had become lovers some months before, when Henry had 'presumed to sleep adulterously' with Eleanor after she had 'cast unchaste eyes on him' when she was still married to the King of France. Their marriage saw the foundation of a great Plantagenet empire, and set the pattern for European diplomacy and warfare for the next four centuries.

Their son, Richard I, 'the Lion Heart', was married in 1191 at Cyprus while on his way to join the Third Crusade. His bride, Berengaria of Navarre, had been fetched from Spain by his mother, Queen Eleanor. Deterred from anchoring in Cyprus, through fear of its tyrannical ruler, Berengaria was rescued by King Richard, who avenged the insult by conquering the island. Then, because it would have caused a scandal for an unmarried virgin to stay under the same roof as the King, he had to marry her as soon as possible, with the hastily arranged ceremony, conducted by his chaplain, taking place at the chapel of St George in Limmasol Castle. The wedding was followed by three days of feasting, with the formidable King 'happy and splendid, laughing and pleasing everyone'.

Queen Eleanor had chosen Richard's spectacular wedding outfit: a rose samite belted tunic with a mantle of striped silk tissue threaded with gold crescents and silver suns, with an embroidered scarlet bonnet, buskins of cloth of gold and gilded spurs. Berengaria must have caused some astonishment when she appeared in a Spanish mantilla veil that covered her face. Prior to the Reformation, brides wore their hair loose to denote virginity; after marriage, they would cover it with veils or headdresses, a tradition that persisted into Victorian times, when married women wore lace caps.

In 1200, Richard's brother, the notorious King John, apparently took one look at beautiful, thirteen-year-old Isabella of Angoulême, and stole her from her furious betrothed, who later rebelled against him. 'It was as if she held him by sorcery or witchcraft.' But John also wanted an alliance with her father. With the connivance of Isabella's willing parents, who realised that a king was a far better match for her than a local count, he abducted her, then married her at Bordeaux Cathedral.

In Isabella, John found that 'he possessed everything he could desire'. He was 'madly enamoured' of his young bride, and so lusted after her that he was

accused of having lost Normandy to the French through being 'chained' to his marriage bed. But within only a few years, lust had degenerated into mutual hatred and John had come to see Isabella as 'an evil-minded, adulterous, dangerous woman', whose lovers he was driven to have 'strangled with a rope on her bed'.

Several medieval royal weddings took place in England's great abbeys and cathedrals. In the thirteenth century, Canterbury Cathedral was chosen for the nuptials of Henry III and Eleanor of Provence, and of their son, Edward I, to his second wife, Margaret of France. The cost of royal weddings is still a matter for heated debate, but it is no new thing: in 1236, the heavy tax levied to fund Henry III's wedding might have raised £22,500, but that, and the fact that Henry had insisted on wedding a dowerless, asthmatic girl of barely fourteen, ensured that the marriage was unpopular from the start, even though the couple were to enjoy a long and happy union.

Their nuptials were conducted with 'unprecedented solemnity' in the presence of 'many magnates, nobles and prelates', with the King 'glittering very gloriously' and the Earl Marshal going before him and using his wand of office 'to clear the way before him, both in the cathedral and in the banqueting hall. Here, the Earl Marshal had 'arranged the banquet and the guests at table'. For the sumptuous wedding feast, there was an 'abundance of meats and dishes, with large quantities of venison and a variety of fish', and all was served to 'the joyous sounds of the gleemen', or minstrels. 'Pleasure and magnificence was there brought together from every quarter', and the celebrations continued in London when the couple arrived there for Eleanor's coronation. 'There were assembled at the king's nuptial festivities such a host of nobles of both sexes, such numbers of religious men, such crowds of the populace that London could scarcely contain them. The whole city was ornamented with flags and banners, chaplets and hangings, candles and lamps, and all the roads were cleansed from mud and dirt.' Seven centuries later, similar arrangements still apply when royal wedding processions pass through the capital.

When, in 1254, a marriage was mooted between the future Edward I and Eleanor of Castile, the bride's brother, King Alfonso X of Castile, insisted on

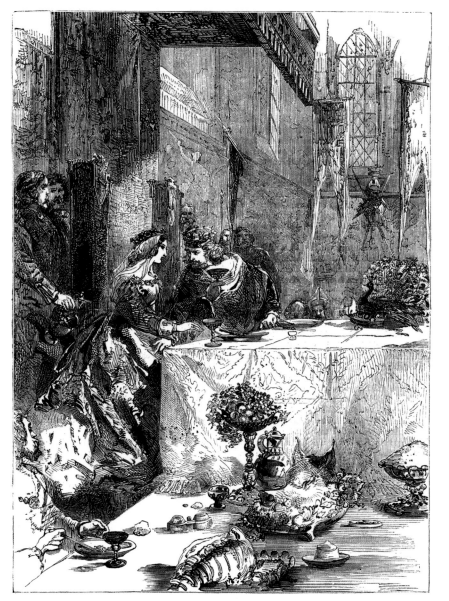

The extravagant and much criticised wedding of Henry III and Eleanor of Provence, 1236. 'Pleasure and magnificence was there brought together from every quarter.'

inspecting the suitor beforehand, so that he could see that he was 'worthy in mind and body of his sister'; so fifteen-year-old Edward was sent to Spain. Alfonso pronounced himself well satisfied with the young prince and conferred on him the honour of knighthood, then married him to his sister at the Cistercian abbey of Las Huelgas in Burgos, amidst great celebrations, the wedding being followed by feasts and tournaments.

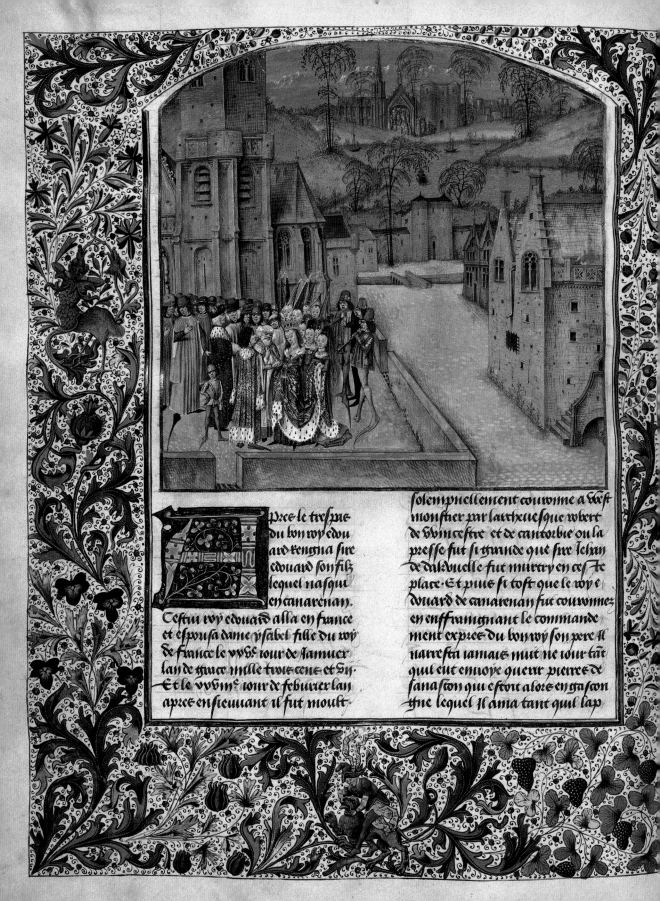

Apres le trespas
du bon roy edou
ard regna sire
edouard son filz
lequel nasqui
en canarenan.
Cestui roy edouard alla en france
et espousa dame ysabel fille du roy
de france le xxve iour de januier
lan de grace mille trois cens et dy
Et le xxvme iour de feburier lan
apres en ficuiant il fut moult

solempnellement couronne a west
monstier par larcheuesque robert
de vvincestre et de cantorbie ou la
presse fut si grande que sire iehan
de dalvvelle fut murtry en celle
place. Et puis si tost que le roy e
duard de canarenan fut couronne
en enfraingnant le commande
ment expres du bon roy son pere Il
narresta iamais nuit ne iour tant
quil eut enuoye querir pierre de
sanaston qui estoit alors en gascon
gne lequel il ama tant quil lap

Edward and Eleanor enjoyed a long and happy marriage that produced sixteen children, and he was grief-stricken when she died in 1290. Nine years later, at the age of sixty, he decided to seal a peace with France with a marriage. Having heard of the goodness and beauty of twenty-year-old Princess Margaret of France, Edward sent envoys to discover the intimate details of her person, such as the width of her waist and the size of her foot. With portraiture a thing of the future, kings had to rely on the accuracy of such reports. Evidently Edward was pleased to hear that Margaret was 'pious and charitable' and 'good withouten lack'. Prior to being joined in wedlock, he stood with his bride at the entrance door of Canterbury Cathedral and formally granted her her dower. Minstrels of many nationalities played throughout the wedding, which was followed by four days of feasting, tilting and sports. The couple spent one week of their honeymoon in Canterbury, and the other at romantic Leeds Castle in Kent, which Edward had enlarged for his first wife, Eleanor of Castile. Then the new Queen was escorted into London by a deputation of six hundred citizens wearing red-and-white liveries, and so went in procession to Westminster.

In 1308, Edward II married Isabella of France, daughter of King Philip the Fair, in a lavish ceremony in Boulogne Cathedral, which was attended by eight kings and queens and a great throng of princes and nobles from all over Europe. The importance of the union was underlined by the magnificence of the ceremony and the nuptial celebrations, which continued for eight days. The bride wore a costly gown and overtunic of blue and gold, with a red mantle lined with yellow, in which she would, decades later, be buried. Her crown, glittering with precious stones, had been a gift from her father. King Edward was resplendent in a satin surcoat and a cloak embroidered with jewels.

The wedding night was spent in lodgings near the cathedral, but given that Isabella was only twelve and did not bear a child for another four years, and that Edward apparently preferred his own sex, and was soon to send King Philip's wedding gifts to his favourite, Piers Gaveston, in England, it is unlikely that the marriage was immediately consummated. Indeed, it was to end in acrimony and bloodshed.

When Edward III married Philippa of Hainault at York Minster in January 1328, the nave was only partially roofed and the wedding, conducted by the Archbishop of York, took place in the middle of a snowstorm. This was one

The magnificent wedding of Edward II and Isabella of France, Boulogne Cathedral, 1308. Edward sent the wedding presents to his male favourite in England.

Overleaf: The wedding of Edward III's son, John of Gaunt, and Blanche of Lancaster, Reading Abbey, 1359. Blanche's inheritance made John the richest magnate in England.

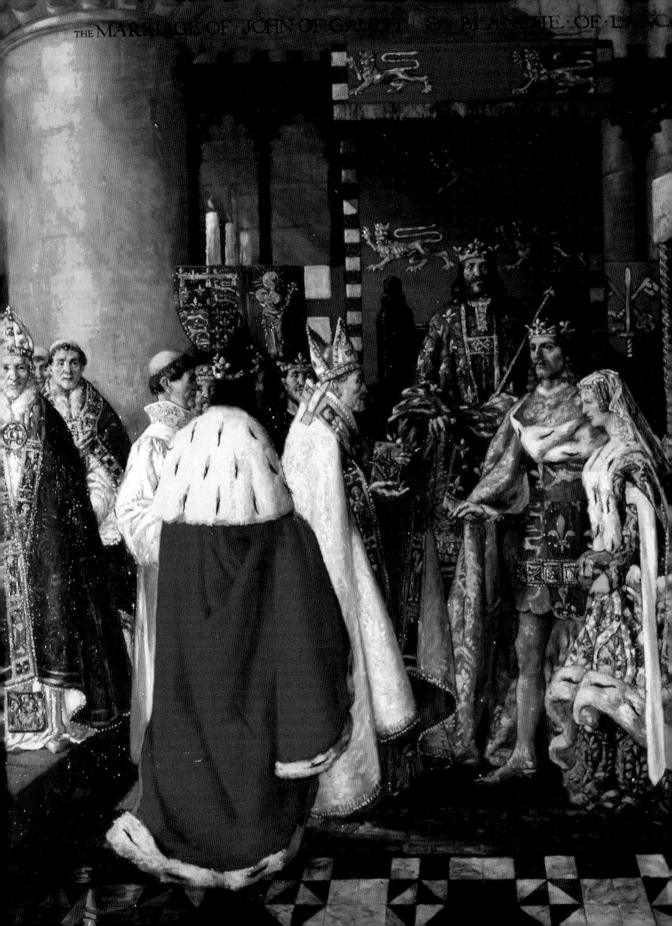

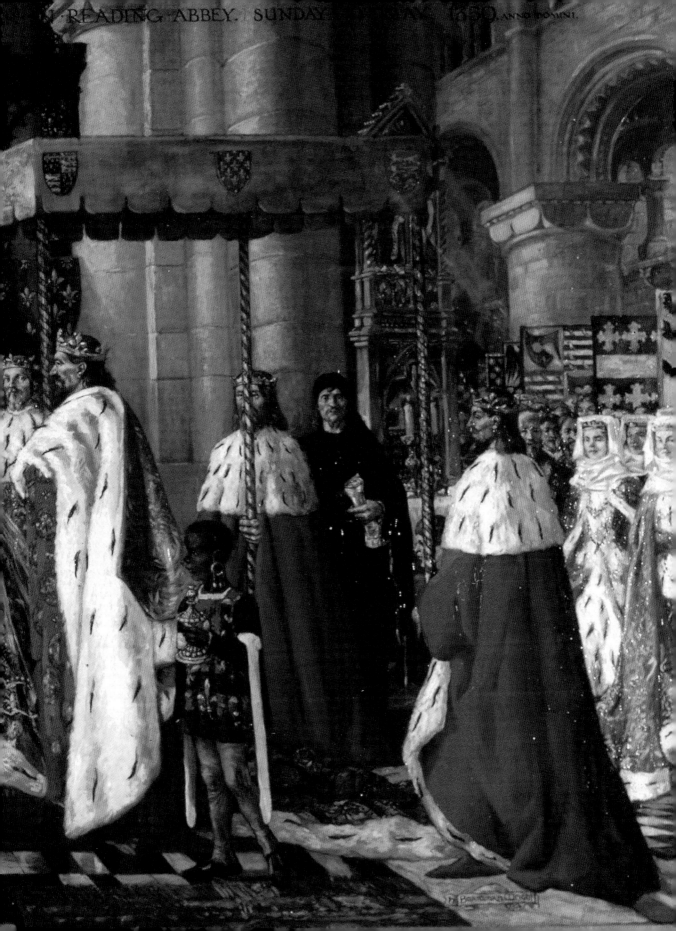

IN READING ABBEY. SUNDAY ... MAY 1350. ANNO DOMINI.

royal marriage that was made for love as well as policy, for Edward had met his future bride, and been much taken with her, two years earlier. When Philippa finally arrived outside York, having endured a terrible journey in snow up the quagmire that was the Great North Road, after enjoying a rapturous reception in London, the fifteen-year-old King, 'magnificently clad' and attended by all his lords 'in fair array', came on horseback to meet her, 'took her by the hand, and then embraced and kissed her; and so, riding side by side, with great plenty of minstrelsy and honours, they entered the city'. The honeymoon was spent in the apartments built for the new Queen in the Archbishop's Palace at York, but because the couple had married in Lent, they were obliged to refrain from consummating their union, and had to delay their 'display of marriage' until after Easter.

Reading Abbey, of which only fragmentary remains survive today, witnessed the marriage ceremonies of three of Edward III's children, most notably that of John of Gaunt, Duke of Lancaster, to the lovely heiress Blanche of Lancaster in 1359. The marriage made John a magnate of stupendous wealth and status, and was celebrated as royally as any monarch's, being followed by two weeks of festivities, with feasting, boat races and three days of tournaments at Smithfield in London. The bridegroom's gift to his bride, traditionally given on the morning after the wedding night, was a gold ring with a great diamond set in pearls. It was traditional, too, for a bride, on the morning after her wedding, to appear in wifely attire, with her head covered.

St Stephen's Chapel in the Palace of Westminster, of which only the heavily restored crypt remains today, was the scene of the weddings of Edward III's eldest son, Edward of Woodstock, 'the Black Prince', to Joan of Kent in 1361, and of their son, Richard II, to his beloved Anne of Bohemia in 1382. The latter was marked by 'great solemnity', 'mighty feastings' and a splendid tournament between the English and Bohemian knights, and no doubt the bride was glad to be there to enjoy them, because she had endured a treacherous journey to England, with twelve French galleons lying in wait in the Channel to intercept her ship. No sooner had she disembarked safely at Dover than a storm blew up and her vessel was 'terribly rent to pieces before her face'.

It was at Richard II's wedding that we encounter the first mention of a royal bridesmaid, Anne's maid-of-honour, Margaret, great-niece of Wenceslaus IV, King of Germany and Bohemia.

Anne and Richard, both fifteen years old, spent the first week of their married life at Westminster, and then moved to Windsor, where they kept open court, looking 'very happy together'. But there was adverse comment about the poverty of the plain little Queen, and the fact that the King was obliged to supplement her meagre dowry; many felt that it was not worth laying out 'so great a sum for so little a scrap of humanity'.

When Anne of Bohemia died of plague at Sheen Palace in 1394, a distraught Richard had that part of the palace razed to the ground. Two years later, to cement yet another peace with France, he married six-year-old Isabella of Valois at the church of St Nicholas in Calais. Manuscript illustrations show her being handed over by her father, the mad Charles VI of France, to her husband, who was nearly thirty. Richard was heard to thank Charles for 'so gracious and honourable a gift'; he kissed the little girl then handed her over to the Duchesses of Lancaster and Gloucester and other great ladies. Child marriages were permitted by the Church prior to the Reformation – Edward I began negotiating a daughter's

Richard II receives the six-year-old Isabella of Valois in marriage from her father, Charles VI of France, Calais, 1396. The little bride was sent back to her governess.

27

The 'magnificent espousals' of Henry V and Katherine of Valois, Troyes Cathedral, 1420. This was the first recorded occasion of a royal bedding ceremony.

wedding when she was four days old – but cohabitation was forbidden until girls were twelve and boys fourteen. In 1478, for example, Edward IV's son, Richard, Duke of York, and Anne Mowbray, both aged five, were married amidst great celebrations at St Stephen's Chapel, Westminster. After her wedding to Richard II, the young Queen Isabella was entrusted to the care of Katherine Swynford, Duchess of Lancaster, and sent to be brought up at Windsor with a governess. The cost of her wedding and coronation was estimated at £200,000, and the ladies attending her to her marriage filled twelve chariots.

Henry IV, who deposed Richard II and usurped the throne in 1399, married his queen, Joan of Navarre, at Winchester Cathedral in 1403. The bridal feast was another costly event, with many lords and ladies enjoying two courses of fish and two massive sugar sculptures known as subtleties, fashioned and coloured to represent crowned panthers and eagles. The bridegroom's marriage gift to his bride was a gold collar costing £75,000.

Katherine of Valois, the younger sister of Isabella of Valois, was also destined to be Queen of England. Henry V's courtship of her was romanticised by Shakespeare, but the stark truth is that their marriage, which took place in the church of St Jean at Troyes in 1420, was negotiated with much hard bargaining to cement his claim to the French throne. Their 'magnificent espousals' were conducted in great state and solemnity for, by the terms of the marriage treaty, Henry was to succeed his new father-in-law as King of France, and on his wedding day he was treated 'as if he had been king of the whole world'. Katherine was conveyed to her wedding in a litter drawn by eight white English horses, the gift of her bridegroom. The English wanted to celebrate with a tournament, but Henry refused, saying they would have enough tilting shortly. Four days later, he was back at war, besieging a French town. His bride, who had 'passionately longed to be espoused' to him, was left to make her state entry into Paris in the company of her mother. We are told that 'the flame of love had fired the heart of the martial King', but there is little evidence for it. Katherine represented France, and France was what he was determined to have.

It is for Henry V and Katherine of Valois that we have the first account of the bedding ceremony of an English king and queen. In the Middle Ages, newly married couples were publicly put to bed together by their guests. After

Henry V woos Katherine of Valois, a scene immortalised by Shakespeare and romanticised in this engraving of 1754.

the feast or other festivities, the women guests would escort the bride to the nuptial chamber, where they would undress her, comb her hair and then put her into bed, all the while giving friendly advice. The men would take the groom to another chamber, where they would strip him and help him into his nightgown, and then they would bring him to the bedchamber, where he would get into bed beside his bride. This was inevitably an occasion for laughter and bawdy jokes, but these would cease when the priest arrived to bless the bed and pray that the couple would be fertile. Then everyone would depart, leaving the bride and groom to consummate the marriage. It is recorded that, after the wedding of Henry V, the Archbishop of Sens went in state to bless the Queen's bed. Later that night, after the couple had been allowed some time alone together, their guests formed a great procession and came to their bedside bringing wine and soup to fortify them after their endeavours. This now seems an unnecessary intrusion into their privacy, but the getting of heirs was a state matter, and of legitimate public concern in an age in which monarchs ruled as well as reigned.

Henry V died two years later. His only son, the feeble and pious Henry VI, decided to wed Margaret of Anjou after having fallen in love with her portrait,

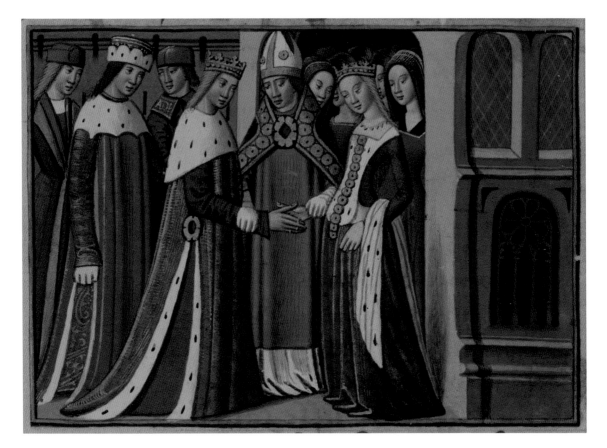

but she came without a dowry, provoking complaints that Parliament 'hath brought a queen not worth ten marks!' Parliament, nevertheless, applauded the new accord with France and the marriage that was to cement it, 'by which two happy events they nothing doubted, but by God's grace, justice and peace should be firmly established throughout the realm'.

But Margaret was so poor that she had to pawn some silver to pay the sailors who brought her to England in 1445, and, when she arrived, the King was obliged to send for a dressmaker from London, so that his future queen could be equipped with a suitable trousseau. He had also had to pawn his private jewels and household plate to pay for her entourage and triumphal reception in London. Margaret's wedding ring was made from a 'fair' gold ruby ring given to Henry VI by his uncle, Cardinal Beaufort. The Queen also received one of the most startling wedding gifts ever given to a royal bride: a lion, which was immediately sent to the menagerie in the Tower of London.

'Parliament hath brought a queen not worth ten marks!' The wedding of Henry VI and Margaret of Anjou, Titchfield Abbey, 1445.

31

Margaret's voyage to England was so rough that she fainted on coming ashore at Porchester, where the people ran in crowds to meet her. She then had to rest for some days at Southampton, suffering from the effects of seasickness and an attack of 'the pocks' before she could travel to Titchfield Abbey for her wedding. This was not the most auspicious start to the marriage, which, although a successful partnership, would end in civil war and murder. And Henry was so averse to sex that England had to wait eight years for an heir, while his descent into madness precipitated the Wars of the Roses between the royal Houses of York and Lancaster.

As we have seen, nearly every marriage of a medieval monarch – with the exception of King Stephen, whose wedding venue is unrecorded – took place in royal or prestigious surroundings. And every medieval king from William the Conqueror to Henry VI had married for policy or state reasons. Marrying in secret, for love (or, more likely, lust), as Edward IV, the first Yorkist sovereign, did in May 1464, caused a scandal of epic proportions and nearly cost him his throne.

Edward was young, handsome and notoriously promiscuous, but he was intrigued when Elizabeth Wydeville, an impoverished Lancastrian war widow, appealed to him for succour; she is said to have waylaid him under an oak tree in Whittlebury Forest while he was hunting, and to have knelt with her two young sons by her side to plead for the restoration of her husband's confiscated lands. The tale is a myth, as her husband had never been attainted, but, however they met, the King was much taken with Elizabeth's sophisticated blonde beauty. Inflamed by her refusal to become his mistress – rumour had it she had threatened to stab herself when he tried to rape her, or had resisted him even when he held a dagger to her throat – he impulsively married her in a little chapel known as the Hermitage, which lay hidden in woodland near the manor house at Grafton, Northamptonshire, the Wydevilles' family home.

The wedding took place early in the morning, with no one present but 'the spouse and spousesse, the Duchess of Bedford her mother, the priest, two gentlemen and a young man who helped the priest to sing. After the espousals, the King rode to Stony Stratford, as if he had been hunting, and then returned

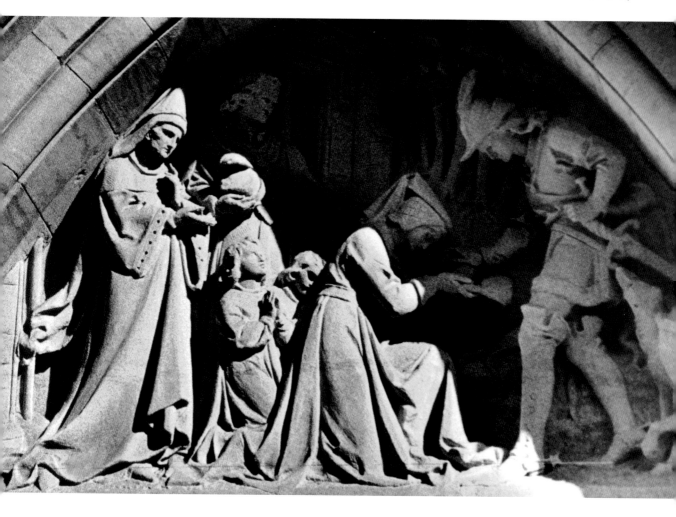

at night, and so tarried there four days. In which season, she nightly to his bed was brought, in so secret a manner that almost none but her mother was of counsel.'

'Now take heed what love may do!' a contemporary was to observe. The marriage, which was not made public for four months, alienated many of the nobility, who had hoped to see Edward make an advantageous marriage alliance with France. Instead, to their shock and 'great displeasure', they were presented with the first commoner to occupy the Queen Consort's throne, who came complete with a horde of greedy, ambitious relatives. Edward, it was said, had been 'led by blind affection, and not by the rule of reason'. His bride was seen as too low-born: 'she was not the daughter of a duke or earl, but

The fateful meeting of Edward IV and Elizabeth Wydeville in 1464, which led to a scandalous secret marriage.

33

her mother had married a simple knight, so that though she was the child of a duchess, still she was no wife for him!' It was even rumoured that the bride's mother had used witchcraft to get Edward to the altar. The marriage sparked a chain of events that led to Edward's deposition in 1470, although he regained his throne a year later. Meanwhile, Elizabeth made a dignified queen and presented her husband with ten children.

Edward IV's youngest brother, the future Richard III, was lucky to secure his chosen bride, Anne Neville. His other brother, the Duke of Clarence, was married to her sister, Isabella, and determined not to cede any portion of the rich inheritance that their father, the famous Warwick 'the Kingmaker', had left his two daughters and co-heirs. Clarence 'caused the damsel Anne to be concealed, that it might not be known by his brother where she was', but Richard, then Duke of Gloucester, 'discovered the young lady in the City of London, disguised as a cook-maid'. After he removed her by stealth to the sanctuary of St Martin le Grand, Clarence erupted in violent recriminations, and Edward IV had to mediate, decreeing that Richard should marry Anne and have her half of the Warwick inheritance.

Richard and Anne were apparently married in 1472. Circumstantial evidence suggests that their wedding (of which no record survives) took place at Westminster, probably in St Stephen's Chapel, or even in the Abbey.

Prior to 1919, the last royal wedding – and certainly one of the most important historically – to be solemnised in Westminster Abbey was that of Henry VII, first sovereign of the House of Tudor, to Elizabeth of York, daughter and heiress of Edward IV, in January 1486. 'By reason of which marriage, peace was thought to descend out of Heaven into England, considering that the lines of Lancaster and York were now brought into one knot and connected together.' It was Cardinal-Archbishop Bourchier 'whose hand held the sweet posy wherein the white and red roses were first tied together', and the nuptials were 'celebrated with all religious and glorious magnificence at court and by their people with bonfires, dancing, songs and banquets throughout all London'. The concept of street parties held in celebration of royal weddings is no new one.

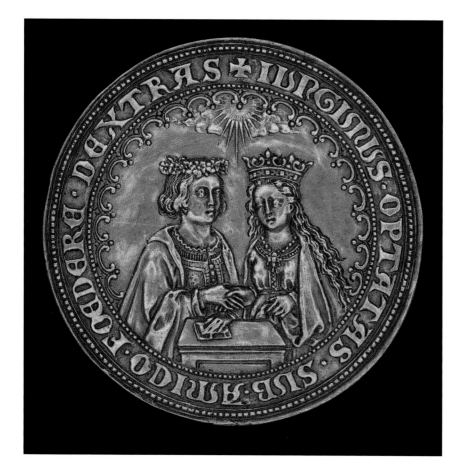

'The lines of Lancaster and York were now brought into one knot and connected together.' Gold medal struck to commemorate the marriage in 1486 of Henry VII and Elizabeth of York, which united the rival royal houses of Lancaster and York.

Henry VII had won his crown by conquest the previous year, at the Battle of Bosworth. He did not rush into this 'blest wedlock' immediately, to consolidate his victory, for it seems he waited to ensure that Elizabeth would be fertile before marrying her, as their first child, Arthur, was born just eight months after their marriage.

John de Gigli, prebendary of St Paul's, described 'bright Elizabeth' as she appeared on her 'ever-honoured and auspicious' wedding day: her shining tresses crowned with a wreath of sparkling jewels and entwined with gems; her radiant necklace 'framed in fretted gold' about her 'snowy neck'; her 'beauteous form' decked out in 'robes that glow with gold and purple dye'. Her wedding ring cost 23s. 4d. (£570 today). A gold medal was struck to commemorate the wedding, which was said to have been even more splendid than Henry VII's coronation the previous October.

When King Henry secured the great prize of a Spanish princess, Katherine of Aragon, for his heir, Arthur, Prince of Wales, he planned a lavish public wedding for the young couple at St Paul's Cathedral to mark this dynastic triumph, which represented the acceptance of his usurping dynasty by a major European power.

In November 1501, crowds gathered to watch as the bride arrived. She and her ladies were wearing 'beneath their waists certain round hoops bearing out their gowns from their bodies after their country's manner'. This was the Spanish farthingale, a garment never before seen in England, which attracted much comment. Katherine's wedding dress, of white satin, was described as 'very large, both in the sleeves and also the body, with many pleats'; she also wore a white silk veil that partially covered her face and reached to her waist, having a one-and-a-half inch border of gold, pearls and precious stones.

Katherine was escorted to her wedding by the King's second son, ten-year-old Henry, Duke of York, the future Henry VIII. He led her into the cathedral, which had been hung with rich tapestries. As was customary at pre-Reformation weddings, the vows were exchanged inside the church porch; here, on a raised round dais carpeted in red cloth, Arthur and Katherine were joined in wedlock in a lengthy ceremony performed by Archbishop Henry Deane, assisted by seventeen bishops and abbots, and watched by the King and Queen from the privacy of a latticed closet. In the old form of the service in use at that time, the bride promised to be 'bonair and buxom [amiable] in bed and at board [table]'. Then the couple proceeded along a wide raised platform that stretched the length of the nave to the altar for the nuptial Mass. Prince Arthur, also wearing white satin, left by a side door, so that he could ride ahead to receive Katherine at her chamber door when she returned to Baynard's Castle by the Thames; when she emerged from the cathedral to the sound of trumpets, she was again on the arm of Prince Henry.

The wedding was followed by pageants near St Paul's, free wine for the people and a great feast and dancing at Baynard's Castle, during which the future Henry VIII – then apparently destined for the Church – danced so energetically that he was obliged to throw off his gown and continue in his doublet. Thus began two weeks of festivities, disguisings, banquets and

tournaments. No expense had been spared in celebrating the marriage of the Tudor heir.

The young couple – Arthur was fifteen, Katherine just sixteen – were then ceremonially put to bed together, this being the only recorded instance of a sixteenth-century royal bedding. According to the ordinances laid down by Henry VII's mother, the Lady Margaret Beaufort, the bed had been made up and sprinkled with holy water before the bride was led away from the wedding feast by her ladies, undressed, veiled and 'reverently' laid in bed. Then her groom, 'in his shirt, with a gown cast about him', was escorted by his gentlemen and a host of merry courtiers into the bedchamber to the sound of shawms, viols and tabors. The music ceased to allow the bishops to bless the bed and pray that the marriage might be fruitful, and only then were the curtains drawn and the pair left alone, fortified by wine and spices, to do their dynastic duty.

Old St Paul's Cathedral, London, where Arthur Tudor, Prince of Wales, married Katherine of Aragon in 1501. The cathedral was burned down in the Great Fire of 1666. The next royal wedding on the site, in the cathedral rebuilt by Wren, would be that of Charles, Prince of Wales and Lady Diana Spencer.

What happened on that particular wedding night was to become a matter of the greatest controversy in the 1520s, when Henry VIII, who married Katherine seven years after Arthur's early death, asked the Pope for an annulment, claiming that his union with his brother's widow was uncanonical; but Katherine always maintained that she had emerged from her six months of wedlock with Arthur as virgin as she had come from her mother's womb. She also believed that her marital troubles were the consequence of her first marriage having been made in blood, for her parents had refused to let her come to England until the Yorkist claimant to the throne, the Earl of Warwick, a simple, blameless but potentially dangerous young man, had been put to death.

The wedding of Arthur and Katherine was the last public royal wedding for more than fifty years. Even though Henry VIII became England's most married monarch, his six nuptial ceremonies all took place in private with only a few select guests present. In 1509, soon after his accession, he quietly married Katherine of Aragon in the Queen's closet at Greenwich, with no public celebrations. That marriage was to collapse amid one of the most notorious divorce cases in history, which would lead to England's break with Rome and the Reformation. The catalysts were the King's need for a male heir, and Anne Boleyn, with whom he had fallen passionately in love.

Henry VIII's controversial marriage to Anne Boleyn was celebrated secretly before daybreak on 25 January 1533 in the 'high chamber' above the Holbein Gate at York Place (later Whitehall Palace) in the presence of only a handful of witnesses. The officiating priest was probably the King's chaplain; Henry apparently pretended that the Pope had sanctioned the marriage. Having discovered that Anne was pregnant, he had not waited until his union with Katherine had been formally dissolved; that came later. In fact, the marriage was kept so secret – it would not be made public for three months – that for a long time neither the date nor the location were known, and – with the future Elizabeth I being born seven months and twelve days afterwards – reverent Tudor chroniclers were moved to suggest that it had taken place the previous November.

When Anne Boleyn was executed for adultery and treason in 1536, the King was betrothed to Jane Seymour the very next day, and there was a flurry of hasty activity as Jane's initials were superimposed over Anne's on carvings, window glass, hangings and bedlinen. Ten days later, Henry and Jane were

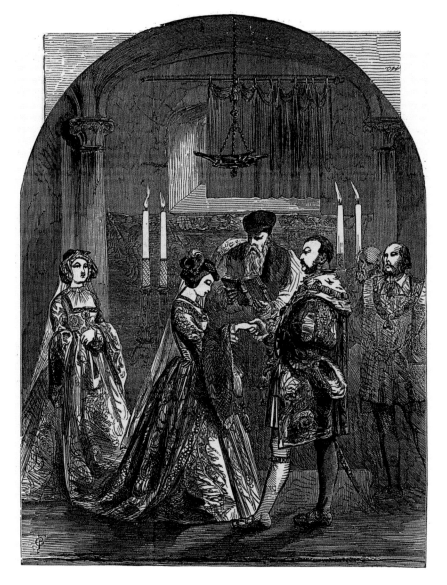

Imaginary Victorian illustration of the secret wedding of Henry VIII and Anne Boleyn, 1533. There are no contemporary images of any of Henry VIII's six weddings.

quietly married by Stephen Gardiner, Bishop of Winchester, in the Queen's closet at Whitehall Palace, after which Jane was publicly 'set in the Queen's seat under the canopy of estate royal'.

Two years after Jane died in childbirth, bearing his longed-for son, Henry married Anne of Cleves, in a private ceremony at Greenwich. Having visited her at Rochester soon after her arrival in England, as an ardent swain eager 'to nourish love', Henry was revolted by her 'displeasant airs' and loudly bewailed the fact that he 'must needs put his neck in the yoke'. Nevertheless, Anne was

afforded a magnificent state reception at Blackheath, with the King behaving as if nothing was amiss.

We know something of the ceremonial observed at this wedding. At 8 a.m. on 6 January 1540, the King, wearing 'a gown of cloth of gold raised with great flowers of silver, furred with black' under a cloak of crimson satin embroidered with large diamonds, and with a rich collar about his neck, summoned his lords and went before them to the gallery that led to the royal closets. There he waited, having summoned the bride, who arrived escorted by two German lords.

Although Henry VIII had six wives, we know only what Anne of Cleves wore to her wedding: 'a gown of rich cloth of gold set full of large flowers of great Orient pearl, made after the Dutch fashion', with a jewelled collar and belt and no train. Her long fair hair was loose beneath a gem-studded 'coronal of gold' with trefoils fashioned to look like sprigs of rosemary.

Anne made three low curtseys to the King, who then led her into the

Queen's closet, where they were married by Archbishop Cranmer. Around the new Queen's wedding ring was engraved the motto *God send me well to keep*. After the ceremony, the royal couple, holding hands, removed to the King's closet for the nuptial Mass. As they emerged, spices and hippocras (mulled wine) were served, then Henry went off to his Privy Chamber to change into a robe of rich silk taffeta lined with crimson velvet, while Anne was escorted back to her apartments by the Dukes of Norfolk and Suffolk. At 9 a.m., the King joined her there, then, 'with her serjeant-at-arms and all her officers before her, like a queen, the King and she went openly in procession to the King's closet, where they made their offerings'. Afterwards, they dined together. In the afternoon, having changed out of her wedding dress, Anne accompanied Henry to vespers and had supper with him. In the evening, there were 'banquets, masques and divers disports till the time came that it pleased the King and her to take their rest'.

There was no bedding ceremony. The bed built for the couple boasted

The bedhead made for Henry VIII and Anne of Cleves for their wedding night in 1540. The erotic carvings did not have the desired effect.

A replica of the cloth-of-gold wedding dress of Mary I, made by costume expert Tanya Elliott for the 450th anniversary of her wedding to Philip of Spain at Winchester Cathedral in 1554.

erotic carvings – a priapic cherub and a pregnant one – clearly intended to inspire lust and promote fertility. But the King refused to consummate the marriage. Afterwards, he unchivalrously declared he believed Anne to be no virgin, 'by reason of the looseness of her breasts and other tokens, which, when he felt them, struck him so to the heart that he had neither will nor courage to prove the rest'. Six months later, after their union had been annulled, he married Katherine Howard in the chapel at Oatlands Palace, Weybridge, a house that has long since been demolished. The wedding night – evidently more successful, given that the King was besotted with his young bride – was spent in a 'pearl bed'. Whether Katherine found it satisfactory – her august spouse was now an ailing fifty and fifty-four inches around the girth – is not recorded. The marriage was made public eleven days later, when Katherine was 'showed openly' and prayed for as Queen in the Chapel Royal at Hampton Court Palace.

Henry's sixth marriage, to Katherine Parr, was solemnised in the Queen's chapel at Hampton Court Palace in 1533, 'with none opposing and all applauding'. Only the bride, it seems, had reservations, for she had apparently told the King that she would rather be his mistress than his wife, for she was secretly in love with another man, Sir Thomas Seymour. But Henry had overruled her protests. The King's niece, the Lady Margaret Douglas, carried Katherine's train at the wedding, and there were twenty guests, including the King's two daughters, Mary and Elizabeth. Four years later, Henry was dead.

His daughter Mary Tudor's marriage, to Philip of Spain, made in 1554 after she had become the first English Queen Regnant, was the last royal wedding to be celebrated publicly for three centuries. Having fallen 'half in love' with Philip's portrait, Mary had set her heart on the match, even though it was deeply unpopular in England because it was feared that he would introduce the Spanish Inquisition and involve Mary's subjects in foreign wars. It was another marriage made in blood, for Philip had refused to come to England until Lady Jane Grey, the unlawful nine-days Queen deposed by Mary, had been executed.

The wedding in Winchester Cathedral was lavish. Mary, wearing cloth of gold, sat in an oak chair that still survives, and was wedded with 'a plain hoop of gold, because maidens were so married in old times'. All through the hour-long service, she never took her eyes off the Holy Sacrament until, at

The chair in which, according to tradition, Mary I sat during her wedding ceremony in Winchester Cathedral. The chair is now in the Triforium Gallery, Winchester Cathedral.

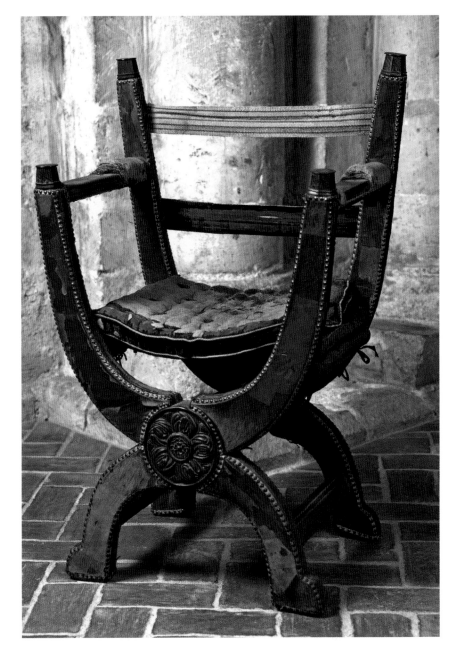

the conclusion, all the people present 'gave a great shout'. At 3 p.m., to the sound of fanfares, the Queen and her new consort left the cathedral for nearby Wolvesey Palace, where they presided over a nuptial banquet lasting three hours, after which they led the dancing.

In deference to the Queen's modesty, there was no public bedding; only a few select courtiers were present as Bishop Gardiner blessed the bed and left the royal couple, still wearing their wedding finery, alone together. According to Philip, his thirty-eight-year-old bride was 'no good from the point of view of fleshly sensuality'. Nor could he ever reciprocate her deep devotion. Instead, he made her very unhappy.

Mary's sister, the Protestant Elizabeth I, never married, and her successor, the Scots King James VI and I, the first Stuart monarch of a united Great Britain, was already wed when he came to the throne in 1603, having travelled to Oslo to claim his bride, Anne of Denmark, in 1589. The wild storms that almost wrecked their returning ship were attributed by James to witchcraft, and a coven of witches at North Berwick was forced under torture to admit responsibility, and executed.

Anne had flinched at first sight of James, with his ungainly walk, protruding eyes and slobbering mouth, but soon recovered sufficiently to allow him to kiss her. As they were driven away from the church, four black men danced naked in the snow for their entertainment; sadly they all perished of pneumonia.

The Stuarts continued the tradition of private, or low-key, royal weddings. In 1625, Charles I wed the Catholic Princess Henrietta Maria of France. Having been enjoined by her mother to be 'sweet, humble and patient' to her husband's will, and to pray for his conversion, the excited, eager bride of fifteen was welcomed at Dover by a hundred-gun salute. When she tried to kneel before Charles, he raised her, embraced her and 'kissed her with many kisses'. That evening, they were married in the great hall of St Augustine's Abbey in Canterbury, and afterwards attended a lavish banquet at the house of Lord Wootton. Then the bride was put to bed by her ladies, but there was to be no public bedding, as the King ordered everyone to leave and himself closed and bolted the doors. The young couple were both virgins; Charles was up early the next day, looking 'very jocund', but Henrietta was 'very melancholy'.

There was to be no state entry into London for the bride, as plague was raging. The marriage was to prove stormy until 1629, when suddenly

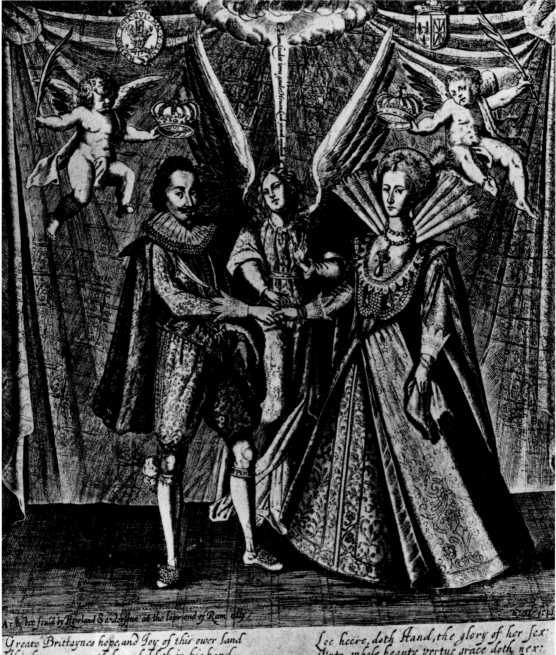

Ar. hee sould by Roreland Sardesson at the lop-end of Ram: ally/

Greate Brittaynes hope, and Joy of this ower land
His heauen on earth, heere holdeth in his hand
Which sweete coniunction, of two mightie powers
Presageth both of peace and plenty showers
To this oure blessed Jland to oure foes
Warr famin ruin and there ouer throws

Loe heere, doth Jtand, the glory of her sex:
Vnto, whose beauty, vertue grace doth, nex:
Whose haert, as well as hand, to him she giues
In, whom the halfe part, of her soule heere liues
Long: may thy happy liue, and when they dye
Yet liue, agayne, with god, æternally

Charles and Henrietta fell in love. Thereafter, they were the most devoted of couples.

In 1661, their son, Charles II, married a Portuguese princess, Catherine of Braganza. After disembarking at Portsmouth to a salute of guns, she was confined to bed with fever for a few days, which was as well, as the King's heavily pregnant mistress, Lady Castlemaine, had staged an epic scene about him abandoning her to claim his bride, threatening to kill herself if he did so. Only when he had calmed her down could he escape to Portsmouth, where he married Catherine privately, by Catholic rites, in her bedchamber, and

The marriage of Charles I and Henrietta Maria of France, which took place in 1625 in the Great Hall of St Augustine's Abbey, Canterbury.

publicly in the great chamber of the Governor's house, the King and Queen sitting enthroned behind a rail, to keep back the press of people. The bride wore a lace veil woven with English emblems, including Tudor roses, and a rose satin gown in the English style, adorned with azure blue ribbons tied in lovers' knots. Catherine, following ancient tradition, afterwards invited the guests to cut off the knots as wedding favours, and an unseemly scramble ensued.

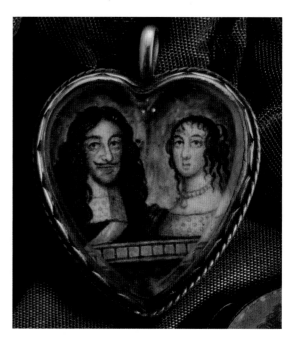

Because the bride had an unexpected period, there was no public bedding ceremony. In a letter to his sister Minette, the King joked that 'it was happy for the honour of the Nation that I was not put to the consummation of the marriage last night', for he himself had suffered such a difficult journey to Portsmouth that he feared 'matters would have gone very sleepily'. In the event, Catherine would fail to bear the King an heir. Having had a cloistered upbringing, she found it hard to come to terms with the licentiousness of the Restoration court and her husband's constant infidelities, but Charles became devoted to her, after his fashion.

Heart-shaped miniature of Charles II and Catherine of Braganza, made to mark their wedding in 1662. Before he could greet his bride, Charles had to escape the clutches of his mistress.

In 1673, the future James II, then Duke of York, aged forty and a convert to Catholicism, married convent-educated Maria Beatrice d'Este of Modena. The innocent fifteen-year-old bride, who had set her heart on becoming a nun, and had wept and stormed on being told she was to be married, had only become reconciled to the idea after receiving a personal letter from the Pope,

exhorting her to think of the great benefits that Catholics in Britain would gain through her marriage. But the announcement of the wedding provoked an outburst of protests in Protestant England, in response to which Charles II withdrew permission for the couple to marry in the Chapel Royal at St James's Palace, the Lord Mayor of London declined to welcome the bride, and the Earl of Rochester wrote a bawdy ballad called 'Signior Dildo', about one of Maria's imaginary Italian attendants.

When James, accompanied by only a few attendants, helped Mary out of her dinghy on to the beach at Dover, she was exhausted after two months of travelling and a debilitating illness, and burst into tears on first meeting her new husband. But the formalities proceeded regardless, and the wedding party immediately repaired to the house of a private citizen at Dover, where the Bishop of Oxford pronounced that the earlier Catholic proxy wedding service in Modena had been good and sufficient, although the people of England were given to believe that he had married the couple according to Anglican rites.

As a wedding gift, James gave his bride a ruby ring, which she was to cherish all her days, for their marriage turned out to be a very happy one. But to begin with, poor Mary was so terrified of her bridegroom that she hid in a cupboard on their wedding night.

When James's fifteen-year-old daughter, the future Mary II, was told by her father in 1677 that she was to marry Prince William of Orange, she was struck speechless and wept copious tears 'all afternoon and all the following day'. The Princess hated the prospect of leaving England to live in Holland; she did not like what she had heard of William, and her heart was already given to her bosom friend and 'dear husband', Frances Apsley. But the people of Britain rejoiced that their princess was to marry such a great Protestant prince, and the virtuous, Calvinistic William professed himself 'a very happy man', having been much taken with the beauty and grace of his bride.

In the days before her wedding, Mary presented a dazed, rebellious and suffering face to her bridegroom and the world. She repulsed all his attempts to court her, which made him hostile. At the ceremony, which took place at 9 p.m. in her bedchamber in St James's Palace, William wore a glum face and Mary was in tears. Charles II, who gave his niece away, sought to lighten the leaden atmosphere with jokes, telling the Bishop to make haste lest the Duchess of York be delivered of a boy who would 'disappoint' the dynastic

The wedding suit of the future James II, worn for his marriage to Maria Beatrice d'Este of Modena, 1673. The terrified bride hid in a cupboard to avoid his advances.

The future Mary II, painted by Sir Peter Lely in 1677 to mark her marriage to William of Orange. She cried all through the wedding service.

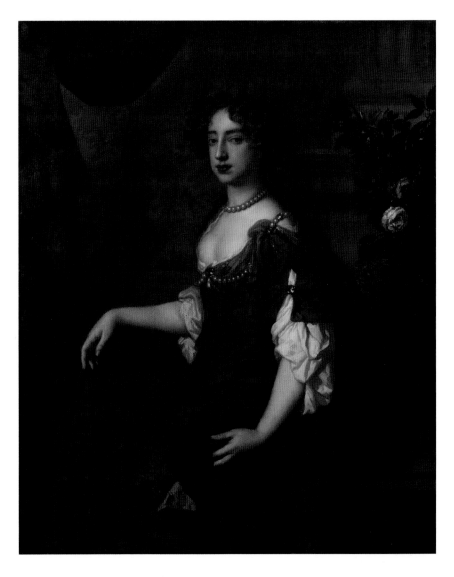

hopes of the bride and groom; and when William endowed Mary with all his worldly goods, the King advised her to 'put it all in her pocket, for 'twas clear gains'.

Afterwards, the couple received the congratulations of the royal family, the courtiers and the foreign ambassadors, and cakes and hot posset were served. Then Mary was undressed in an adjoining chamber by Queen Catherine and the Duchesses of York and Monmouth, and put into her marriage bed to await William, who arrived wearing woollen drawers. King Charles said he should

take them off, but William refused, saying his wife would have to get used to his habits. At 11 p.m., the King drew the bed curtains together, enjoining William, 'Now, Nephew, to your work! Hey, St George for England!' Against all odds, it turned out to be a very happy marriage.

Queen Anne, Mary's sister, was the last of the Stuart monarchs, and succeeded William III in 1702. She had married Prince George of Denmark in 1683. He was 'a simple, normal man without envy or ambition, and disposed by remarkable appetite for the pleasures of the table'. Charles II quickly perceived that he was not only dull but stupid. 'I've tried him drunk and I've tried him sober, but there's nothing in him,' he observed rather cruelly, but Anne willingly 'accepted with complacency what Fortune had brought her'. Her wedding, ten days after the bridegroom had arrived in England, took place at 10 p.m. at the Chapel Royal in St James's Palace. This was the first royal wedding to be celebrated in that chapel. Anne was given away by her uncle, Charles II, as

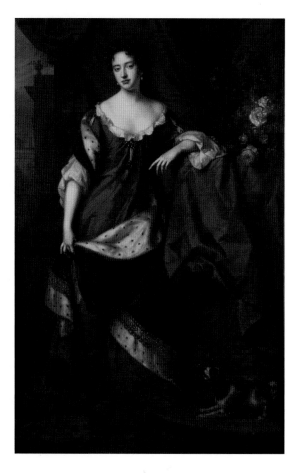

the bells of London pealed in celebration of this popular Protestant match, and the conduits ran with wine. Afterwards, the newlyweds sat at the head of the table, presiding over a private family supper, before being ceremonially put to bed together.

For twenty-five years, Anne lived with her husband in domestic harmony, and conceived eighteen children, none of whom lived to adulthood. When she died in 1714, leaving no heir, the Crown of Great Britain passed to the House of Hanover.

Mary's sister, the future Queen Anne, at the time of her wedding to George of Denmark in 1683. She willingly 'accepted with complacency' the husband that 'Fortune brought her'.

51

KATE WILLIAMS

'POMP AND CIRCUMSTANCE'

ROYAL WEDDINGS FROM 1714 TO 1918

Eighteenth-century royal weddings were small and private ceremonies, held late at night in court dress. The ceremony had little of the social significance that it assumed in the nineteenth century. Similarly, weddings throughout Britain were understated affairs. The bridal supper was usually modest, bridesmaids often not in attendance, and brides were simply attired. Few wore white, for it was seen as impractical. Many merely wore their best dress, and veils were uncommon. It was not until Queen Victoria married Prince Albert in 1840 that the white wedding dress, ornate cake and large ceremony became fashionable, and the royal wedding ceremony became important for securing the loyalties of the public.

The future George II was married at Hanover to the Margravaine Caroline of Brandenburg-Ansbach in 1705. His father George I became King in 1714, and in 1727 George and Caroline came to the throne. Their relationship with their eldest son, Prince Frederick, was thorny, for they found him bitter and rebellious. Caroline chose Frederick a docile bride, Princess Augusta of Saxe-Gotha-Altenburg, twelve years the groom's junior. On 27 April 1736, just after her arrival into the country, the seventeen year-old was put into her wedding dress of silver tissue and diamonds, and a state robe of crimson velvet trimmed with ermine. A crown of diamonds was placed on her head. With four attendants, all daughters of dukes and earls, wearing versions of the bride's dress valued at £20,000 each, she was taken

Queen Victoria felt as if she was leading a lamb to be sacrificed, but the marriage of her daughter, Vicky with Prince Frederick William of Prussia proved happy.

53

to the Chapel Royal, St James's. The chapel had been decked with lanterns, roses and gold velvet.

As Queen Caroline later recalled, the poor Princess clutched at her (heavily bejewelled) skirt and begged 'please don't leave me'. The Prince of Wales shouted into her ear to encourage her to repeat the marriage vows. After the service, the couple knelt to ask the blessing of the King, and the bride was promptly sick. The party dined together until ten thirty, when the couple were taken to prepare for their wedding night. The bride's new sister-in-law helped her into her nightgown and into bed. The King and Prince were admitted, the latter wearing a gold brocade nightgown, and then the court arrived to see the couple in bed together.

Frederick predeceased his father, dying in 1751. When George II died in 1760, Frederick's son with Augusta became George III on 25 October 1760, aged twenty-two. It was imperative that the young King found a wife and reports were demanded of all properly protestant princesses. Seventeen-year-old Princess Charlotte of Mecklenburg-Strelitz was well spoken of: no beauty, but lively and well-educated in virtue and religion. In July 1761, the King announced to Council his intention to marry. A betrothal ceremony took place in Mecklenburg. Charlotte went into a room with the King's proxy, who placed a foot beside her to represent the monarch bedding his bride. She was then presented with a set of diamonds.

The marriage took place on 8 September, two days after the Princess reached Britain, on the hottest evening of the year. The bride wore a heavy and ornate bridal gown of silver tissue with a 'stiffen bodice', embroidered with silver, and a purple velvet mantle lined with ermine, laced with gold and fastened at the shoulders with pearls. On her head was a purple velvet cap covered in diamonds. More diamonds adorned her hair, neck, ears and dress. The gown was so heavy that it dragged down the neckline of her robe.

The Duke of York led her to the Great Drawing Room where the court ladies were assembled, and he felt her fingers tremble. 'Courage, Princess', he said. Just before ten o'clock Charlotte and her attendants, ten daughters of dukes and earls in white and silver gowns and diamond coronets, processed to the Chapel Royal, St James's, as trumpets and drums sounded a salute. Under a canopy in front of the altar, the King and his bride were married by the

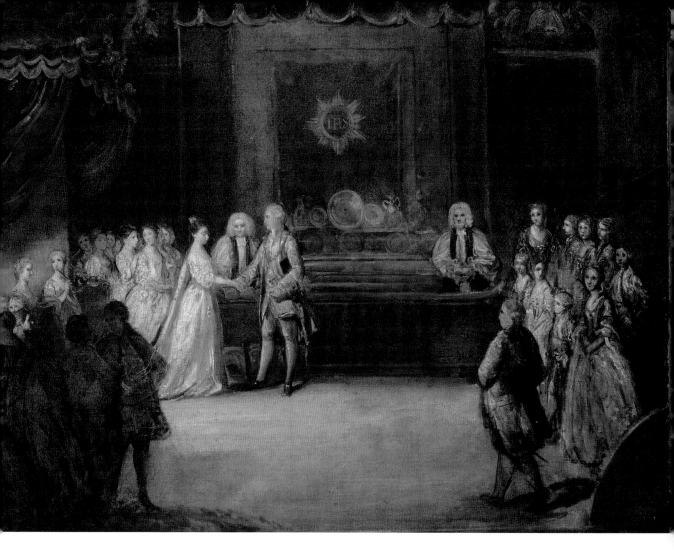

Archbishop of Canterbury. The Archbishop had a copy of the royal marriage service in German for the Princess, for she spoke no English, but there was no time to peruse it. Instead, the King prompted her to say the words at the correct moment. After a reception, the young couple were put to bed. The King had decided that, against tradition, she would not appear in a nightgown before the whole court to be 'bedded', a kind gesture to spare her modesty.

The young King was content with his naive bride, despite her plain looks. He delighted in keeping his malleable Princess to himself. As his brother, Prince William, said, he 'was determined she shd be wholly devoted to him alone, and should have no other friend or society'. Queen Charlotte was almost constantly pregnant between 1761 and 1783. Prince George, the Prince

The Marriage of George III and Princess Charlotte of Mecklenburg-Strelitz by Joshua Reynolds.

of Wales, later Prince Regent and King George IV, was born in August 1762 and Frederick, Duke of York, appeared almost exactly a year later in August 1763, with the Duke of Clarence born in 1765. The royal couple produced seven sons and six daughters (two further sons died in infancy), a resplendent family by any standards.

The King, exasperated by the wanton behaviour of his siblings, decided that the royal family would sacrifice no more grandeur to undignified marriages and so introduced the Royal Marriages Act, which became law in 1772 and still remains on the statute book today. The Act provided that no member of the British royal family (except descendants of princesses who had married foreigners) could marry without the monarch's permission. Those over the age of twenty-five could do so if the Privy Council received twelve months' notice, and agreed to the union. The King intended that the Royal Marriages Act would ensure that his children married goodly Protestant royals, as he had done. The reality was very different.

The King's eldest son, George, Prince of Wales, grew into a self-indulgent young man, charismatic and extravagant with money. After an entanglement with the actress Mary Robinson, the twenty-two-year-old Prince met Maria Fitzherbert, a gentle widow six years his senior. She was both a commoner and a Catholic – and no heir to the throne could marry a Catholic. A virtuous woman, she refused to be his mistress. Crazed by passion, he smeared himself with blood, declared that he had stabbed himself and told her that 'nothing would induce him to live' unless she promised to marry him. She agreed, but delayed for a whole year.

On 15 December 1785, the Prince arrived at Mrs Fitzherbert's house in Park Street. Any witnesses or clergy present at a marriage that contravened the Royal Marriages Act would be guilty of a felony, and it had been difficult to find a clergyman to conduct the ceremony. A young minister, John Burt, was taken from the Fleet Prison where he had been incarcerated for debt, and offered money and promises of a bishopric. In front of the bride's brother and uncle as witnesses, and no other guests, Burt married the pair. The newlyweds left for a brief honeymoon at Ormeley Lodge on Ham Common. Despite the utmost privacy surrounding the ceremony, news about the illegal marriage soon leaked out, much to the despair of the Prince's supporters.

The Duke of York was the first of the brothers to make a legal marriage. In

1791, he wed his cousin, Princess Frederica Charlotte of Prussia, only daughter of King Frederick II of Prussia. They were united in Charlottenburg, Berlin, in September, according to the Reformed Church, and then a ceremony of remarriage was performed by the Archbishop of Canterbury at Buckingham Palace (then known as the Queen's House) in November. The bride, handsome in white satin adorned with gold and diamonds and a headdress of feathers, was given away by the Prince of Wales. Her groom wore the full dress uniform of an army general. The Duke was enthusiastic about Princess Frederica but the marriage soon became polite rather than fond. The Duchess spent most of her time with her many animals at their country home, Oatlands Park in Weybridge, while her spouse frequented various ladies in London.

By the mid-1790s, the Duke of Clarence had set up home with the actress Mrs Jordan, the Duke of York showed no sign of producing an heir and both the Prince of Wales and Prince Augustus, Duke of Sussex, were illegally married. Augustus had married Lady Augusta Murray, the second daughter of the fourth Earl of Dunmore and ten years his senior, in 1793, without permission. The celeritous ceremony in a Rome hotel, with no witnesses, was followed by a further union in St George's, Hanover Square, with the groom pretending to be a commoner.

Matters were little better with the sisters. The King found fault with the suitors suggested for his daughters and the lonely princesses were shut up with their parents, acting as ladies-in-waiting to their mother. Finally, the widowed Hereditary Prince Frederick of Württemberg requested the hand of Charlotte, the Princess Royal. A portly widower with three children, he had previously proposed to her sister, Augusta, but the thirty-year-old Princess eagerly agreed. The Queen busied herself assembling her daughter's trousseau – including two sets of baby clothes, one for a boy and one for a girl.

On the evening of 18 May 1797, the Princess Royal, overcome with nerves, entered the Chapel Royal, St James's, in a heavy dress embroidered with silver. She was so affected on her return from the ceremony that she was unable to speak. The tradition of being 'bedded' was renewed and the whole court was called in to see the couple beneath the sheets.

The Princess Royal's sisters hoped that they, too, would be permitted husbands, but the next marriage was not until 1816, when the King was

incapacitated through mental illness and the Prince of Wales was Regent. The family beauty, Princess Mary, in a rich silver tissue dress with diamonds in her hair, married her cousin, the unprepossessing Duke of Gloucester, on 23 July, when she was nearly forty, at Buckingham Palace.

On 7 April 1818, the forty-eight-year-old Princess Elizabeth, in silver tissue, Brussels lace and a bandeau of diamonds, was married to the Hereditary Prince of Hesse-Homburg, given away by her brother, the Duke of York. Not one of the sisters produced a legitimate heir.

By the time the Prince Regent reached his early thirties he was considering taking a legitimate wife. After nearly ten years with Mrs Fitzherbert, he was wearying of her, and was severely in debt. Marriage seemed the only way of gaining income. The Countess of Jersey, with whom he had become infatuated, pushed the Prince towards his twenty-six-year-old cousin, Princess Caroline Amelia Elizabeth of Brunswick-Wolfebüttel, the daughter of the King's sister. She was no beauty, boisterous and coarse, and there had been gossip about her flighty behaviour. It was suggested that Lady Jersey chose an unattractive candidate to secure the Prince's loyalty to her. Parliament voted to increase the Prince's income from £60,000 to £100,000 a year, and voted £20,000 for the cost of the ceremony. The Prince promptly spent £54,000 on wedding jewels.

The wedding was set for eight o'clock on the evening of 8 April 1795. The Queen assembled the trousseau, planned the dress and styled arrangements on the wedding of Prince Frederick and Augusta in 1736. As she reported to her son, the King had been reading 'papers to make himself master of every etiquette, that he may give directions'.

On 5 April, the Prince entered the apartments of Prince Ernest, in St James's, to meet Caroline for the first time. The Princess knelt to him, he raised her up then hurried from the room in horror. The Princess was left rather confused. 'I think he's very fat and he's nothing as handsome as his portrait', she declared.

Three days later, escorted by the Duke of Clarence, and four trainbearers in ornate silver embroidered dresses, the bride entered the Chapel Royal at St James's, which was decked in crimson velvet and silver tissue. Her gown, ordered by the Queen, was composed of silver tissue and lace dress, decorated with bows, and she wore a robe of ermine lined with velvet. The outfit was so

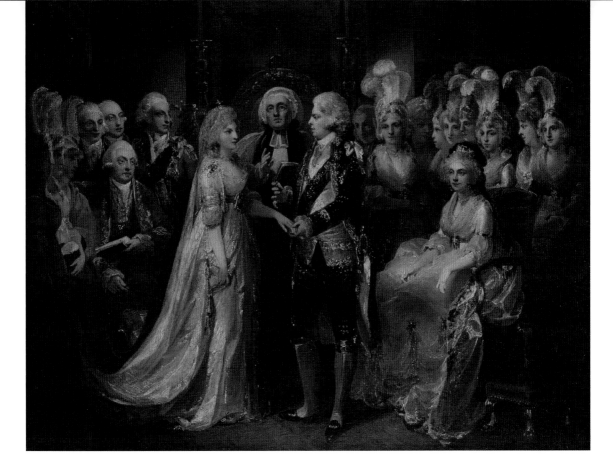

heavy that the Princess stumbled under its weight. All around her the royal ladies glittered in gold, silver and precious jewels. At the altar, she waited for her Prince, chattering to the Duke.

On the morning of the ceremony, the Prince had begged his brother, the Duke of Clarence, to 'tell Mrs Fitzherbert she is the only woman I shall ever love'. He arrived at the Chapel Royal, drunk, but finely dressed in a court suit with the Collar of the Garter. As the ceremony progressed, one of his equerries thought the Prince was about to burst into tears. One guest considered he had never seen a 'more discontented meeting' and it put him in mind of a 'gala in a black hole'. The Archbishop of Canterbury, who was officiating, asked if there were any legal impediments to the marriage, then laid down the book and looked earnestly at the King and bridegroom, suggesting he suspected a previous marriage had taken place. It hardly added to the dignity of the occasion.

The ceremony was followed by a reception in the Queen's Apartments. The Prince looked, according to one of the guests, 'like death and full of confusion'.

The Marriage of George, Prince of Wales and Princess Caroline of Brunswick by Henry Singleton. The groom detested his bride on sight, but the wedding could not be reversed.

When he joined the Princess in her chamber he was so drunk that he fell into the fireplace, where he remained for the rest of the night. Although he could barely tolerate his bride, a child was born of the union on 7 January 1796. 'I receive her with all the affection possible', the Prince wrote to the Queen of the child, Princess Charlotte, but he soon separated from the Princess of Wales, and later tried to divorce her for adultery. She left the country in 1814 and never saw her daughter again.

By the early 1800s the little girl, Princess Charlotte, was the only legitimate child born to the thirteen children of George III. Their illegitimate children have been estimated to number fifty-six. The Princess Charlotte was popular with the people. She was a conspicuous contrast to her debauched and spendthrift uncles, and her alliances with the Whig party made her appear to be in tune with the prevailing public mood towards wider voting rights. Her esteem among the people made her relationship with her jealous father difficult. The Prince also found aspects of her spirited behaviour reminiscent of her mother, and he was irate when she broke off an engagement with the Hereditary Prince of Orange because she refused to leave Britain and live abroad. In 1814, she encountered the penniless Prince Leopold of Saxe-Coburg-Saalfeld, who was visiting London as part of the victory celebrations after the imprisonment of Napoleon Bonaparte on Elba. A kindly and mature young man, he courted the Princess assiduously.

'I *delight* in Coburg because I am *quite satisfied he is really*, truly & sincerely attached to *me*', she wrote. The Prince Regent had wished for a more powerful union, but he was relieved at the prospect of a marriage for his daughter after the broken engagement. Parliament voted the young couple £50,000 a year, with further sums for other items, including £40,000 for jewels and plate.

The date of the wedding had to be altered due to the poor health of the Regent, and was finally decided for 2 May 1816. Charlotte's fears that she would have a private, 'smuggled' wedding were unfounded. The Regent planned a magnificent ceremony in the beautiful Crimson State Room at Carlton House.

On the day of the wedding, crowds gathered around St James's from the early hours, encouraged by the sunny weather. Prince Leopold returned from a morning visit to his bride, and the crush was so great that a footman was nearly killed, and a number of women and children were pushed into Clarence House.

Princess Charlotte and Prince Leopold. The young couple were inordinately popular with the public.

After dining with the Queen and her aunts, the Princess dressed in her wedding gown. Worth around £15,000, it was silver tissue, under silk silver net, embroidered in silver lamé with shells and bouquets and decorated with Brussels point lace. Her heavily embroidered train was over ten metres long. She wore a diamond necklace and earrings given by her father, a diamond bracelet from Leopold and a crown of diamonds in the shape of rosebuds and

leaves. When she saw her, her aunt Mary burst into tears. 'The whole dress surpassed all conception in the brilliancy and richness of its effects', reported the fashion journal the *Lady's Magazine*.

Charlotte drove to the ceremony in an open carriage, with the Queen and her aunts Augusta and Elizabeth. She arrived at Carlton House and was attended by her five bridesmaids into the salon, which was lit by hundreds of candles. Fifty guests were in attendance, nearly all in very fine dress. Her father looked resplendent in his scarlet field marshal's coat and his dazzling orders of knighthood. The groom looked equally impressive in a British general's uniform coat. The Queen wore gold tissue, and among the other female guests there were outfits of silver lamé, much gold, and profusions of diamonds and feathers.

The Archbishop of Canterbury, assisted by the Archbishop of London, conducted the ceremony in under half an hour. Princess Charlotte was heard to laugh when Prince Leopold repeated the words 'With all my worldly goods I thee endow.' He had, it was said, no more than £200 a year. After a grand banquet, Charlotte departed to change into her travelling gown of white corded silk trimmed with Brussels lace and a white satin hat adorned with a plume of ostrich feathers. After the Queen's protests that a young couple could not travel alone late at night were overruled, Charlotte and Leopold departed for their honeymoon at Oatlands, the country home of the Duke and Duchess of York.

Princess Charlotte had a magnificent wedding trousseau including dresses of gold lamé and tissue, Brussels point lace, and satins, silks and muslin embroidered in gold and trimmed with ermine. Unfortunately, many of her dresses did not fit and had to be altered.

Charlotte had achieved the domestic felicity that had proved so unattainable for her uncles and the young couple were very content. 'A Princess, never, I believe, set out in life (or married) with such prospects of happiness, real domestic ones like other people', she wrote. Sadly, on 5 November 1817, after a lengthy and difficult labour, the twenty-one-year-old Princess gave birth to a stillborn son, and herself died a few hours later. She was buried in the Royal Tomb House at Windsor, with her son at her feet. The people were plunged into genuine grief at the loss of an admired and respected future queen.

The wedding dress of Princess Charlotte. The gown was said to cost £15,000 and she was adorned with diamonds.

Great Britain needed an heir and the sons of George III saw their chance to attain riches and see their debts paid. The year 1818 was one of marriages. Adolphus, Duke of Cambridge, the seventh and youngest brother, married his second cousin, Princess Augusta, youngest daughter of the Landgrave of Hesse-Cassel, in May and then in front of the Queen on 1 June at Buckingham Palace. The Duke of Clarence, who had broken off relations with Mrs Jordan, alighted on Princess Adelaide, eldest daughter of the Duke of Saxe-Coburg. The twenty-six-year-old Princess had a poor complexion, but she was reputed to be kind and well brought up by her widowed mother. The Duke threatened to end the engagement when Parliament did not vote him sufficient funds but later relented, and, at the beginning of July, the Princess Adelaide arrived at Grillon's hotel in Albemarle Street. They were married on 13 July 1818 at Kew Palace, in a joint ceremony with the Duke of Kent.

Even before the death of Charlotte, the fourth brother, fifty-one-year-old Edward, Duke of Kent, had been pondering ending his relationship of twenty-seven years with his mistress and marrying. Leopold had suggested his sister, the Princess Victoire, the pretty thirty-one-year-old widow of the Prince of Leiningen-Daschburg-Hardenburg. After the Duke's gentle courtship and promises of protection for her children had surmounted the Princess's unwillingness to be married to a man so much older than herself, the pair were married at the Hall of the Giants in the Schloss Ehrenburg at Coburg on 29 May 1818. The Duke, who had borrowed £3,000 for the wedding, wore field marshal's uniform and the Princess's gown was of blonde silk lace, decorated with orange blossoms and white roses. After a gun salute and a grand banquet, the royal pair retired to their apartment. They quickly settled into a happy intimacy.

The Duke and Duchess were remarried alongside the Duke of Clarence and Princess Adelaide on 13 July. Queen Charlotte was too unwell to travel to London and so the wedding took place at Kew Palace (she would die four months later). A temporary altar was erected in the drawing room and decorated with the gold plate from the Chapel Royal. The Prince Regent gave away both brides, Princess Victoire wearing gold tissue and gold lamé and Princess Adelaide in silver. As soon as the service was over, a messenger rode to London with the tidings that Britain had two new duchesses. Bells rang out across the capital. The Kents departed for their honeymoon at Claremont,

with Prince Leopold. The Prince Regent invited the remaining guests to tea in the pagoda.

On 24 May 1819, at Kensington Palace, the Duchess of Kent gave birth to a daughter, Alexandrina Victoria. The elated Duke apparently showed the little girl around, telling everyone to 'look at her well for she will be Queen of England'. But the doting father saw little of her childhood for he died when she was barely eight months old. The Prince Regent, later King George IV after the death of King George III in 1820, spent his life with mistresses. The Duke of York and the Duke of Clarence, who became King William IV in 1830, died without legitimate heirs. After a lonely upbringing at the hands of her mother and John Conroy, the Duchess's confidant, the young Princess Victoria came to the throne less than a month after her eighteenth birthday, on 20 June 1837. The people were delighted by their young, liberal Queen.

'I dreaded the thought of marrying', Queen Victoria wrote. 'I was so accustomed to having my own way that I thought it was 10 to 1 that I shouldn't agree with anybody.' She was concerned that her work as sovereign or her freedom might be curtailed. But by the time she was twenty-one she had become weary of living with her mother, as she was compelled to as a single female, and she wished for a companion. Her thoughts began to turn to her cousin, Prince Albert, whom her beloved uncle Leopold, once Charlotte's widower, now King of the Belgians, had advocated as a match for her.

Albert, born in the August after Victoria, was the son of Ernest I, Duke of Saxe-Coburg-Gotha, and the nephew of the Duchess of Kent and the King of the Belgians. King William had tried to sway Victoria towards one of the young Princes of Orange (whose father had been jilted by Princess Charlotte) but Victoria was unconvinced. Her first meeting with Albert, however, had not been propitious. The young Prince had been exhausted by the round of entertaining at the British court, and had left Victoria's seventeenth birthday ball early, looking as though he was about to faint.

Victoria decided to reserve judgement until she met Albert once more. He arrived at Windsor Castle, accompanied by his brother, on 10 October. She saw a handsome man where there had once been a boy. 'It was with some emotion that I beheld Albert – who is *beautiful*', she wrote in her journal. The pair passed the following days together and the Queen was enchanted. As the monarch, she could not receive a proposal, and so would have to offer

original Sketch by
VR for the dress of the
Queen's 12 Brides Maids. —

marriage – a daring act. Five days after his arrival, she called Albert to her and he agreed. 'Oh! To *feel* I was, and am, loved by *such* an Angel as Albert, was *too great delight* to describe!' she recorded. 'I have obtained the height of my desire', the Prince wrote to a friend.

There were public reservations that the Queen had chosen an impoverished prince as youthful as herself, but the wedding inspired public fascination. 'The rage is begun', sighed the journal *The Satirist*. 'We are all going stark, staring mad. Nothing is heard or thought of but doves and cupids, triumphal arches and whit favours, and last but not least, variegated lamps and general illuminations.' In contrast to so many of the previous royal brides and grooms, Victoria was the Queen Regnant, beloved by the people, young and appealing. Lord Melbourne, the Prime Minister, and Victoria planned a ceremony to secure the public affections. More guests than ever before would be invited and, most significantly of all, the ceremony would be at 1 p.m. rather than the late evening, so the crowds would be able to see the bridal procession drive to St James's. The ceremony would be based on the marriage of King George III, without the pomp. Victoria refused the weighty gowns of gold, silver tissue, ermine and jewels of her predecessors and also declined to don her crimson velvet Robes of State.

The Queen planned a simple dress of pure white, playing on notions of purity and innocence which she had used so effectively before (George Hayter had painted her first meeting with her Privy Council to show her in white rather than the mourning gown she had worn). Her bridal gown followed a pattern reminiscent of a simple day dress, a bodice with puffed sleeves over a full skirt. In order to retain a regal aspect, since she did not have her robes, the Queen had a court train ornamented with orange blossoms attached to her waist. She designed similarly delicate white outfits for her bridesmaids, the sketches of which still remain in the Royal Collections today.

The Queen wished to patronise British industry, and her gown was

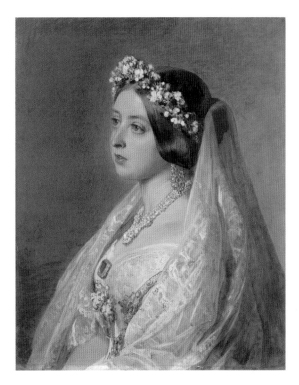

Queen Victoria in Her Wedding Veil by Franz Xaver Winterhalter. The only colour the Queen wore was her handsome sapphire brooch, a gift from Prince Albert.

Queen Victoria's own design for her the dress of her twelve bridesmaids. The Queen was quite delighted with the 'beautiful effect'.

⁓ Flounce of lace from the Queen's gown.

composed of finely woven Spitalfields silk satin and trimmed with British lace, against the prevailing fashion for Brussels point lace. More than two hundred women in the village of Beer in Devon were constantly employed from March to November under the supervision of dressmaker Miss Jane Bidney, making the lace, which was four yards long and three-quarters of a yard deep (the Queen had clearly commissioned the lace prior to her engagement, perhaps for a court dress). The pattern was later destroyed, so that the Queen's design could never be replicated.

Albert demanded that each of the twelve bridesmaids be born of a mother of spotless character. He had to be denied. Such a judgement would have scandalised the court, at which many ladies had enjoyed affairs with the Queen's uncles. The guest list also caused difficulties: three hundred people would be crammed into the Chapel Royal, with seats pushed into every spare spot. Ladies were told not to wear court trains, so as to take up less space. The Queen was resistant to inviting Tories and there were only five present, including the Duke of Wellington, provoking comment that she had revealed her bias towards the Whig party.

At half past four on the afternoon of Saturday 8 February, Prince Albert arrived at Buckingham Palace with his escort, after being cheered at every stop on his journey. The Queen took Albert by the hand and led him to her sitting room. He presented her with a handsome sapphire surrounded by diamonds, and she gave him a diamond Garter and the Star and Badge of the Garter in diamonds. On Sunday night, the Queen and Prince Albert rehearsed the

ceremony and tried on the ring. 'The last time I slept alone', wrote the Queen in her journal. She awoke on the morning of Monday 10 February 1840 to pouring rain, in incorrigible spirits. 'How are you today and have you slept well?' she wrote to her bridegroom. Outside, the crowds had been braving the bad weather since eight o' clock. They cheered when a royal salute of twenty-one guns indicated that the Queen was entering her carriage, accompanied by her mother and the Duchess of Sutherland, her Mistress of the Robes, wearing her gown and very few jewels other than Albert's gift, a diamond necklace and the chain of the Garter. The procession was impressive, although Florence Nightingale, in the crowd, thought Albert wearing clothes 'no doubt borrowed to be married in'.

Upon her arrival, the Queen processed through the State Rooms to the Chapel Royal, attended by her trainbearers and the Duke of Sussex, who was to give her away. The Queen was delighted by her bridesmaids, all 'dressed in white with white roses, which had a beautiful effect'. Some guests were less impressed by their unadorned appearance. Lady Lyttleton thought the bridesmaids looked like 'village girls' next to the fine clothes and jewels of the guests. Unfortunately the Queen's train, although eighteen feet long, was too short for all the attendants to hold and the bridesmaids rather scrambled their way along, treading on each other's feet.

Ten minutes before the Queen's arrival, Prince Albert had walked into the Chapel Royal to the sound of trumpets, in the scarlet and white uniform of a British field marshal. The Queen had insisted on keeping the vow 'to obey', despite political concerns, although Albert would find that she was unwilling to obey anybody. She thought the ceremony 'very imposing and fine and simple, and I think OUGHT to make an everlasting impression on everyone who promises at the Altar to *keep* what he or she promises'. The party proceeded to the crimson and gold Throne Room, for the signing of the register, and then to Buckingham Palace for the wedding breakfast. There, the Queen and Prince Albert had half an hour alone together. She gave him a ring and he said there should never be a secret they did not share. Each bridesmaid was presented with a brooch designed by Prince Albert in the shape of an eagle. The bird was set with rich turquoises, pearls, a ruby and diamonds, the symbols of true love, passion and eternity.

A hundred cakes were ordered, two to be consumed on the day and the

Overleaf: The Marriage of Queen Victoria and Prince Albert by George Hayter. The Queen declared that the ceremony 'OUGHT to make an impression on everyone who promises at the altar.'

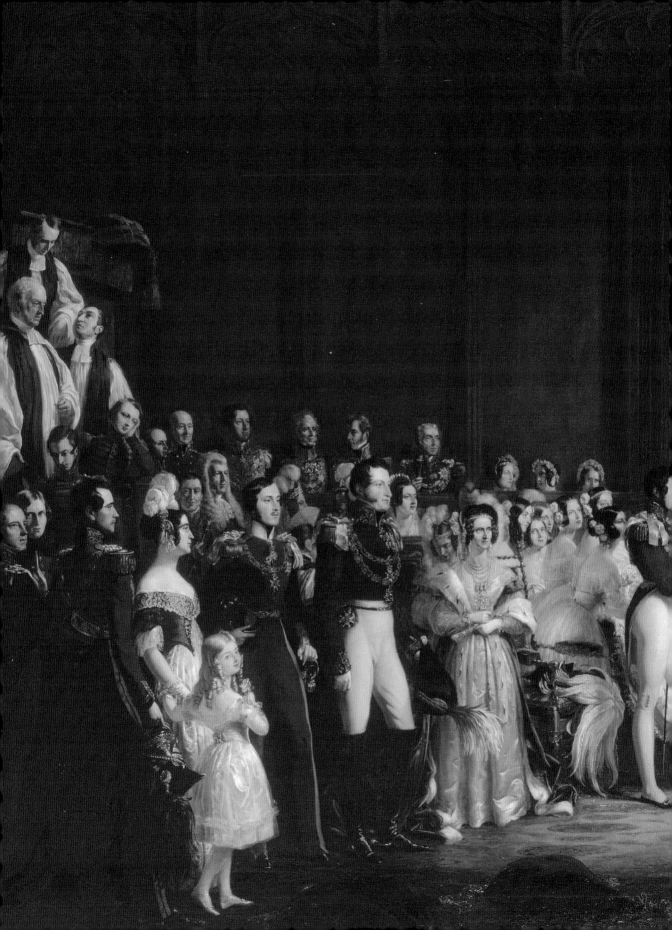

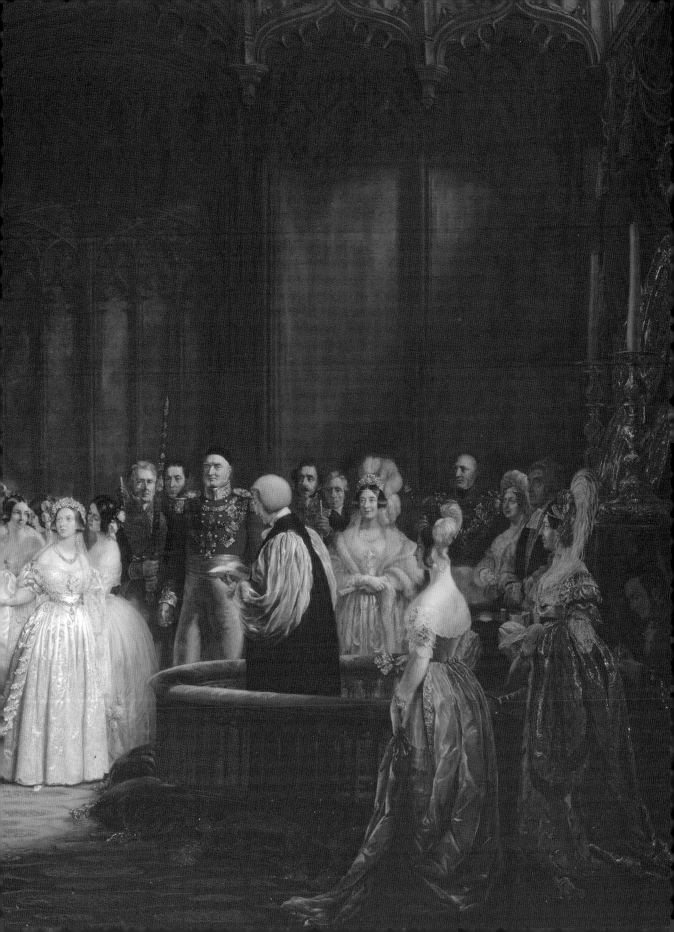

others to be distributed among relations, foreign ambassadors, the household and officers of state. The wedding guests enjoyed a cake weighing three hundred pounds, nine feet in circumference and sixteen inches high, requiring four men to carry it in. It was decorated by a figure of Britannia with cupids at her feet, one holding a book bearing the date of the wedding. 'We are assured', declared *The Times*, 'that not one of the cherubs on the royal wedding cake was intended to represent Lord Palmerston. The resemblance therefore pointed out . . . must be purely accidental.'

After the banquet, the Queen changed into a white silk travelling gown and set off with Albert for Windsor Castle. The diarist Charles Greville thought the newlyweds travelled to their honeymoon in very shabby style, in an old coach with a small escort. But the Queen preferred less grandeur, and her wish pleased her people. They did not reach Windsor until eight. As the Queen wrote, there was 'an immense crowd', all along, 'quite deafening us'.

After dinner, Victoria felt overwhelmed and had to lie down with a headache. Albert sat by her side, and she wrote, 'his excessive love and affection gave me feelings of heavenly love and happiness I never could have *hoped* to have felt before!' Prince Albert had wished for a six-week honeymoon, but the Queen was set on three days. The poor Prince would not even enjoy a quiet rest. The Queen, so eager to share her happiness, threw a dinner party for ten on Tuesday evening and a ball on Wednesday.

'Nothing could have gone off better', remarked Lord Melbourne of the ceremony. The newspapers judged the Queen had conducted matters perfectly, not least in her choice of outfit. As the *Morning Chronicle* informed its readers, 'Her Majesty, with regard to whose dress so much and so many contradictions have taken place, was attired plainly, and with simple magnificence.' Victoria's choice pleased a people weary of the excess of her uncles. Moreover, her gown was easy to replicate. The eighteenth-century princesses had worn excessively splendid court dress that few could copy. After the Queen's wedding, royal brides were married in white silk or satin – and the fashion for a white wedding dress took hold of the entire country.

Victoria had the myrtle from her bouquet planted and a sprig from the bush was later carried by the future Queen Elizabeth II on her wedding day. The Queen's wedding lace became one of her treasured possessions. She wore it at family weddings and the christenings of many of her nine children. Her

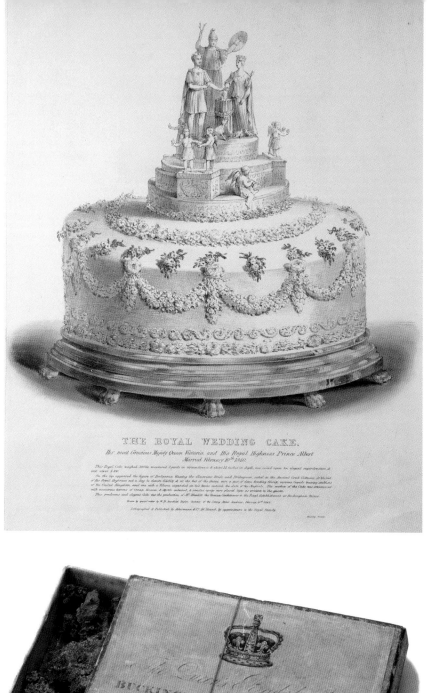

THE ROYAL WEDDING CAKE.

Her most Gracious Majesty Queen Victoria, and His Royal Highness Prince Albert
Married February 10th 1840.

The
Queen's wedding
cake was nine feet
in circumference
and weighed three
hundred pounds.

A hundred
wedding cakes were
made to celebrate the
marriage and pieces
were distributed to
various dignitaries and
family members.

The Queen and Prince Albert took hours to reach Windsor, thanks to the crowds of people lined up along the route, cheering the couple.

The Queen's determination to have a simple white wedding gown set the new fashion. Brides across Britain wished for a white wedding and a large ceremony – like the Queen.

first child, Princess Victoria Adelaide Mary Louisa, was born on 21 November 1840 and christened on her parents' wedding anniversary.

As Vicky grew up, Albert and Victoria conceived plans for her to marry Prince Frederick William, heir to the Crown of Prussia. The pair had first met in April 1851 when she was ten and he nineteen, and she had conducted him around the Great Exhibition. He returned when she was fourteen and, after asking permission from Victoria and Albert to propose, told her he hoped to see her soon in Prussia – and he would like her to stay there for ever. That evening, the Princess told her happy parents the news. 'He is a dear, excellent charming young man, whom we shall give our dear child to with perfect confidence', Victoria wrote to her uncle Leopold.

The wedding was set for 1858, when Vicky would be seventeen. In the interim, Albert occupied himself with the education of his daughter, determined that she would play a crucial role in the future of Germany. A trousseau was

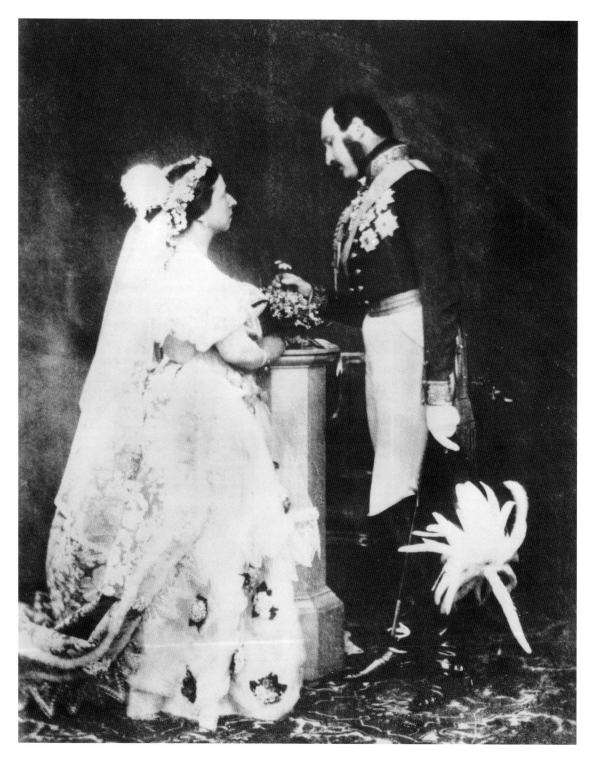

assembled, containing twelve evening gowns, six ball dresses and three court gowns, various other dresses (including mourning), and sufficient velvet, silk and lawn to make at least forty further gowns, as well as shoes, bonnets and shawls. One hundred packing cases were filled with furniture, paintings, materials, books and foods from Fortnum & Mason.

'Such a house-full. Such bustle and excitement!' wrote the Queen. As the ceremony approached, guests arrived at Buckingham Palace. Relations, Prussian royals and King Leopold were entertained with hunting parties, a ball for over a thousand guests, and three gala theatre performances. More than ninety sat down for dinner in full ceremony every evening. Fritz presented Vicky with a necklace of diamonds and turquoise and his parents sent her a string of thirty-six great pearls, worth apparently £5,000. Albert and Victoria gave the couple three large silver candelabra, and Vicky received a diamond corsage from her mother, an emerald and diamond bracelet and pendant from her father and a set of jewels in opals and diamonds from both her parents, as well as brooches of diamonds, rubies, sapphires and emeralds from each of her sisters.

'I felt as if I was being married over again', the Queen wrote, 'only much more nervous.' She worried it was 'like taking a poor Lamb to be sacrificed' and feared she would collapse in the Chapel. The procession of eighteen carriages, along with over 300 soldiers and 220 horses, set off from Buckingham Palace to St James's Chapel. The 150 spectators took their places, gentlemen allocated a square of twenty inches, the ladies a mere twenty-four. The Princess entered accompanied by her father, uncle Leopold and her eight bridesmaids. 'Our darling Flower looked very touching and lovely, with such an innocent, confident, and serious expression on her dear face', wrote the Queen.

The bride wore a wide crinoline of white moiré over a petticoat flounced with Honiton lace and wreathed with orange flowers and myrtle, and wore a lace veil secured by a headdress of orange blossom and myrtle. Her eight trainbearers, all the daughters of peers, wore white glacé petticoats and tulle, with wreaths of pink roses and white heather. The Queen thought they looked 'like a cloud of maidens hovering around her'. She was less enthused by the Archbishop of Canterbury, who, she noticed, 'omitted some of the passages'.

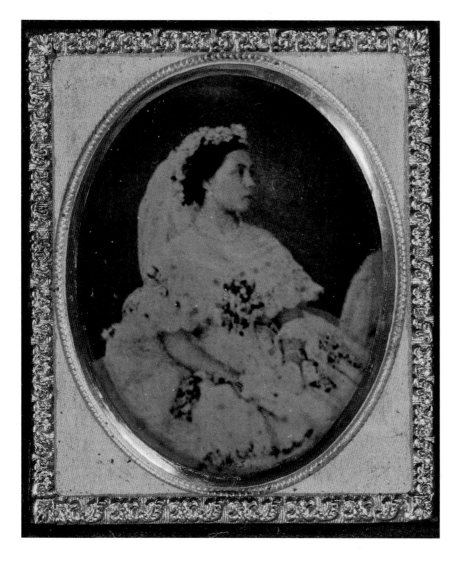

Princess Vicky, a bride at just seventeen.

After the ceremony, the Princess went to the Throne Room to sign the register, holding her husband's hand to Mendelssohn's 'Wedding March'. Originally written as incidental music for a production of *A Midsummer Night's Dream*, the piece's first recorded appearance at an English wedding was in 1847. The use of it as a recessional at the wedding of Princess Victoria turned it into one of the most fashionable choices a bride could make.

'I felt so moved, so overjoyed and relieved, that I could have embraced everybody', wrote the Queen. The party returned to their carriages and drove back through the ecstatic crowds to Buckingham Palace. Before the wedding

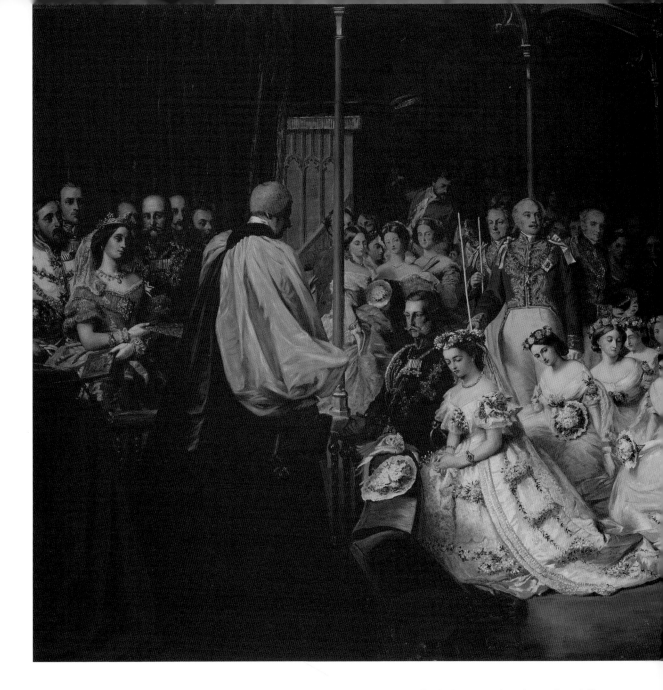

breakfast, the young couple emerged on to the balcony to be cheered. It 'all had been so brilliant, so satisfactory', she decided.

After the Queen's wedding, the fashion was for ornate centrepieces of baking and sugarcraft. Vicky's cake stood over six feet tall, with three tiers separated by rows of pearls, adorned with orange blossom, jasmine and silver leaves. The cake was decorated with two cupids holding medallions of the

The Marriage of the Princess Royal by James Brooks. The Queen worried that she felt as if she were leading a lamb to be sacrificed, but Vicky's marriage with Prince Frederick William of Prussia proved happy.

bride and groom, surrounded by busts of their parents, allegorical statues and the arms of Great Britain and Prussia.

The bridal couple drove off for a brief honeymoon at Windsor Castle, where they were met by fireworks, cannons and a guard of honour. One hundred Eton schoolboys unhitched the ponies and pulled their carriage up the slope leading up to the Castle from the Long Walk. Back in London the

King and Queen gave a state banquet, fireworks exploded in the parks, and gifts were distributed to the poor. On 2 February, Vicky and Fritz left London in an open carriage to catch the royal yacht at Gravesend. She walked under banners emblazoned 'Fairwell, Fair Rose of England'. Apparently, the men from the local brewery shouted to the bridegroom, 'Be kind to her or we'll have her back!'

During their journey, and upon arrival in Berlin, more celebrations and parties were arranged, including another great court ball during their passage through Brussels. There was a slight hiccup when the celebratory banquet provided at Hanover was served on a dinner service which had been the subject of an unpleasant lawsuit between Queen Victoria and King Ernest, a dispute decided against the Queen. Although Vicky found the Prussian court hostile, she tried hard to please. 'The whole Royal Family is enchanted by my wife', Fritz telegraphed to Albert.

In September 1861, Prince Albert Edward, the Prince of Wales, was sent to Germany, supposedly to watch military manoeuvres. The true purpose was to introduce him to Princess Alexandra, eldest daughter of Prince Christian of Schleswig-Holstein-Sonderburg-Glucksburg, and Princess Louise, niece of King Christian VIII of Denmark. Queen Victoria and Prince Albert, knowing that few German princesses were sufficiently appealing to meet their son's exacting demands, chose Alix, an acknowledged beauty, although her family were rather poor. Bertie and Alix were introduced by Vicky, the Crown Princess of Prussia, on 24 September, even though she wished her brother would marry a German. Bertie was 'decidedly pleased' by Princess Alix's pretty face and figure. She felt similarly. 'Wasn't it lucky that I was wearing my best bonnet?' she commented to her family.

The twenty-one-year-old Prince of Wales was very susceptible to a pretty face, despite plans for the engagement. When Prince Albert heard his son had invited an actress into his tent during manoeuvres in Ireland, he set off to reprimand him. The Prince Consort had been suffering from a heavy cold and exhaustion and on his return fell ill and died on 14 December. Victoria was devastated.

In July 1862 the Queen roused herself sufficiently from her heavy mourning to allow a quiet wedding for Princess Alice with Prince Louis of Hesse-Darmstadt, in the State Dining Room at Osborne House, on the Isle of

Wight. Only family and a few courtiers were present. The Queen wore black, but the other ladies were permitted to exchange their mourning for grey or violet. Even the bridesmaids wore grey ribbons on their dresses. Princess Alice, given away by her brother, wore a modest gown with a flounce of Honiton lace and no train. The Queen struggled not to weep and retired to her room after the ceremony. After a rather subdued wedding luncheon in the ground-floor Horn Room, the bride clothed herself in mourning attire for her departure.

Princess Alexandra and the Prince of Wales were engaged during a week together in Belgium, under the supervision of Prince Leopold in September 1862. The news was greeted with great pleasure in Britain and Denmark. The

The Marriage of Princess Alice by George Housman Thomas. Princess Alice's wedding took place quietly at Osborne, her mother devastated by grief for Prince Albert.

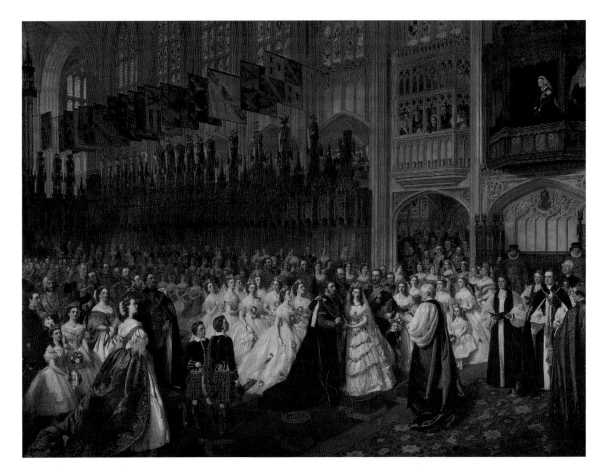

The Marriage of the Prince of Wales and Princess Alexandra of Denmark by William Powell Frith. The groom gave the bride a ring spelling out the letters of his name in jewels.

Prince sent his fiancée £3,000 towards the cost of her clothes and £15,000 worth of jewels, including a complete set of diamonds and pearls. King Leopold gave a wedding dress in Brussels point lace.

At three o'clock on the afternoon of 26 February 1863, the eighteen-year-old Princess and her family emerged from their home, the Yellow Palace in Copenhagen, to begin their journey to Britain. On 7 March they arrived in Queenborough and took the train to London. As the Princess made her way up the Thames, she was surrounded by boats eager to greet her. Thousands of photographs of the bride had been displayed in shops and the public were determined to give her a great welcome. The Corporation of London spent £40,000 on decorations and illuminations and spectators thronged the route to the Palace. Many were disappointed by the royal carriages the Queen had chosen for the Princess and her family – *The Times* declared them the 'very

dregs'. At Paddington the party caught a special train to Slough. Alix was presented to the Queen at Windsor, who thought she looked 'like a rose' but soon retired mournfully to her room. Alix then apparently delighted the wider family by executing a cartwheel.

The wedding was set for Tuesday 10 March at St George's Chapel, Windsor. It was to be the first marriage at Windsor since Henry I had married Adela of Louvain in 1122. The venue was criticised for being outside London and too small for the wedding of the heir to the throne. As *Punch* complained, the ceremony would take place 'in an obscure village in Berkshire, remarkable only for an old castle'. The Archbishop of Canterbury, who would officiate, strongly objected to holding a wedding during Lent.

On the morning of the 10th, four carriage processions left the Castle – the royal guests, the royal family and household, the bridegroom and finally the bride. The ladies of the royal family had been instructed to wear half-mourning, white, grey, mauve or lilac. Guests could dress as they pleased and many came decked in excessive clothes and jewels, even those who travelled down on the 10.45 special train from Paddington. The Queen, sombre in black, made her way via the Deanery to take her position in Catherine of Aragon's closet, on the north side of the altar, from where she could not be seen. Dignitaries and foreign royals crammed into the pews. Bertie entered wearing a general's uniform with the Robe of the Garter, supported by his uncle Ernest and the Crown Prince of Prussia. Then, to Handel's Processional March, Alexandra, on her father's arm, accompanied by the Duke of Cambridge and eight aristocratic bridesmaids in silk and tulle, walked down the aisle. The Queen had not allowed her to wear Leopold's dress, for it was of foreign manufacture, and instead her gown was white satin, decked with tulle, silver embroidery and Honiton lace. Orange flowers adorned her lovely hair and she wore Bertie's gifts of a diamond

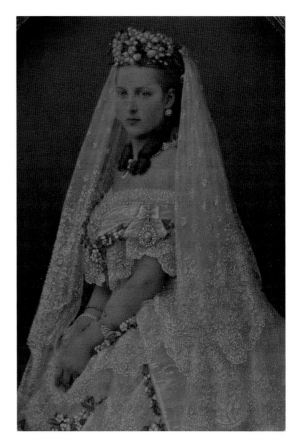

Eighteen-year-old Princess Alexandra was an acknowledged beauty and very popular with the British people.

The Queen, still deep in mourning, insisted that a bust of Prince Albert feature in their family photograph.

necklace, earrings and brooch, as well as an opal and diamond bracelet from Queen Victoria.

The celebrated Jenny Lind sang the Chorale, for which the Prince Consort had composed the music. The Prince had bought Alexandra an exquisite wedding ring set with six precious stones, a beryl, an emerald, a ruby, a turquoise, a jacinth and a second emerald. The initials of the stones spelt 'Bertie'. As the ceremony ended, bells rang out and the electric telegraph communicated the great news across Britain and then the world.

A sprig from Princess Alexandra's headdress, kept by the Queen.

After the signing of the register, there were three wedding breakfasts at the Castle, one for the company in St George's Hall, a second for thirty-eight royal personages in the Dining Room and a third for the Queen and her youngest daughter, Beatrice, in the Queen's private room. Lord Granville was a pragmatic guest: 'the music good – the service not too long . . . rather a scramble for luncheon'. Each bridesmaid received a locket of diamonds and coral with the royal cipher in crystal.

Shortly before four o'clock, Bertie and Alix departed the Castle for a week's honeymoon at Osborne House. On the train that returned the wedding guests from Slough to Paddington all order and precedence were forgotten, as sightseers also tried to enter. The Duchess of Westminster, in her half-a-million pounds' worth of jewels, and Lady Palmerston managed to clamber into a third-class carriage, Disraeli sat on his wife's knee and the Archbishop of Canterbury held tight to the back of a carriage. The wedding inspired great celebrations across Britain and Denmark. London was once again alight with illuminations and decorations, and the streets were packed with joyful crowds until three in the morning. Vicky and Fritz paid a visit to the couple on honeymoon at Osborne. 'It does one good to see people so thoroughly happy as this dear young couple are. As for Bertie, he looks blissful', Vicky wrote to her mother. Such marital harmony was furthered over their

forty-eight years of marriage by Alix's willingness to overlook her husband's many mistresses.

After an ill-fated friendship with a royal librarian, Princess Helena was lined up to marry Prince Christian of Schleswig-Holstein. The Prince and Princess of Wales protested because he had fought against Denmark in the 1864 war with Germany, but Victoria insisted he was the correct match for her ungainly middle daughter and the ceremony was held in St George's Chapel on 5 July 1866. The Queen softened her mourning appearance with a white cap and escorted her daughter to the altar, along with eight bridesmaids and the Prince of Wales, standing in for his father. Prince Christian, fifteen years older than the bride, was an idle man content with no official role in Britain. The marriage was the longest lasting of Queen Victoria's children, ended only by his death in 1917, after fifty-one years.

After the bitter wars between Prussia and Austria and Germany and Denmark, her children divided, the Queen began to reconsider the suitability of foreign alliances. When the artistic Princess Louise proposed marrying John Campbell, Marquess of Lorne, Queen Victoria agreed to the match. No royal had married a subject since 1515, when special dispensation was granted for the sister of Henry VIII, Mary Tudor, to marry the Duke of Suffolk. 'Times have changed', the Queen wrote to the Prince of Wales when he protested, 'great foreign alliances are looked on as causes of trouble and anxiety and are of no good.' Abroad, and especially in Prussia, there was resentment that a foreign prince had not been chosen, but the British were generally pleased by the news and cartoons were published showing the Scotsman beating the Prussians in a 'German defeat'.

The wedding was held in St George's Chapel on 24 March 1871, three days after Louise's twenty-third birthday. Many of the wedding guests wore Highland dress, including Prince Leopold and the three small sons of the Prince and Princess of Wales. Louise was dressed in white satin and a veil she had designed of Honiton silk, and the wedding cake was a masterpiece of ostentation. It took three months to make, stood five feet tall and weighed over sixteen stone.

The only one of her children's marriages not attended by the Queen was that of Prince Alfred to the Grand Duchess Marie of Russia. The pair first married on 23 January 1874 in the Imperial Chapel of the Winter Palace in

St Petersburg, in full Orthodox tradition, followed by an Anglican service conducted by the Duke of Westminster. Vicky, Fritz and Prince Arthur were present. Five years later, on 13 March 1879, twenty-eight-year-old Prince Arthur married Princess Louise Margaret of Prussia, the grand-niece of the Emperor of Germany, at St George's Chapel. Queen Victoria had thought her rather dull, but was soon won over by her 'amiable and charming character' and the newlyweds settled happily at Buckingham Palace. Perhaps the saddest royal wedding was that of the Queen's youngest son, Prince Leopold. After a youth dogged with ill health caused by haemophilia, he married Princess Helen of Waldeck-Pyrmont, a spirited young woman who had arrived with her family and eighty trunks of luggage. The Prince was suffering with an injured knee in the ceremony at St George's Chapel in April 1882, and he died two years later when Princess Helen was carrying their second child.

Finally, in 1885, the youngest daughter, Beatrice, married Prince Henry of Battenberg at St Mildred's, the parish church of Whippingham on the Isle of Wight. The Queen's insistence that her daughter marry near her beloved Osborne House meant that guests crammed into every possible property on the island and two royal yachts became floating hotels. The Duchess of Buccleuch, Mistress of the Robes, instructed that only those who had travelled down on the day could wear 'bonnets and smart morning dresses'. The other guests must wear long gowns and jewels on the dress and hair 'as for full evening dress party'.

After the ceremony, conducted by the Archbishop of Canterbury, Prince Henry, in the dress of the Prussian Garde du Corps, and Beatrice, in ivory white satin, decorated with orange blossoms, myrtle and white heather, processed down the aisle to Mendelssohn's 'Wedding March'. The bride was attended by ten small nieces, rather than the adult daughters of peers. At Osborne, the guests were entertained in outdoor marquees while the Queen, the bridal couple and other family members ate in the pavilion. The Queen wept bitterly to see her last child depart, but she had been delighted by the ceremony in the 'simple, pretty village church, all decorated with flowers, the sweet young bride, the handsome young husband'. She had married her children into families across Europe. Her grandchildren by them would number forty.

'A good, sensible wife – with considerable character – is what he needs

most', the Prince of Wales wrote to Queen Victoria of his eldest son. 'But where is she to be found?' Prince Albert Victor, Duke of Clarence and Avondale, could settle to nothing but self-indulgence. He had joined the navy as a cadet, but failed to benefit from the discipline. Queen Victoria rose to the challenge of finding a 'good, sensible wife' for the heir of the future King Edward VII. In November 1891, she issued an invitation to Balmoral to Princess Victoria Mary and Prince Adolphus, the two eldest children of her cousin, Princess Mary Adelaide. The daughter of her uncle, the Duke of Cambridge, and Princess Augusta, Princess Mary Adelaide was married to Prince Franz of Teck, the morganatic son of Duke Alexander of Württemberg, grandson of the King of Württemberg (Duke Alexander had forfeited his rights to the succession by marrying). The family had little money, but Princess Mary Adelaide was a strict and affectionate mother and her daughter's character, by all accounts, was both sweet and steady. Queen Victoria was very pleased by the visit. 'May is a particularly nice girl, so quiet & yet cheerful & so very carefully brought up & so sensible', she wrote. 'I think & hope that Eddy will try & marry her.'

Eddy proposed, May was pleased to accept and the engagement was announced on 6 December 1891. The date was fixed for 27 February, but Eddy died of influenza, after only a week of illness, on 14 January. He was buried six days later and May's bridal wreath of orange blossom was laid on his coffin. 'The dear girl looks like a crushed flower', wrote the Queen.

The new heir to the throne was Eddy's brother, twenty-six-year-old Prince George Frederick Ernest Albert, a shy but intelligent young man. Prince George, aware of the hopes of his family that he would marry May, paid her visits and the two began to forge a friendship while consoling each other in their grief. On 3 May 1893, George proposed to May while they were walking together. The news prompted much rejoicing. 'The Princess May is endeared to the public by her personal charm and her amiable disposition, by the memory of her bereavement and still more by the devotion she displayed at that trying juncture', declared *The Times*. Eddy and May had been due to marry at St George's Chapel, but, as Eddy had been buried there, her wedding with his brother was moved to the smaller Chapel Royal, St James's.

Princess May and the wedding became a subject of obsessive newspaper fascination. Women's magazines published features and wedding specials,

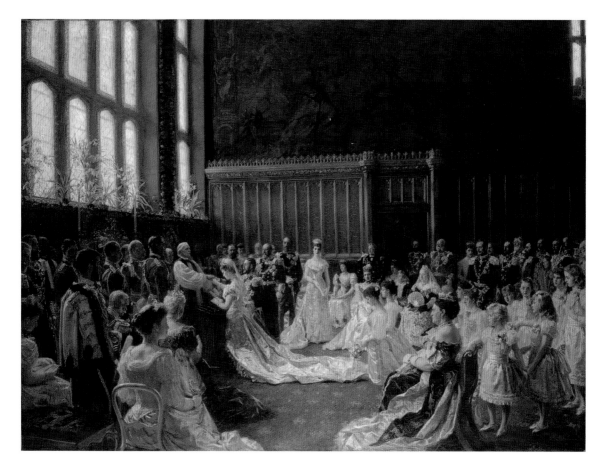

with details about the trousseau. May already had a trousseau for her wedding to Eddy, but it was considered bad luck to use it, so she was required to have another (indeed, clothes ordered for 1891 would have been out of fashion by 1893), and her maternal grandmother, the Grand Duchess of Mecklenburg-Strelitz, had to give May £1,000. The new wardrobe included forty outdoor outfits, fifteen ball dresses, five tea gowns, bonnets, shoes, gloves, travelling capes, wraps and driving capes. Public interest was such that the royal wedding gifts were put on display at the Imperial Institute in London and those who crowded in saw nearly 1,500 ornaments, plate, glass, china, jewellery and other costly gifts together worth over £300,000.

The morning of 6 July 1893 was one of bright sunshine. Crowds from all over the world began to assemble in the early hours, and four thousand policemen were on duty around Buckingham Palace and along the bridal route.

The Marriage of the Duke of York and Princess Mary of Teck by Lauritz Regner Tucman. 'May is a particularly nice girl,' wrote Queen Victoria, eager for her grandson to marry the pretty and intelligent granddaughter of her uncle Cambridge.

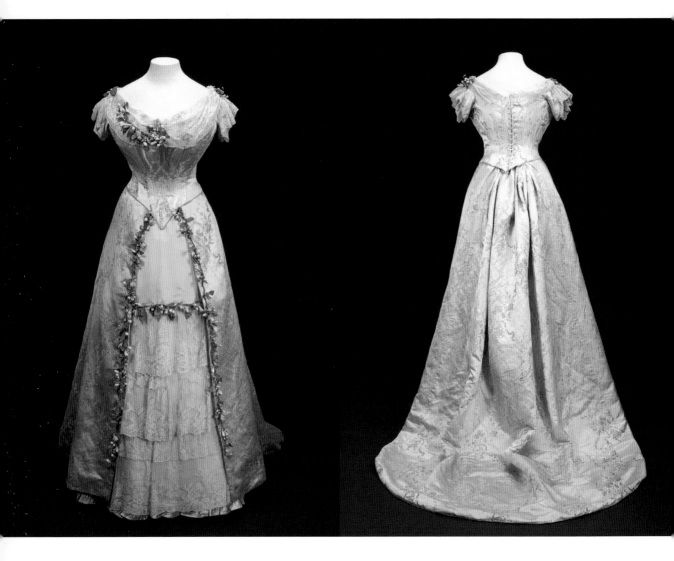

Princess May's simple, tightly corseted wedding dress of satin brocade over a silk and lace slip was pronounced the height of elegance.

Flags and banners billowed all around St James's, with tapestry and bunting hanging over the balconies and streamers flying on the posts.

At half past eleven, the first carriage left Buckingham Palace. The Duke of York and the Prince of Wales left the Palace at a quarter to twelve, followed by Queen Victoria, dressed in black satin draped in white lace, accompanied by the mother of the bride. The twenty-six year-old bride came last, escorted by her father and her brother Adolphus.

'Princess May is the ideal bride', declared the *Lady's Magazine*. May's wedding dress was a short-sleeved, tightly corseted white satin brocade

woven with the love emblems of roses, shamrocks, thistles and orange flowers, decorated with lace and sprays of orange blossom, open over a satin and lace slip. She wore her mother's bridal veil, rather than the long silk veil designed for her marriage to Eddy, with a wreath of orange flowers, myrtle and white heather and a diamond necklace. *The Times* declared her gown 'at once simple and elegant'.

One hundred and fifty guests, including the King and Queen of Denmark, packed into the Chapel Royal. The Princess, smiling at the guests she knew, was escorted up the aisle to the Archbishop of Canterbury by her father. As with Beatrice in 1885, her ten attendants were not the daughters of great peers selected to secure political loyalty, but members of the royal family. She was attended by Princess Victoria of Wales and Princess Maud of Wales, the sisters of the groom, seven first cousins of the groom, including Princess Patricia of Connaught, and Princess Alice of Battenberg, daughter of the groom's first cousin.

The ornate wedding cake for the future George V and Queen Mary.

After the ceremony, the royals returned to Buckingham Palace and the couple were led to the central balcony where they waved to the crowds. The royal party dined in the State Dining Room while the other guests enjoyed a buffet in the Ballroom, near a display of the wedding cakes. After the reception, George changed into a frock coat and top hat, and Mary wore a dress of cream white poplin and a gold bonnet.

The wedding guests showered them with rice as they left. Cheered by enthusiastic crowds all the way, they drove through the City to a newly scrubbed and decorated Liverpool Street Station. There, they boarded a train to Sandringham to spend their honeymoon at York Cottage. The Queen thought the choice of venue 'rather unlucky and sad', for it was a short walk from the room where Eddy had died less than a year and a half before. Although the first days together were a little nervous, the two were soon very fond of each other. 'I do *love* you, darling girl, with all my heart,

The Duke and Duchess of York, with their attendants. The twenty-six-year-old bride already possessed the dignity and composure that would make her so respected when she became Queen Mary.

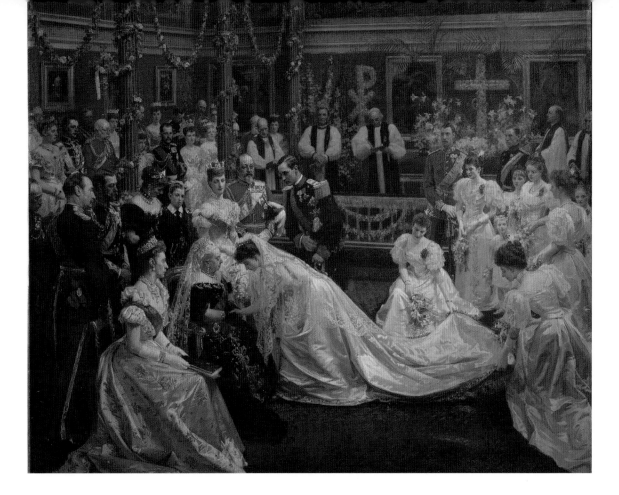

The marriage of Princess Maud and Prince Christian of Denmark – the future King and Queen of Norway.

and am simply devoted to you', George wrote to May, a few months after their return.

The eldest daughter of Bertie and Alix, Louise, the Princess Royal, married the wealthy Alexander MacDuff, Earl of Fife, after meeting him at the wedding of Princess Beatrice. The match suited Princess Alix, who was determined that no daughter of hers would take a groom from the enemy country of Germany, and marriage to a subject would allow her daughter to remain near her. Princess Louise was married on 27 July 1889 in the private chapel of Buckingham Palace. Queen Victoria thought the bride 'too plainly dressed', but the wedding was popular in the country. As the *Illustrated London News* declared, 'we are glad that the Prince of Wales has chosen his first son-in-law from among the old English houses whose history is bound up with the nation's life'.

The second daughter, Princess Maud, had attracted the attention of Prince Christian of Denmark, much to the pleasure of her mother. The cousins had

been friendly since childhood, and as Prince Christian grew into a young man, he became devoted to Maud, elegant, self-possessed and three years his senior. The engagement was announced in October 1895, and the wedding was celebrated on 22 July 1896 in the chapel at Buckingham Palace. The Queen demanded a subdued ceremony, for Prince Henry of Battenberg, husband of Princess Beatrice, had died in January. The guest list was restricted and the guests were requested not to wear court dress. The bride wore a simple gown of ivory satin, without jewels, and her mother's wedding veil, and was attended by bridesmaids in white adorned with red geraniums. After a luncheon in the State Ballroom at Buckingham Palace the guests were presented to the Queen, and then the Prince and Princess of Wales hosted a garden party at Marlborough House. The couple took a train for a short honeymoon at Sandringham. When Princess Maud married, there had been talk that she could have found a more impressive bridegroom than a humble naval sub-lieutenant. But in late 1906, Prince Christian was chosen by a committee of the Norwegian government to become King Haakon VII of Norway. He became one of the most popular monarchs in the country's history.

Five years after the wedding of Princess Maud, Queen Victoria died at Osborne on 22 January 1901 and the Prince of Wales became King Edward VII. The last royal wedding of the old age was that of Prince Arthur of Connaught, son of Queen Victoria's third son, Prince Arthur. He married his cousin, Princess Alexandra, daughter of Princess Louise and the Earl of Fife, on 15 October 1913 in the Chapel Royal, St James's. One year later, war engulfed Europe, and the old order of royal families and their relations ruling Europe passed into history.

The marriage of the future George V and Queen Mary was the last properly engineered by Queen Victoria. Princess May, the sweet girl descended from a morganatic marriage, became Queen Mary, family matriarch, mother of George VI and grandmother of Queen Elizabeth II. Queen Victoria had capitalised on the newspapers' fascination with royal weddings, and her establishment of the ceremony as public spectacle laid foundations that could not be disturbed, despite her efforts to keep the weddings of her younger children private and restrained. As the century wore on, gowns were scrutinised and wedding presents were put on show and brides became the subject of intense public fascination.

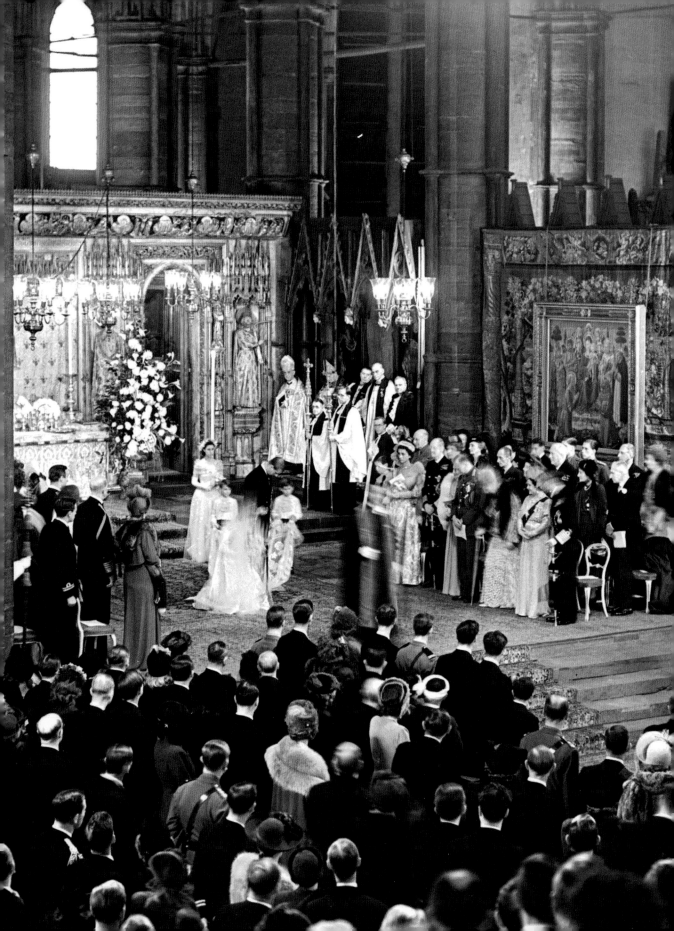

SARAH GRISTWOOD

'A SORT OF FAMILY FEELING'

ROYAL WEDDINGS FROM 1919 TO 1960

T he First World War was over and it seemed as if the world had begun anew. The Edwardian age was long gone and the former House of Saxe-Coburg-Gotha was now the House of Windsor. The events of recent years – the death of the British monarch's relations in the Russian Revolution – had cast a new light on the remaining royal dynasties. And, coincidentally or otherwise, with the new age of royalty came what would eventually mature into a new style of royal marriage ceremony.

It was a style which would increasingly come to exploit and be exploited by the new media opportunities of the twentieth century; which saw the royal wedding become – for better and perhaps for worse – the embodiment of the national fairy story. The actual power of the monarchy might have declined, but its emblematic significance had never been more apparent. A royal family event was coming to feel like an event in everyone's own family. As Walter Bagehot had said, the women of Britain (and perhaps not only they) cared more about the marriage of a Prince of Wales than about a ministry.

The first royal wedding of the twentieth century with which most of us are familiar is, of course, that of the Duchess of York – the Queen Mother, as we now remember her. But in fact that wedding, in 1923, was prefigured by two earlier ceremonies.

The first royal bride after the war was Princess Patricia of Connaught, the daughter of Queen Victoria's third son, the Duke of Connaught. 'Princess

The scene in Westminster Abbey in 1947 as Princess Elizabeth wed Lieutenant Philip Mountbatten.

PRINCESS PATRICIA of CONNAUGHT

 Princess Patricia of Connaught was the first royal bride of the modern era to choose Westminster Abbey for her wedding.

Pat', as she was known, was also the first modern royal to be married in Westminster Abbey, and begin what now looks like an established tradition. It was the bride herself who chose the venue, reputedly saying that for 'a junior member of the royal family' it was more appropriate than the more recent favourites: St George's Chapel, Windsor, or the Chapel Royal, St James's Palace.

Her attachment to Alexander Ramsay, third son of the Earl of Dalhousie and her father's aide-de-camp, was a long-standing one, but her father, like her uncle Edward VII, had reputedly disapproved of her marrying a commoner – other rumoured partners had included the Kings of Spain and Portugal – and it was only in the aftermath of the war that he gave his consent. On the day of her marriage, 'in accordance with the express wish of HRH Princess Patricia', as the official announcement declared, the bride relinquished her royal title, to be known in future as Lady Patricia Ramsay, a decision she may later have come to regret. With the country at large it was (said George V) 'a most popular marriage', and, when 27 February 1919 dawned, *The Times* would describe the enthusiasm of the crowds as 'almost embarrassing'. 'Princess Pat a Sailor's Bride' proclaimed the front page of the *Daily Sketch*.

The guests included the King and Queen of Portugal as well as the massed ranks of the British royal family, a detachment of Princess Patricia's Light Infantry and a party of seamen from the bridegroom's ship. The bride was resplendent in a train of cloth of silver and an antique lace veil that had once belonged to Queen Charlotte. If Princess Pat had eschewed the kind of wedding all recent royals had chosen, she had arguably enjoyed something even more delightfully redolent of the very highest society.

Perhaps her choice of venue was an expression of her sense of independence. It is not as if Westminster Abbey were a frequent wedding location: as a 'Royal Peculiar', coming directly under the jurisdiction of the monarch, the families of Knights of the Bath or of Abbey clergy and officials are the

only commoners regularly allowed to marry there (usually in one of the smaller chapels), while its last use for a royal wedding had been more than four centuries earlier. Before the First World War, Princess Pat's brother had used the Chapel Royal to marry his bride, the youthful Duchess of Fife. Her elder sister had married the future King of Sweden in St George's. Princess Pat was no ingénue but a woman in her thirties, well accustomed to substituting for her invalid mother as hostess when her father was Governor-General of Canada, and making a match very much of her own choice.

Herself a painter, perhaps it was the sheer beauty of the Abbey that appealed to her, a decision in tune with the aesthetics of the time. Or – is it permissible to wonder if, in the changed world, there was (consciously or unconsciously) any sense of need for the royal family, in what was now shaping up to be one of its most popular ceremonies, to position itself in the building itself most closely aligned with the ritual significance of monarchy?

The Archbishop of Canterbury, addressing the couple, made that connection explicit. At a time when the whole earth was 'athrob at a great junction between war and peace . . . to be married at such an hour, in such a place, is a wonderful, a priceless thing', he said. 'It links your new start with the whole world's new endeavour; and the *genius loci*, the illustrious memories which belong to the most historic church in Christendom must uplift and invigorate and inspire.'

Whatever the reason, Princess Pat's choice of Westminster Abbey struck enough of a chord to make it the venue of choice for most of the important royal marriages in the century ahead. On 28 February 1922 Princess Mary, the daughter of George V and one of Princess Patricia's bridesmaids, again chose the Abbey for her marriage to Viscount Lascelles (later Earl of Harewood), a wealthy nobleman fifteen years older than she.

Her brother Bertie had written that the 28th was 'going to be a day of national rejoicing', and the prophecy proved correct. Such huge crowds had gathered, many sleeping on the pavement overnight, that the Archbishop of Canterbury's car became stuck in the traffic. The Archbishop's chaplain would describe the shimmering bride, in her dress of silver lamé, embroidered with English roses worked with thousands of tiny diamonds and seed pearls: 'straight and true and determined, with a real strength in her

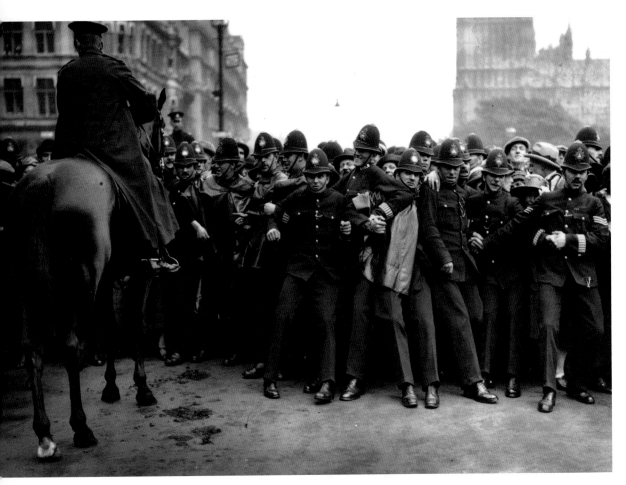

Police struggle to hold back the crowds at the wedding of Princess Mary.

face . . . ' Special stands had been constructed in the Abbey to increase the numbers of seats to 2,860, while the composer Sydney Nicholson wrote an anthem, 'Beloved, Let Us Love One Another', for the occasion.

As with so many royal marriages this one had a back story. There would be whispers that the bride was reluctant – in love, even, with someone else – and the marriage made only at the insistence of her mother. Her parents had been warned that the usual expedient, of selecting a spouse from the Protestant German principalities, would not at that moment be popular with the country. It was said that her eldest brother, the future Duke of Windsor, was reluctant to see her placed under pressure: and that she, in the years ahead, would refuse to attend the wedding of her niece Princess Elizabeth on the grounds that the Duke was not invited. Meanwhile, there was another royal marital connection

THE ROYAL WEDDING.

PHOTO,
ANDYK, Lᴛᴅ.
LADY D. GORDON-LENNOX. LADY E. BOWES-LYON.
LADY MARY CAMBRIDGE. PRINCESS MAUD.

VISCOUNT PRINCESS
LASCELLES. MARY. MAJOR SIR VICTOR MACKENZIE. LADY D. BRIDGEMAN. LADY MAY CAMBRIDGE.
LADY RACHEL CAVENDISH. LADY MARY THYNNE.

532.W.
BEAGLES' POSTCARDS

to be made. Among Princess Mary's bridesmaids was Elizabeth Bowes-Lyon – writing to her future husband about how hard she had found it, at the rehearsal, to walk steadily in high heels. Lady Elizabeth was a friend of the Princess's, certainly, but not so close as to make her an obvious choice: one story suggests that this was another piece of matchmaking on Queen Mary's part. If so, it was a successful one. A year or so later, on 23 April 1923, Elizabeth of Glamis was back in the Abbey on her own account.

It is well known that the Yorks' courtship – even theirs – did not run entirely smooth. The sought-after Lady Elizabeth, reluctant to commit to the demands of a royal life, twice refused proposals from 'Bertie', King George V's second son. Her father, the Earl of Strathmore, had determined on one thing for his children: that they should never take any position around the court.

One of Princess Mary's bridesmaids was her brother's future queen, Lady Elizabeth Bowes-Lyon.

The train in which Princess Mary and Viscount Lascelles left for their honeymoon.

The pair had originally met as children before a dance in 1920 brought them together as adults but it was not until January 1923 that Lady Elizabeth finally agreed to marry the Duke of York. The news was greeted with delight by his parents, this despite the fact that marriage between a senior member of the royal family and a commoner was still considered something of an oddity. The Press Association reported shortly before the wedding: 'The future style and title of the bride is a matter for the King's decision. Recent times supply no precedent . . .' (Besides Princess Patricia, Princess Mary and Princess Louise, the daughter of Edward VII – and none of their own children, as the offspring

of a monarch's daughter rather than a monarch's son, would themselves be princes and princesses – there had been only two other remotely recent examples, and they featured more distant members of the family.)

From the moment of her acceptance, Lady Elizabeth's life changed. During the three-month engagement she travelled with the Duke between England and Scotland, notably visiting the McVitie & Price factory in Edinburgh, which was to produce the immensely elaborate nine-foot principal wedding cake, decorated with the coats of arms of the Duke of York and of the Strathmore family, and topped by ornamental figures symbolising love and peace. A number of identical cakes would be made and slices distributed, at special wedding tea parties and at the Duke's expense, to poor children across London and other cities.

The wedding presents that started to arrive ranged from a thousand gold-eyed needles from the Worshipful Company of Needlemakers, and an ostrich-feather mantlet from the South African ostrich farmers, to a diamond tiara in the form of a garland of wild roses, given to the bride by her father, and a set of diamonds and turquoises from her prospective father-in-law. The invitations specified that ladies should wear 'Morning dress with hats; also Orders and Decorations'. For men it was more complicated: Full Dress Uniform (for those officers who had it), Service Dress; Full Dress Coat or Levée Dress for members of the Royal Household or the Civil Service; Court dress for 'Civilians'. The groom was among those who wore dress uniform: the blue-grey of a group captain of the Royal Air Force with the Orders of the Garter and the Thistle, the latter given to him on his wedding day. Much public pleasure was taken in the bride's Scottish origins, with genealogists proclaiming that she and her husband were both descended from Scotland's King Robert I.

The bride's outfit, made by the court dressmaker Madame Handley-Seymour in the unstructured lines of the 1920s, had something of a medieval feel. Of ivory chiffon moiré heavily appliquéd on the bodice, with gold embroidery and beads in pearl and paste, it was nonetheless described not altogether enthusiastically by *The Times* as being 'the simplest ever made for a royal wedding'. The veil, made of *point de Flandres* lace, was held in place by a circlet of myrtle around the brow, with knots of white roses and heather at the side. Lady Elizabeth would differ from later royal brides in not wearing a tiara. Two trains flowed down, one from the shoulders and one from the hips. At the

Lady Elizabeth Bowes-Lyon leaving her parents' home at 17 Bruton Street on her way to the Abbey.

Colour-tinted photograph reflecting the period style of the Duchess's wedding dress.

bride's request lace from the struggling Nottingham lace industry was used to make her own train and to decorate the dresses of the eight bridesmaids: ivory, with a leaf-green sash at the waist. Each would wear the bridegroom's gift to them – a carved crystal brooch showing the white rose of York, with the letters E and A (for Albert) picked out in diamonds at the centre.

Photographs show the bride, her dress covered by an ermine cape, leaving her parents' Mayfair home at No. 17 Bruton Street, where more than five thousand spectators had gathered to wish her well. With her father, she drove to the Abbey in a state landau, but modestly escorted by four mounted police officers. Entering by the west door, Lady Elizabeth, one of whose brothers had been killed, and others wounded, in the First World War, was delayed when a member of the clergy in the procession ahead of her fainted, and in the pause

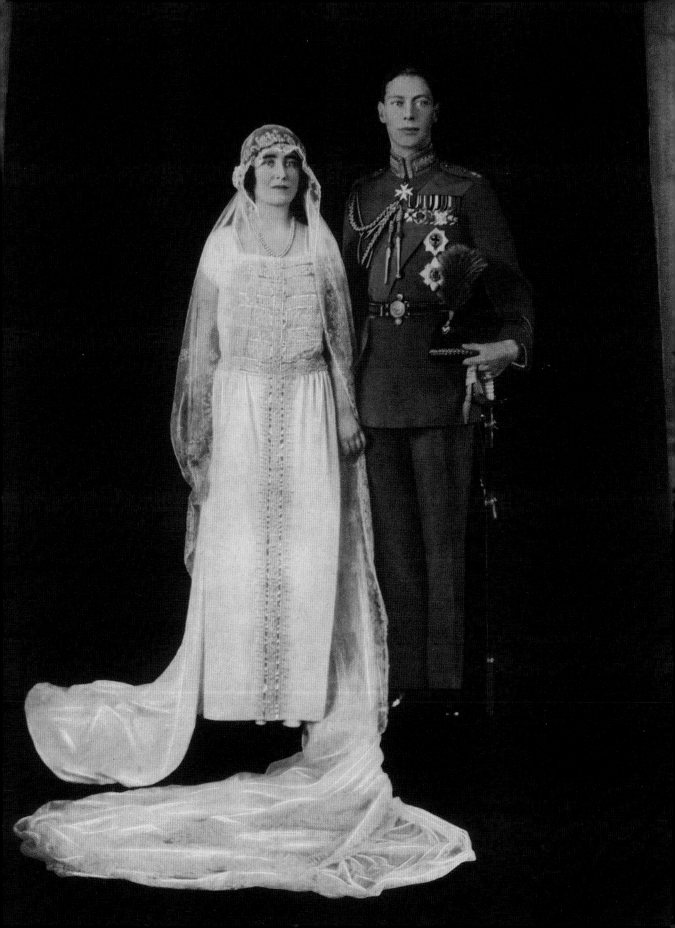

she suddenly stepped forward to the tomb of the Unknown Warrior, laid her bouquet of white roses and lilies of the valley there, before proceeding to the altar. The gesture was not quite unprecedented – Princess Mary, admired for her war work, had paused on the way back from the Abbey to hand her bouquet to an officer, who placed it on the steps of the Cenotaph, and Lady Elizabeth was to have done the same. But the apparent spontaneity of this action – the personal touch this bride would bring to the British monarchy – was what captured the imagination. Even subsequent royal brides, while copying her gesture, have donated their bouquets *after* the wedding ceremony.

The procession was led by the Archbishop of Canterbury, the Most Revd Randall Davidson; followed by the Archbishop of York, the Most Revd Cosmo Lang; and the Primus of the Episcopal Church of Scotland, to which the bride belonged. The waiting guests included three prime ministers, past and present; Winston Churchill; Lord Curzon (who, as the *Yorkshire Post* noted disapprovingly, slouched in with his hands in his pockets); Sir Oswald Mosley; thirty factory boys and a party of Boy Scouts, reflecting the Duke's interest in industrial welfare and his establishment of a chain of summer camps. The King had ordained that, given the prevailing economic climate, the wedding should be 'of as simple a character as possible', involving 'no unnecessary expense': not even decorations in the Mall. Without the special stands used for Princess Mary's wedding, the numbers who could be seated were reduced to a mere 1,800 or so. Nonetheless, those present also included four of Queen Victoria's surviving offspring, and the groom's great-aunt, the Dowager Empress of Russia, mother of the murdered Tsar. The dress of the other ladies came in for almost as much comment as did the bride's own: feathers, *The Times* observed, were more popular than flowers. Queen Mary wore a dress and turban of aquamarine and silver, decked out with magnificent diamonds, the Star of Africa among them; Lady Strathmore divided opinion in a 'handsome' but perhaps rather theatrical outfit with a collar of blue roses topping a dress and cloak of black. Queen Alexandra had enlivened her usual black with gold embroideries, an ermine stole and a violet hat. The prize, however, was generally awarded to the bride's elder sister and sister-in-law: the former in dove-grey satin draped at the side in oriental roses of jade and gold; the latter in a soft, flowing silver that made hers 'one of the most successful costumes in the Abbey' . . . Or so the *Illustrated London News* said.

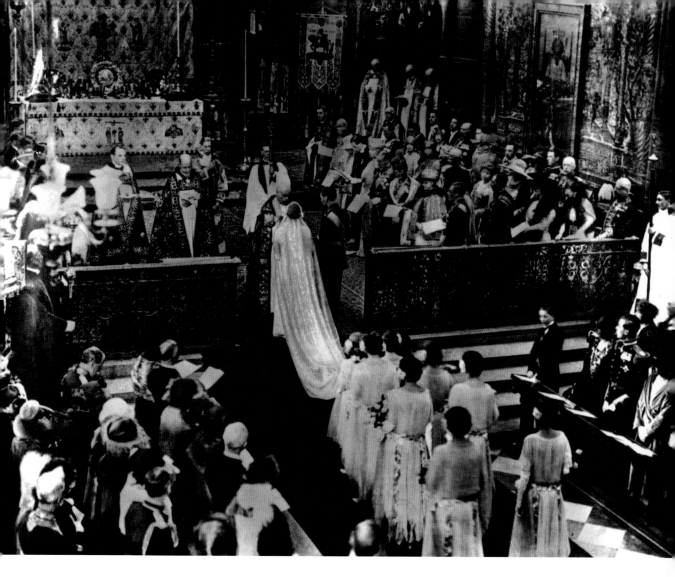

The day had dawned with the proverbial April showers but, King George recorded, 'It stopped raining at about 9.30 & the sun actually came out as the Bride entered the Abbey.' As *The Lady* wrote: 'The bride, supported by her father, had passed right up the length of the great building. There at the head of the steps leading up to the Sacrarium stood her royal bridegroom waiting to greet her. And then, just at that very moment, the Abbey was flooded with a glorious burst of sunshine. It was wonderful and dramatic and unforgettable.' One guest, Frederick Dalrymple Hamilton, described how the loud organ suddenly hushed into the strains of 'Lead Us Heavenly Father', '& there was Elizabeth with her father & looking extraordinarily nice . . . She did it amazingly well & even appeared to be enjoying it as she smiled up at Lord S

The scene inside Westminster Abbey as Elizabeth is married to the Duke of York.

when he bent down & asked her something.' A minute later, however, and *The Times* noted that the couple 'seemed to think of no one but each other'.

The Archbishop of Canterbury read the service, and the Archbishop of York gave an address. 'You have received from Him at this Altar a new life wherein your separate lives are now, till death, made one. With all our hearts we wish that it may be a happy one. But you cannot resolve that it shall be happy. You can and will resolve that it shall be noble. The warm and generous heart of this people takes you today into itself. Will you not, in response, take that heart, with all its joys and sorrows, into your own?' In the years ahead, his words would come to seem like a prophecy.

After signing the marriage register in the chapel of Edward the Confessor the couple travelled back to Buckingham Palace in the Glass Coach (as would also become a tradition for royal brides). They took the long route – Marlborough Gate, St James's Street, Piccadilly, Hyde Park Corner and down Constitution Hill – with as many as a million people lining the way. The eight bridesmaids (two of the groom's cousins, four of the bride's personal friends and her two young nieces) filed into the back of a large motor vehicle that, to modern eyes, looks almost like a delivery van. The wedding breakfast for more than sixty people was laid in a State Dining Room decked out in pink tulips and white lilac. *Consommé à la Windsor* was succeeded by *Suprêmes de Saumon Reine Mary, Côtelettes d'Agneau Prince Albert, Chapons à la Strathmore* and *Fraises Duchesse Elizabeth*. It was in an open-topped landau that they left for Waterloo Station, and above her dove-grey dress and coat wrap the bride wore a small brown hat with an upturned brim carefully chosen to allow the crowds to see her face, an early example of the kind of care the Queen Mother would come to display.

Their friends and family threw rose petals over them and even the railway carriage that awaited them had been decorated with white roses and upholstered in gold brocade. (A footman added two odd shoes which had been flung into the carriage – the traditional wedding tokens.) A short train journey took them to the first leg of their five-week honeymoon, at Polesden Lacey in Surrey, which had been lent to them by its owner, Mrs Ronald Greville. From there they went on to Glamis, where, however, in the pouring rain the bride caught whooping cough – 'So unromantic', as the groom complained to his mother, 'to catch whooping cough on your honeymoon.' The Queen

Mother's official biographer, William Shawcross, was able to quote the diary of the bride:

> 'Thur 26 Apr. Woke at 8.30. Up by 10. Put on my wedding dress aided by Suzanne and Catherine. It looked lovely . . . Lots of people in B. St., & crowds in the streets. Did not feel very nervous. Bertie smiled at me when I got up to him – & it all went off well.' Though it was 'awful' saying goodbye to her family (and perhaps it had come as something of a shock when, on her return from the Abbey, her waiting friends all curtsied to her?), she ended the entry: 'Very tired & happy.'

Confetti showers down on the royal couple as they leave Buckingham Palace for their honeymoon.

A request by the newly formed British Broadcasting Corporation that they should be allowed to broadcast the service on the radio had won initial approval from the Dean of Westminster but was eventually vetoed by the Chapter. Disrespectful people, it was feared, 'might hear the service, perhaps even some of them sitting in public houses, with their hats on'. This was, however, the first royal wedding captured extensively on film and cinema goers could see newsreel footage of the couple smiling from the balcony, between Queens Alexandra and Mary, and George V, by the evening of the same day. Gaumont Graphic, seizing the occasion to test a new processing plant, proudly declared that by 9 p.m. they had produced twenty-five million feet of film.

Britain had to wait eleven years for another royal wedding, and then it came as advance guard to another, far more controversial set of royal ceremonies. At the time, however, the country was happy simply to rejoice in the fairy-tale spectacle. On 29 November 1934, Prince George, Duke of Kent, George V's fourth son, married Marina, daughter of Prince Nicholas of Greece and Denmark by Elena Vladimirovna, Grand Duchess of Russia, in, once again, Westminster Abbey. They were, as the MP and diarist Henry 'Chips' Channon described them, a 'dazzling pair', and the nation responded gladly to their glamour. London particularly was *en fête*, Bond Street decked out with garlands of waxed paper flowers and the Greek and British flags. With the bride a guest at Buckingham Palace there was a pre-wedding ball for more than two thousand; a lunch party given by the Yorks on 28 November; while that evening, the fiancés, together with Queen Mary, made a surprise visit to see Laurence Olivier and Marie Tempest in a play called *Theatre Royal*, driving back around the decorated streets. The whole mood was one of a more social, as well as formally royal, festivity; on the morning of his wedding, finding his pockets empty and looking for something to do to calm his nerves, the Duke slipped out unnoticed to cash a cheque.

But the ceremony itself was all royal-watchers could desire. The guests included the Kings and Queens of Norway and of Denmark as well as the Prince Regent of Yugoslavia and the King of Greece. Of the eight bridesmaids the six elder included the Princesses Eugenie, Irene and Katherine of Greece,

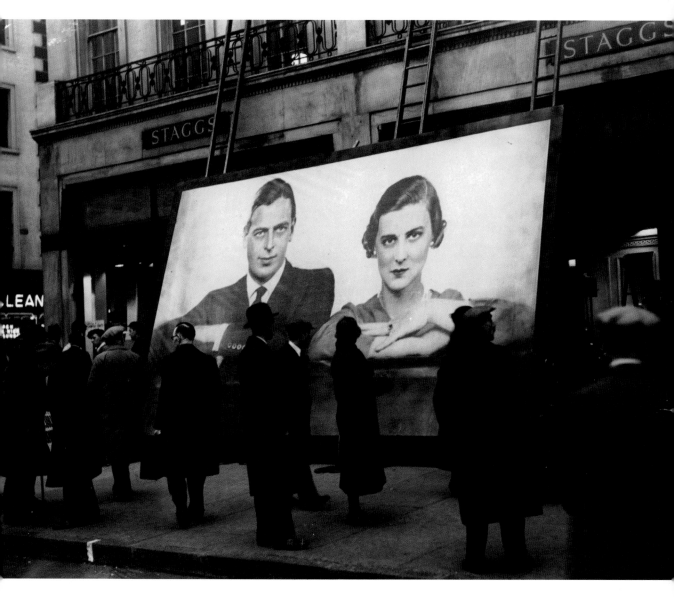

Princess Juliana of the Netherlands and Princess Kyra of Russia. Among the two younger was Princess Elizabeth of York.

The bride made a dramatically lovely figure in a silver and white brocade lamé designed by the couturier Captain Edward Molyneux, with a cowl neck, trumpet sleeves and a silver-lined train. She carried a sheaf of Madonna lilies. Only the Prince of Wales, as his brother's chief supporter (royal bridegrooms have two supporters, rather than a single best man), seemed abstracted,

Public anticipation of the wedding of the Duke of Kent to the glamorous Princess Marina reached almost Hollywood levels of excitement.

111

The official photographs of the Kents show the young Princess Elizabeth (seated far right) as a bridesmaid.

forgetting to hand over the ring for blessing until his father gave him the nod. Perhaps he was aware that, by his own request, one Mrs Wallis Simpson was among the guests in the Abbey. The ceremony – performed by the Archbishops of Canterbury and York, with the Bishop of London and prelates of the Greek Orthodox Church – was the first royal wedding ceremony to be broadcast on the radio.

From the Abbey the royal couple drove back to the palace past St George's Hospital, of which the Duke of Kent was patron. A large donation to the hospital had been the nation's wedding present. Back at the Palace, a thirty-minute Greek Orthodox ceremony was performed, with the pair crowned with jewelled crowns made especially for the occasion; drinking from a common cup of wine in token of 'their shared one lot for weal or woe'; and processing three times around the nuptial table, symbolising their shared journey through life. After the balcony appearance and the wedding breakfast, they drove to Paddington Station through a crowd whose roar, as they even began to draw near, was, said *The Times*, 'like the approach of a distant hurricane'. Unusually, the King and Queen came along to bid a final farewell before the pair left on their extended honeymoon.

The following year, 1935, the nation was deprived of another royal spectacle. Westminster Abbey was once again the proposed venue for the marriage of Prince Henry, Duke of Gloucester, George V's third son, to Lady Alice Montagu-Douglas-Scott, third daughter of the Duke of Buccleuch, but the death of the bride's father only three weeks before the date of 6 November meant that the big public wedding was replaced by a much smaller ceremony in the Private Chapel of Buckingham Palace; albeit one where the little Princess Margaret (dressed, at her grandfather's request, in short and 'girlish' pink) joined her elder sister to play bridesmaid for the first time. The bride (perhaps thinking of Princess Marina's Molyneux!) had called on Norman Hartnell to make the frocks, initiating his long association with the royal family. In consideration of the dim lighting in Westminster Abbey, he had decided to go not for stark white, but for 'a soft tone with something of the glimmer of pearl'. At least his dress was appreciated when the couple – the groom in the

The wedding cake, featuring Greek pillars in celebration of Princess Marina's nationality, was made by McVitie & Price, the Edinburgh company that also made the cakes for the Yorks.

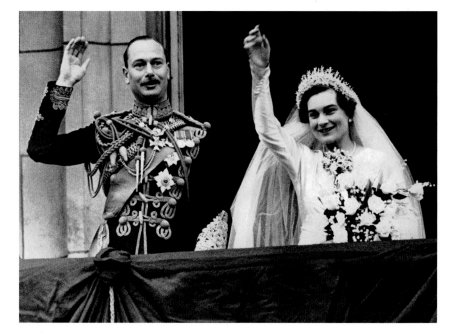

The Duke of Gloucester and the new Princess Alice wave from the balcony of Buckingham Palace.

The Duke of Windsor and Wallis Simpson on their wedding day at the Château de Candé.

gold-braided uniform of the 10th Royal Hussars – came out to wave from the balcony.

But soon it would appear that this curtailed ceremony was only one cloud among many. George V died on 20 January 1936, leaving his eldest son, David, to succeed as Edward VIII. When the Yorks had married in 1923, a *Times* editorial had said with what proved to be a certain irony that there was 'but one wedding to which the people look forward with still deeper interest – the wedding which will give a wife to the Heir to the Throne and, in the course of nature, a future Queen to England and the British peoples'. Earlier in the decade, the ever-busy Lord Mountbatten had prepared for his cousin David a list of eighteen unmarried European princesses. But the year of the Kents' wedding had been the one in which, in the words of the twice-divorced Wallis Simpson, she and the Prince had 'crossed the line that marked the indefinable bond between friendship and love'. The rest is a painful episode in history, culminating in Edward VIII's abdication in 1936 and his brother's coronation the following May as George VI

Weeks later at the end of that month, in the Château de Candé in the Loire Valley, on almost the eve of his wedding, the new Duke of Windsor was receiving, as he said bitterly, 'a nice wedding present' – the news that his bride

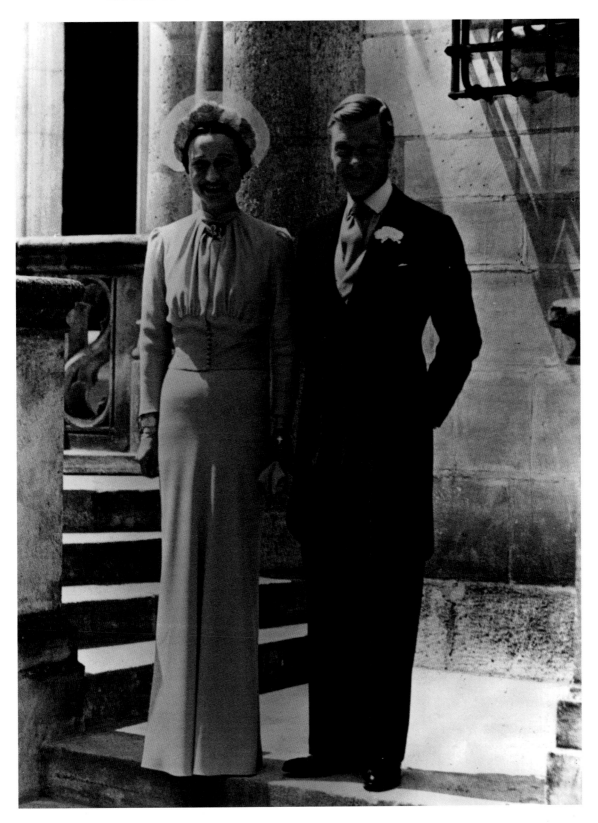

would not be granted the title of Her Royal Highness. 'Why in God's name would they do this to me at this time?'

Others were more generous. Constance Spry's gift to the bride was to provide all the flowers – lilies and white peonies. (Adolf Hitler sent an inscribed gold box.) The official photographs were taken by Cecil Beaton; the bride's floor-length blue dress by Mainbocher got enough publicity to give fashion the term 'Wallis blue'. It was set off by a matching hat from Reboux and a bracelet of sapphires and diamonds three inches deep, the groom's present.

But when the wedding day, 3 June, dawned, Randolph Churchill, the Rothschilds and Lady Diana Cooper were among the few famous names on a short guest list that included none of the royal family – although, as the groom's mother Queen Mary wrote, 'We all telegraphed to him.' Despite the Duke's continued hopes, the new King would not authorise any of his courtiers or senior officials to attend – not even such old friends of the groom as Lord Mountbatten, whom the Duke had originally asked to be his best man. Lines were being drawn, sides were being taken. The main ceremony was conducted by the local mayor, Dr Charles Mercier, who gave rein to his romantic and patriotic feelings, speaking of an 'illustrious union which many hearts in secret celebrate'. In this 'simple but solemn ceremony', he said, he represented 'a nation which has always been sensitive to the charm and chivalrous unselfishness and bold gestures prompted by the dictates of the heart'.

That civil ceremony, at 11.35 in the salon, was followed by a religious service in the music room (converted for the occasion into a chapel), as the groom had urgently desired. The eccentric Revd Robert Anderson Jardine, vicar of St Paul's Church in Darlington, had offered to marry the couple in defiance of his bishop's order, and arrived to find himself having hastily to assemble the trappings of a religious ceremony from the furnishings already available. The role of best man was in the end taken by the Duke's equerry, Major Edward Dudley 'Fruity' Metcalfe, whose wife, Lady Alexandra, later wrote in her diary: 'It could be nothing but pitiable and tragic to see a King of England of only six months ago, an idolized King, married under those circumstances, & yet pathetic as it was, his manner was so simple and dignified & he was so sure of himself in his happiness that it gave something to the sad little service which it is hard to describe.'

As the new Duchess of Windsor wrote later in her memoirs: 'it was a

supremely happy moment. All I had been through, the hurts I had suffered, were forgotten.' As the ceremony ended the organ – especially imported from America by the chateau's owner – swelled into the strains of 'O Perfect Love'.

The Duke, Lady Alexandra said, was in tears, and when next day the couple drove away from the château to the cheers of a crowd five-thousand-strong, the grateful Duchess flung red roses to the supportive French crowd. In England, the marriage was reported only in a fifty-five-word statement in a regular news bulletin. The French government, as a gesture to their British counterparts, had forbidden any radio broadcasts. But the Metcalfes would be asked to report to the royal family, privately.

The ten years between 1937 and 1947 passed without the luxury of a royal wedding: indeed, the war saw a depressing dearth of any sort of colourful ceremony. The world was waiting for another and, ever dutiful, England's heiress, Princess Elizabeth, would provide.

Princess Elizabeth and Philip Mountbatten had known each other since before the war – a photograph shows them together in 1939, when Elizabeth was thirteen and Philip eighteen – and speculation started comparatively soon afterwards. By the beginning of 1944 'Chips' Channon was writing with conviction, 'I do believe that a marriage may well be arranged one day between Princess Elizabeth and Prince Philip of Greece'; a form of words that reflected one important truth. Though this would undoubtedly be a love match, its sheer suitability was also an important element. Though the days were long gone when a glorious wedding had been the velvet glove over the iron fist, the old realities – that a royal marriage was about romance and *power* – had not entirely gone away.

From the earliest years, Elizabeth had too strong a sense of duty ever to marry to disoblige her family (and her country), which meant that the pool of potential suitors – European royals or senior members of the British aristocracy – was not a large one. Philip was an obvious choice – the great-great-grandson of Queen Victoria; Lord Mountbatten's nephew; reared in Britain and on British tradition, despite his Greek title, his Danish, German and Russian blood. As far back as the autumn of 1944, the long process had

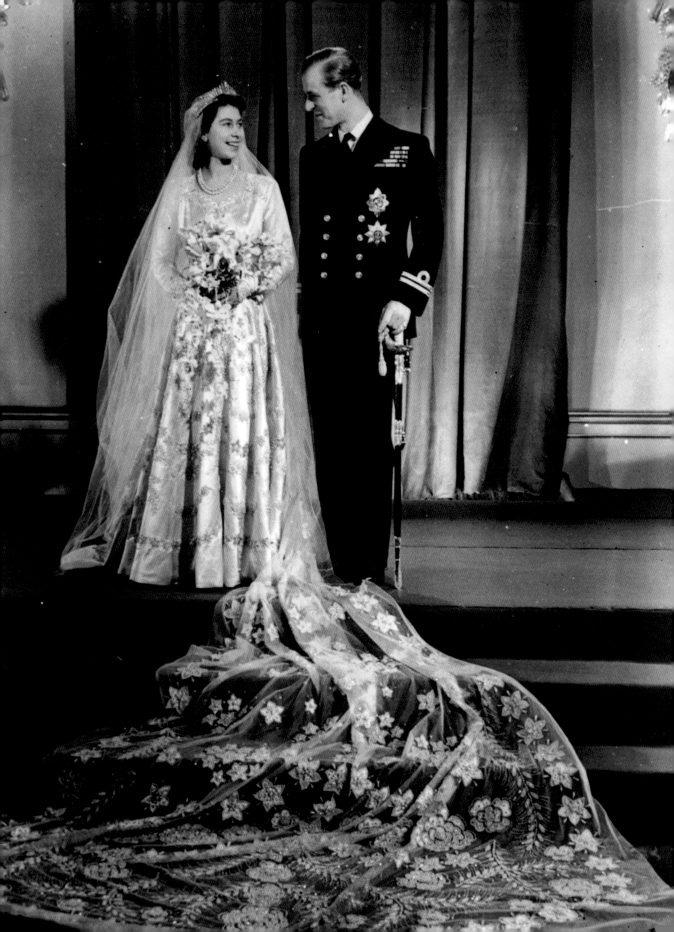

An invitation to the wedding.

begun of turning him into a naturalised British subject. It was completed in February 1947, by which time Philip had proposed and been accepted, albeit that the King insisted any formal betrothal should wait both until the royal family had completed their planned African tour, and until, in April 1947, Elizabeth had turned twenty-one. On Thursday 10 July the announcement was posted from Buckingham Palace:

> It is with the greatest pleasure that the King and Queen announce the betrothal of their dearly beloved daughter The Princess Elizabeth to Lieutenant Philip Mountbatten, RN, son of the late Prince Andrew of Greece and Princess Andrew (Princess Alice of Battenberg), to which union the King has gladly given his consent.

There were critics – there would always be critics – who felt Philip was too spiky, too far outside the regular royal club; and, of course, too German (Russian, Danish). When the guest lists went out, it was notable that none of Philip's German relations were on it – not even his three sisters who had married German princes. (Immediately after the event, his cousin Princess Marina had to pay a conciliatory visit to the 'affronted' German clan.) But to

An official portrait of the smiling couple displays the symbolic embroidery on the bride's train.

the nation at large the news was immediately welcome – 'a flash of colour on the hard road we have to travel', as Winston Churchill hailed it.

Not that the celebrations were to be extravagant. Abroad, the independence and partition of India was just weeks away; there was concern over the formation of the new Israeli state. At home, though war had ended, rationing was still very much in force – indeed, new controls were being imposed. The economy was in a fragile state and the past winter had been an exceptionally hard one with record snowfall: the last two, of course, circumstances with considerable resonance today. A number of Labour MPs protested at the likely cost – both of the wedding and of the couple's future maintenance. Prince Philip himself, who had grown up in habits of necessary economy, scrimping on clothes and travelling third class, was against excessive display. A private wedding at Windsor was considered. But the Duke of Leeds wrote to the Queen that in a choice between austerity and traditional pageantry, he thought most people would prefer the latter and he probably reflected the feelings of many. One newspaper asked its readers: 'Should the Princess's wedding day be selected as the first post-war occasion to restore to Britain the traditional gaiety of a gala public event?' More than 86 per cent of the readers said it should be – though other opinion polls were more cautious.

When Prince Philip joined the royal party at Holyrood that summer the King wrote that he and the Queen had been 'delighted to observe the spontaneous affection displayed towards Princess Elizabeth in connection with her betrothal'. The days were long gone – if, indeed, they had ever existed – when the monarchy regarded such issues with complacency. The King declared that he would pay all wedding expenses from the Privy Purse, with the exception of street decorations in Whitehall and the Mall.

As many as three thousand presents were sent, the bulk put on display by men from the Grenadier Guards, of which regiment Princess Elizabeth was Colonel. One wonders what they made of the Compact personal weighing machine, the rabbit tea cosy sent by Nurse Kirkpatrick and the 'shoe worn by one of Queen Victoria's ponies', presumably sent for luck. The King had decided to recognise people's wish to be a part of the celebration by relaxing the rule that the royal couple only accepted presents from people personally known to them. When the presents were placed on display at St James's Palace, drawing huge crowds, those given by royal relations were listed first.

Amid the catalogue of jewels, silver and porcelain, one such gift stands out. 'Rear-Admiral The Earl and Countess Mountbatten of Burma: A cinema.' A specially fitted room in Clarence House.

The Aga Khan gave a thoroughbred filly, 'The people of Kenya' gave a hunting lodge; President and Madame Chiang Kai-shek a dinner service of Chinese porcelain. Eleanor Roosevelt sent towels and kitchen cloths; the American President and Mrs Truman a Steuben glass vase. The Government of Queensland sent five hundred cases of tinned pineapple to be distributed as the bride felt appropriate; the Rothschilds sent rhododendrons for her garden. A lady in Brooklyn sent a turkey because 'they have nothing to eat in England'.

The wedding presents, placed on public display in St James's Palace, ranged from sapphires to nylon stockings.

123

Many members of the public sent nylon stockings (a generous act, since these were still a rationed luxury) and two district nurses in Corsham in Wiltshire sent a Siamese kitten. The King, besides a sapphire and diamond necklace and earrings, gave a pair of Purdey guns. Mahatma Gandhi, famously, sent what the catalogue of the exhibition clearly describes as: 'A fringed lacework cloth made out of yarn spun by the donor on his own spinning wheel.' Queen Mary, however, who had taken it for one of Gandhi's notorious loincloths, went on muttering about indelicacy.

Norman Hartnell had been asked to submit sketches for the wedding dress: the one selected would eventually take three thousand coupons and cost £1,200. In so far as this was to be in every sense a national celebration, even the origin of the silkworms producing the fabric for the dress came into question – were they perhaps Italian or, worse, Japanese? Hartnell recounted in his memoirs how he had to telephone the Scottish firm providing the silk, which assured him the worms were Chinese . . . He had toured the London art galleries looking for inspiration and found it in the clinging lines of Botticelli, alive with flowers and breathing the promise of rebirth and growth after the long winter of the war. The ivory silk of the skirt would be embroidered with blooms picked out in the white of crystal and of some of the 10,000 small pearls Hartnell imported from America. The fifteen-foot train was embroidered with syringa and orange blossom, with jasmine and wheat ears and the white roses of York. It took seven weeks' hard work in Hartnell's in-house embroidery workshop.

Speculation about the design, Hartnell remembered, 'became wild and almost hysterical'. His manager had to sleep in the workrooms for fear of spies, and, when later the dress went on display, queues could stretch the length of the Mall. The Palace press secretary had to issue a statement that it was the Princess's own wish her dress should be secret until her wedding day. Meeting with the Women's Press Club, Hartnell found himself being questioned as to whether the bridegroom would kiss the bridesmaids, and what make-up the bride would wear on the day. Did they really think such details worthy of publication? he asked, rather bemused.

With the wedding set for 20 November, the King arranged to give the Order of the Garter to Princess Elizabeth on the 11th (so that she would be the senior) and to Philip on the 19th. 'I have arranged that he shall be created

a Royal Highness', he wrote to his mother, Queen Mary, '& that the titles of his peerage will be: Baron Greenwich, Earl or Merioneth & Duke of Edinburgh . . . It is a great deal to give a man all at once, but I know Philip understands his new responsibilities on his marriage to Lilibet.' Philip's stag night took place at the Dorchester Hotel with a group of the fellow naval officers who had become almost his family, his best man and cousin, the Marquess of Milford Haven, and Lord Mountbatten.

The King and Queen gave a dance at the Palace two nights before the wedding. An Indian rajah became drunk and assaulted the Duke of Devonshire, and the King led a conga through the State Apartments. This was a huge gathering of royalty – albeit many now dispossessed – and, as at any other wedding, they were letting their hair down in the security of the family.

On the morning of the wedding, Prince Philip ordered tea and coffee to be taken to the photographers waiting outside Kensington Palace in the cold. At Buckingham Palace the Princess, too, was 'excitedly' (so her old governess, Crawfie, reported) peering out of her window at the crowds. She told Crawfie she had to keep pinching herself – 'I can't believe it's really happening.' The dress had been delivered the night before but Hartnell's assistants were back at 9 a.m. for a last long fitting. Engagingly, there was a trio of last-minute crises. No one could find the bride's bouquet – white orchids with a sprig of myrtle from the bush at Osborne, grown from a cutting brought by Prince Albert from Coburg: the bush that has since given sprigs to all royal brides. Finally, the footman who had taken charge of it remembered he had put it in a cool room to keep fresh. The fragile fixtures of the tiara snapped as it was placed on to the Princess's head, and a hasty repair had to be effected: loaned by her mother as 'something borrowed', it was composed of diamonds originally part of a necklace given by Queen Victoria to Queen Mary on her wedding day.

Then the Princess found that the double strand of pearls she had planned to wear – a gift from her parents – was at St James's Palace with the rest of the presents, already out on public display. Her private secretary was hastily dispatched, virtually commandeering the car of King Haakon of Norway, and then found himself trying to explain to the detectives guarding the presents that he was taking this one on the best authority. He was back before the Princess's scheduled departure at 11.15 – but only just. She arrived sixty seconds late. It all went to prove that not even a royal wedding can be organised to the ultimate degree.

Queen Elizabeth and Princess Margaret had been the first to leave Buckingham Palace, meeting Queen Mary at the west door of Westminster Abbey. The Princess and her father, he in the uniform of an Admiral of the Fleet, drove to the Abbey in the Irish State Coach escorted by an escort of the Household Cavalry, giving their full ceremonial uniforms and plumed helmets a first outing after the years of wartime battle dress. 'The crowd was enormous',

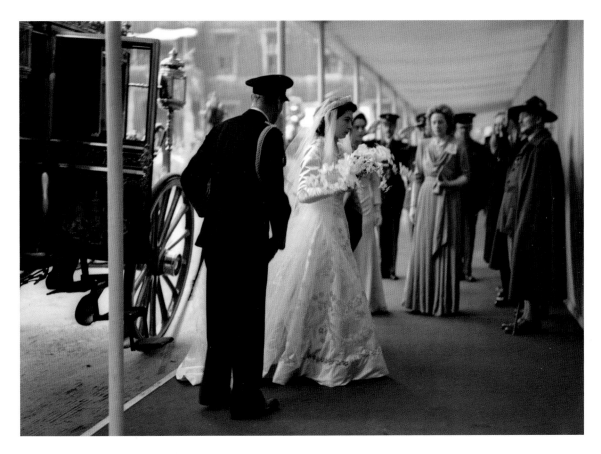

Country Life recorded. It was fifty deep in places. 'And it was a happy, good-tempered crowd obviously determined to enjoy its brief escape from what we have come to call austerity. Flags and streamers flowered from every hand, and countless periscopes – most of them little mirrors fixed on pieces of stick – danced like crystallised sunshine above the tightly packed heads.'

The bride entered under the specially erected awning; the eight brides-maids arranged her train, then they and the two kilted pageboys – Prince William of Gloucester and Prince Michael of Kent – lined up to form the procession. As they moved off, to the strains of 'Praise, My Soul, the King of Heaven', ahead of the bride went the choirboys of the Chapel Royal in their scarlet and gold; the Lay Vicars in scarlet and white; the Canons and Minor Canons in green and gold and the Dean of Westminster. Behind, in cyclamen and sea-green, came the ladies of Princess Elizabeth's household. Despite the absence of many of Philip's closest relations, more distant members of his

The Princess and her father, King George, arriving at the Abbey.

127

The ceremony, glimpsed through an archway.

family included the Queens Helen of Romania, Alexandra of Yugoslavia and Frederika of Greece. There were so many foreign dignitaries that British MPs had to ballot for places. Though day dress rather than court dress was decreed, the royal ladies still appeared in floor-length dresses, with gloves.

The Archbishop of York, Cyril Garbett, officiating alongside the Archbishop of Canterbury, said the wedding was 'in all essentials exactly the same as it would have been for any cottager who might be married this afternoon in some small country church in a remote village in the Dales'. The actual solemnisation was taken from the Book of Common Prayer, and the bride promised to obey. The register recording the marriage of 'Philip Mountbatten, Bachelor' and 'Elizabeth Alexandra Mary Windsor, Spinster' was signed with a gold pen, the gift of the Chartered Institute of Secretaries to which 18,000 members had contributed. In the crowded page, the central signature is that of 'Patricia Ramsay' – the erstwhile Princess Pat. The couple left to the strains of Mendelssohn's 'Wedding March', which had first become such a popular choice when it had been used at the wedding of Queen Victoria's daughter, the Princess Royal, almost ninety years before.

Baron took the official photographs: the wedding breakfast was described as an 'austerity' event for a mere 150 guests, and, indeed, the main course on the menu (between *Filets de Sole Mountbatten* and *Bombe Glacée Princesse Elizabeth*) was a casserole of unrationed partridges. The tables were decorated with smilax and white carnations, with a little bunch of white heather from Balmoral at each place. Bagpipes played, the speeches by King and Prince were notable for their brevity. Various cake makers had received permission to present a sample of their work: to provide the rationed ingredients for all twelve cakes in other ways might have taxed even the royal family.

Hartnell had made the going-away outfit in love-in-the-mist blue. In case her velvet coat and bonnet trimmed with ostrich feathers were not warm enough for the long drive to Waterloo in an open landau, several hot-water bottles were tucked under the rugs, along with the Princess's favourite corgi, Susan. The send-off had a warm family feeling: it was noticed that the King and Queen came down hand in hand to see the couple off and Philip's mother, the widowed Princess Alice, stood waving until they had disappeared from view. (It had been, wrote Anne Edwards in the *Daily Express*, 'the Queen's personality which had shaped the entire wedding'.) Princess Elizabeth wrote

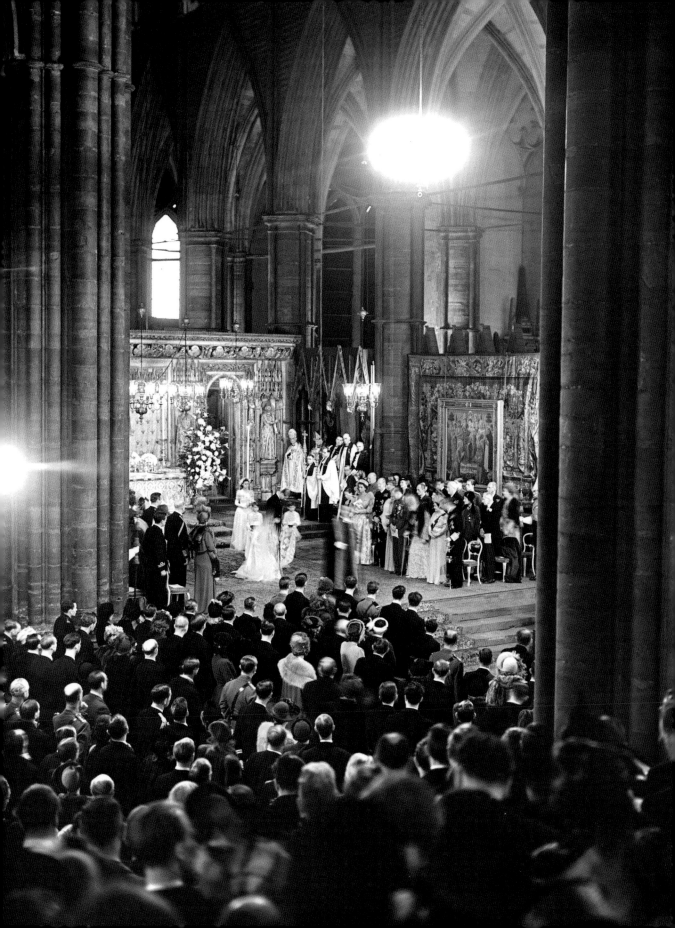

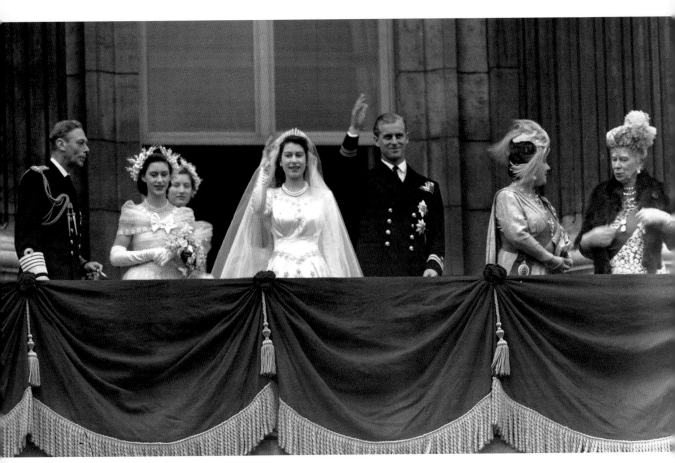

King George, Princess Margaret, Lady Mary Cambridge, the Bride and Bridegroom, Queen Elizabeth and Queen Mary on the balcony of Buckingham Palace.

to her mother afterwards that her mouth and eyes had been jammed with the rose petals thrown over her and she felt she easily might cry.

The same feeling was reflected in the letters written by their parents to the young couple now embarked on their honeymoon at Broadlands, the Mountbattens' house in Hampshire, and Birkhall on the borders of the Balmoral estate. King George wrote to his daughter that night: 'I was so proud of you & thrilled at having you so close to me on our long walk in Westminster Abbey, but when I handed your hand to the Archbishop I felt I had lost something very precious. You were so calm and composed during the Service & said your words with such conviction, that I knew everything was all right.' Princess Alice wrote to Philip: 'How wonderfully everything went off & I was so comforted to see the truly happy expression on your face and to feel your decision was right from every point of view.'

The Princess wrote from Broadlands to her mother that she had looked wonderful in her apricot and gold brocade, also from Hartnell: 'Not just "the bride's mother", but *you*.' She hoped (William Shawcross relates) that her mother had not been unhappy at the loss of a daughter, but 'I was so happy and enjoying myself so much, that I became completely selfish and forgot about your feelings or anyone else's!' Philip, she added, was 'an angel'. Part of the crowd's enthusiasm had been that this was so clearly a love match, and this wedding had been a triumph of popularity – crowds were calling for the King and Queen to appear on the balcony of their floodlit palace until late into the night. Noël Coward wrote in his diary: 'The wedding was most moving and beautifully done. English tradition at its best.'

For the first time newsreel cameras had also been allowed into the Abbey itself, and while in the South Atlantic the skipper of a New Zealand ship hove to so that his crew could crowd around the radio; the film version was shown all over the world – in occupied Berlin, the four-thousand-seater cinema was full day after day. The volume of press coverage was even greater than it would be six years later for the coronation of Elizabeth II. In time this escalation of media interest in the monarchy might come to seem like another, unholy union – one which would lead, just fifty years later, to a wrecked car in a Paris underpass – but in 1947 there could be no thought of that. Given the economic climate, it had not been felt possible to grant a public holiday, but offices around the country put work aside to listen in.

Attending the dance at the Palace before the wedding, Duff Cooper, British ambassador to France, had recorded in his diary that Princess Elizabeth had looked 'really charming – everything that a princess in a fairy-tale ought to look like on the eve of her wedding day'. The fairy tale image recurred again and again – but at the same time it had been a curiously domestic fantasy, giving, as one woman described it to Mass Observation, 'a delighted sort of family feeling'. The historian G.M Trevelyan, called to write in the official souvenir, evoked the idea of a link between the virtue of its family and the actual function of the monarchy. Affection for the King, and for the King's family, had become, he wrote, 'a kind of popular poetry'.

No one could have guessed it at the time of Princess Elizabeth's wedding, but the next major royal ceremony would be not a wedding but a funeral. George VI died in February 1952 and the coronation of his daughter, sixteen

months later, was one of the great spectacles of that – or any other – decade. It would be on the cusp of another decade, the 1960s, that Princess Margaret married; five years after the ending of her relationship with the divorced and therefore ineligible Peter Townsend. It was in the month of Townsend's remarriage to someone else that the Princess at last became engaged, and even then the name of her prospective husband came as a surprise, and not only because their relationship had been conducted largely in secrecy.

As so often with the spectacular royal weddings of this last century, the timing was fortuitous, albeit that now the expectations of a different era made different requirements of the royal family. As the sixties dawned, the sympathy engendered by George VI's funeral, the glow of Elizabeth II's coronation, had begun to die away. There was a debate about the relevance of the monarchy. Had Princess Margaret been about to marry the predictable princeling or fly-fishing aristocrat, the news of her impending marriage would still have been a major story. As it was, her choice of groom caught the zeitgeist precisely. A photographer? A man called Jones? Even if the Eton-educated Tony Armstrong-Jones was a long way from being one of the proletariat, he still looked like the people's candidate to claim their princess. An Edinburgh company director called Sidney Jones set up a plan for everyone in England with the name Jones to contribute a shilling towards a wedding present and a charitable donation. The papers reported that, in Highgate Cemetery, the grave of a long-forgotten merchant was hastily cleaned when it was discovered he was an ancestor of Tony Armstrong-Jones.

In royal circles, however, the groom's background caused something of a problem. The Queen Mother, perhaps aware of potential difficulties, took care to throw herself behind the couple, writing to the Archbishop of Canterbury that she was 'very happy', the more so since they had gone to Holy Communion together on the first Sunday after they became engaged. This time, in a poignant variant on the words that had announced the Princess Elizabeth's engagement, the official statement from Clarence House read: 'It is with the greatest pleasure that Queen Elizabeth The Queen Mother announces the betrothal of her beloved daughter The Princess Margaret to Mr Antony Charles Robert Armstrong-Jones, the son of Mr R. O. L. Armstrong-Jones QC, and the Countess of Rosse, to which union The Queen has gladly given her consent.'

'Gladly' . . . but observers on the wedding day felt the Queen looked 'quite miserable'. And Harold Macmillan's biographer recalls how, arriving for a stay at Balmoral, he was greeted by the Duke of Gloucester with the words: 'Thank Heavens you've come, Prime Minister. The Queen's in a terrible state; there's a fellow called Jones in the billiard room who wants to marry her sister . . .' As *The Times* put it: 'There is no recent precedent for the marriage of one so near the Throne outside the ranks of international royalty and the British peerage.' The *New Statesman* declared that 'only a few years before this would have been unthinkable'. Noel Coward observed a 'distinct *froideur* in Princess Alexandra and the Duchess of Kent: They are *not* pleased.' In Paris, the Duchess of Windsor, bitter about her own rejection by the royal house, said that at least she was keeping up with the Joneses. As the invitations went out, refusals began to come in from the crowned heads of Norway, Sweden, Belgium, Greece and the Netherlands – in the end, Queen Ingrid of Denmark, Margaret's godmother, was the only ranking foreign royal to attend.

Margaret said, 'We are so happy it is unbelievable.' But Tony's friend Jocelyn Stevens cabled to him: 'Never was there a more ill-fated assignment', worried (with reason, as it would turn out) that the groom wouldn't be able to settle into royal life, while the bride couldn't live any other way. The bridegroom's father – on honeymoon with his third wife, a former airline hostess – said unguardedly: 'I wish in heaven's name this hadn't happened . . . It will never work out.'

The older generation of courtiers – the same type of whom Princess Diana would complain – spoke of 'the boy Jones' and the air of raffishness that clung to him. It was probably what appealed to the Princess. 'In a way', she said, 'he introduced me to a new world.' But they must have felt vindicated when the groom's original best man, Jeremy Fry, had to withdraw because of the stirring up of old stories about his homosexuality; when his ex-girlfriend Jacqui Chan (a guest in the Abbey) chose this moment to cut a pop record. But there was perhaps a feeling in the highest circles that after the Townsend affair, and with the Princess's thirtieth birthday approaching, she could not reasonably be thwarted in her second choice. And to those further down the scale, of course, the memory of Princess Margaret's earlier heartbreak combined with the dramatic, the almost Cinderella-like, elevation of the groom to heighten the fairy-tale aspect of the story.

Norman Hartnell – now nearing sixty, a couturier in the new age of the ready-made and the mini – was instructed by the couple to move away from the heavily embroidered gowns he usually made for the royal ladies. Hartnell had ordered a silk tulle veil from Paris, made by Claude St Cyr, which fell from the 'Poltimore' tiara Princess Margaret had brought at auction for some £5,000, the whole attached to a hairpiece carefully chosen by her hairdresser, René. But the dress itself, though immensely elaborate in its construction – three layers of white silk organza, twelve panels nipped in at the waist – was spectacular in its very lack of ornamentation. A ballgown-style variant on the 'Princess' line Worth had first developed for Princess Alexandra's wedding dress in 1863, the shape served to emphasise the Princess's full bust and tiny waist, while the unrelieved white concentrated attention on her sapphire eyes. She had, Hartnell said, decided on a dress without a sequin or a bead. 'With its high neckline, moulded bodice and flowing skirt, it is almost medieval in its simplicity.' Medieval, as her mother's had been medieval, but in a very different way. 'Against the background of the Abbey it stood out triumphantly – and that is what the Princess wished.' Perhaps lessons had been learned from the wedding of Grace Kelly to Prince Rainier of Monaco just four years earlier, an MGM extravaganza which had captivated the world. Even the bride's dress had been designed, with a sharp eye for what worked on camera, by MGM designer Helen Rose.

Official photographs for Princess Margaret's wedding were to be taken by Cecil Beaton: a difficult assignment, given the bridegroom's own profession, but Beaton found the Queen Mother very helpful, encouraging him to take informal photographs of the bridesmaids, led by Princess Anne – the real 'star performer . . . so quiet and efficient', one guest said. They were to be dressed, at the bride's request, in a re-creation of one of her first ball dresses – one her father had particularly admired.

The wedding was to cost £26,000 and there was some grumbling in the press and even in Parliament about not only the expense but the use of the royal yacht *Britannia* (subsidised by the tax payer to the tune of some £10,000 a week) to take the couple on their Caribbean honeymoon. The Queen Mother announced that, if necessary, she herself would meet the wedding costs: in fact, Macmillan's government decided that for such a powerful feel-good factor, the price was a small one to pay.

Princess Margaret's dress, striking in its simplicity, was designed by Norman Hartnell, acting on the bridegroom's instructions.

〜 Princess Margaret travels to her wedding in the Royal Coach.

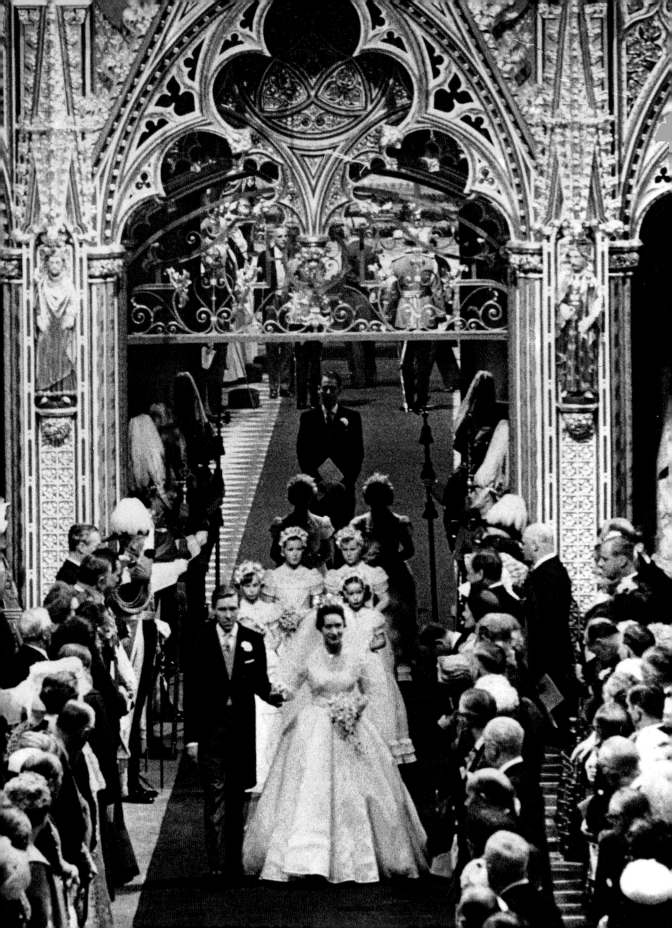

When 6 May dawned, Noël Coward noted: 'The morning was brilliant, and the crowds lining the streets looked like endless, vivid herbaceous borders.' The Princess had chosen to travel to the Abbey in the Glass Coach that more often brought brides back to the Palace; it would give the public – calling 'We want Margaret' – the maximum chance of a view. It passed down the Mall under a sixty-foot arch of pink and red flowers, between white silk banners emblazoned with the Tudor rose and the letters 'M' and 'A'. Many in the crowd had slept out for as much as three nights to secure a good place, and the St John Ambulance brigade treated more than 1,200 casualties. Prince Philip was to give the bride away and, as Princess Margaret told her authorised biographer Christopher Warwick, when they arrived at the Abbey he joked, 'Am I holding on to you, or are you holding on to me?' 'I'm holding on to you', she said.

This was the first real televised wedding, reaching what was then an extraordinary worldwide audience of some three hundred million, and there was an element of dramatic spectacle in it. The TV cameras – some using the new zoom lens for the first time – jostled for space with spectators who had paid £25 for a seat in the grandstand opposite the Abbey. Inside, the two thousand guests included Churchill, Attlee and Eden; the Bonham-Carters and a posse of dukes; Margaret's hairdresser and the groom's charlady; Noël Coward and actors Joyce Grenfell and Margaret Leighton; poet laureate John Betjeman; and Jean Cocteau.

The voice commentating was that of Richard Dimbleby. As Princess Margaret and Philip made their way up the aisle: 'For one moment we see the bride now as she looks about her in the Abbey in this lovely gown of white silk organza, with the glittering diadem on her head, the orchids in her hand, and the comforting, tall, friendly, alert figure of the Duke of Edinburgh on whose right arm she can rely.' The bride had chosen the prayers and the music – Bach, Handel, Purcell and Schubert – with a reading of the Beatitudes instead of a sermon. Her voluminous skirts belled out around her as she curtsied to her sister, the Queen, before leaving the Abbey.

After the wedding breakfast and the balcony appearance, as the open topped Rolls-Royce made its way across the city to the Pool of London, the press of the enthusiastic crowd was such that there were fears *Britannia* might miss the tide. But as the arms of Tower Bridge were raised the ship moved

Princess Margaret and her new husband process down the nave.

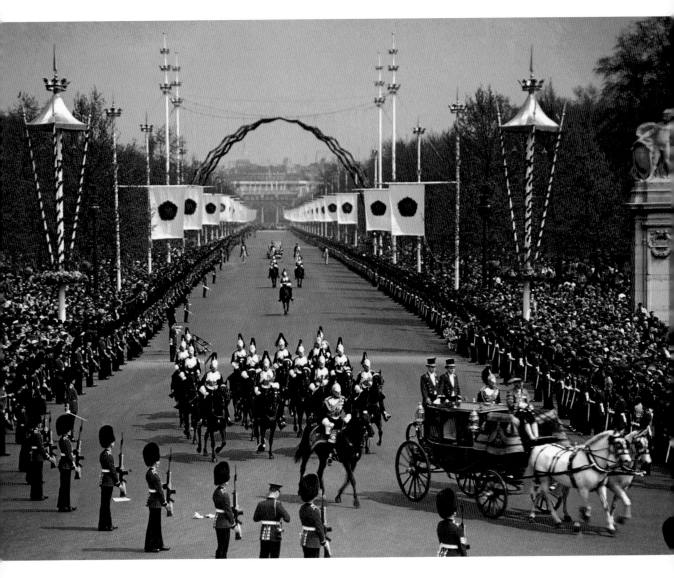

The couple returning to Buckingham Palace.

away to the strains of a Royal Marine band playing show tunes on deck – passing, on its way, the rented room in Rotherhithe where the couple had often met in the first secret days of their relationship. As they moved on down the Thames fresh crowds constantly appeared to greet them: at Southend, 10,000 spectators lined the pier head.

Noël Coward wrote afterwards: 'I discovered, unashamedly and without surprise, that my eyes were filled with tears.' The Queen Mother wrote to her daughter on honeymoon: 'I felt that it was a *real* wedding service, holy &

A young Prince Charles (left) and Princess Anne (centre) carrying confetti baskets to help send the newlyweds on their way.

beautiful, and you looked heavenly darling.' Princess Margaret wrote to her that every moment of the ceremony had been 'a dream of happiness'.

The effect, as the Queen's biographer Ben Pimlott said, would be to help in 'fixing in the public mind, ever more firmly, the idea of nuptials and matrimony as a centre point of the royal fable'. Once again, the image that occurred to many who witnessed it would be that of a fairy story. With hindsight, we know that this fairy-tale marriage would end in divorce – know, too, that in the decades ahead it might come to seem as if a dark spell had been cast over the whole saga of the royal family's marital history, making Trevelyan's link between their familial virtues and their function a hollow mockery. But, then, if you really look at the old tales, there always is an element of darkness in every fairy story.

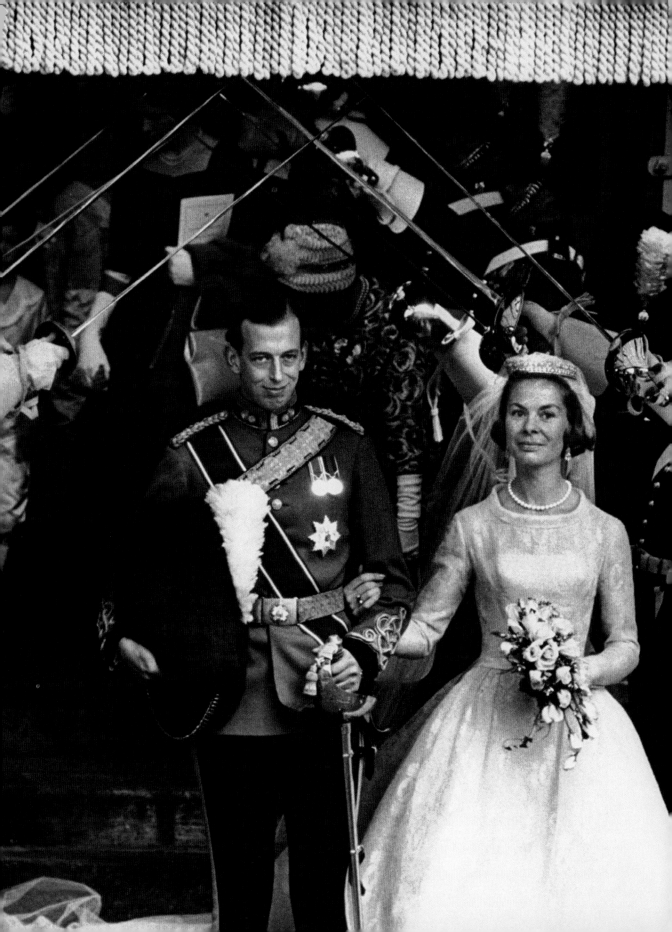

TRACY BORMAN

'WHATEVER "IN LOVE" MEANS'

ROYAL WEDDINGS FROM 1961 TO 2011

When the Duke of Kent married Katharine Worsley in 1961, the popularity of the royal family was buoyant. It still inspired the natural deference and respect that it had enjoyed (with some notable intermissions) for the past nine centuries. By 2011, the monarchy had endured one of the most turbulent periods of its history. The romance, spectacle and pageantry of royal weddings in the sixties, seventies and eighties had given way to scandals, divorces and, as a result, a growing cynicism not just about the institution of marriage, but the entire monarchy.

The first two marriages of this half-century involved the Queen's cousins, Prince Edward, Duke of Kent, and, two years later, his sister, Princess Alexandra. The former was an altogether quieter affair than the full royal pomp and ceremony of Princess Margaret's wedding the previous year. It took place not in London, but in York, a rare instance of a royal wedding bowing to the age-old tradition of allowing the bride to marry in her locality. Miss Katharine Worsley was the only daughter of Sir William and Lady Worsley of Hovingham Hall in North Yorkshire. Although an eminently suitable royal wife in terms of her sensible, down to earth character and flawless beauty, Miss Worsley could trace her descent to Oliver Cromwell, a fact the press had a great deal of fun with. Despite the lack of fuss (compared to later royal weddings), her dress, by designer John Cavanagh, was kept such a closely guarded secret that the windows of his Mayfair salon were blacked out to prevent any opportunistic

The Duke and Duchess of Kent pass under the traditional arch of crossed swords after their wedding at York Minster, 1961.

press photographers from spoiling the surprise. There were also no fewer than forty-six television cameras inside the Minster on the day itself.

The Duke of Kent's wedding had aroused significant interest, but it did not generate anything like the publicity that his sister's did two years later. Described by a family friend as 'a whirlwind of a girl', Princess Alexandra was extremely popular with the press and people alike. Attractive and vivacious, she burst on to the royal scene with a refreshing informality that won her many supporters. She was also something of a socialite and brought some much-needed glamour to the royal family. At the age of twenty-five, she accepted a proposal of marriage from Angus Ogilvy, a City businessman and second son of the twelfth Earl of Airlie.

Plans for the wedding proceeded apace. It was to be held in Westminster Abbey with all the ceremony and pageantry of a full royal wedding. A celebratory ball was held at Windsor two days before which was almost as big an event as the wedding itself and was attended by two thousand guests. They included the fifteen-year-old Prince Charles and his sister Anne who watched the dazzling spectacle from a gallery above and filmed it on cine camera. An estimated two hundred million people worldwide tuned in to watch the wedding itself, which in an era when by no means every household owned a television was a staggering number. One of the most anticipated elements of the day was the bridal gown. Princess Alexandra was an icon of fashion and her exquisite lace dress did not disappoint. The most striking feature was the veil, which was made of the same material as the dress, rather than the more traditional tulle. This set a new trend that rapidly caught on. Meanwhile, Alexandra's voluminous train was so heavy that it obliged her to walk down the aisle at a snail's pace. At the end of the ceremony, the bride turned to Princess Anne, her chief bridesmaid, and said, 'Your turn next', to which the astonished Anne replied: 'Me?' In fact, there would be another royal wedding before Anne's (that of Prince Richard, now Duke of Gloucester), but the Queen's daughter would be the next to marry in Westminster Abbey.

The late sixties and early seventies saw a significant change in attitudes towards the royal family. This was partly due to a conscious ploy on the part of Buckingham Palace's press office to portray them as human beings with a job to do rather than a distant group of highly privileged individuals whose relevance to the general population was increasingly being questioned. The

decision to allow cameras into the Palace to film a fly-on-the-wall documentary of the Queen and her family backfired spectacularly. It served merely to destroy the mystique of the monarchy, and amidst rising criticism the Queen ordered its withdrawal from the public domain. Thenceforth, the royal family sought more subtle means to show that they were in tune with the changing times. The collapse of several high-profile royal marriages during the decades that followed would test this resolve to the limit.

On 29 May 1973, Buckingham Palace ended weeks of speculation by

The wedding of Princess Alexandra and the Hon. Angus Ogilvy, Westminster Abbey, 1963.

announcing that Queen Elizabeth's second child and only daughter, Anne, was to marry Lieutenant Mark Phillips of the Queen's Dragoon Guards. The announcement came as something of a surprise, for, as well as repeated and increasingly strenuous denials of a pending engagement by the Palace, few people beyond the couple's inner sanctum had known that the relationship was so serious.

Mark Phillips was a complete unknown. A keen horseman and showjumper, he moved in the same circles as Anne, but had kept a very low profile during their courtship. The press hastily researched his background and produced a few interesting but tenuous links to the royal family. Among his more esteemed ancestors was Queen Elizabeth I's godson, Sir John Harington, who claimed the dubious honour of being the inventor of the water closet.

The fact that the first of the Queen's children was to marry sparked a media frenzy, something that Anne herself did not take kindly to. She famously lost her temper with a group of journalists who turned up to catch a glimpse of the couple exercising their horses together. The wedding date was set for 14 November 1973 – Prince Charles's twenty-fifth birthday. It coincided with a time of crisis in British industry. A state of emergency had been declared and the country faced the prospect of a freeze on essential goods such as petrol. In response, a group of recalcitrant Labour MPs demanded that the wedding be cancelled. Thankfully, their call was not heeded, for the occasion provided a much-needed morale boost for a beleaguered population.

Never a conventional princess, Anne wanted as simple a wedding as possible, and therefore insisted on discarding some of the traditions associated with a full royal wedding. Refusing to be followed down the aisle by 'yards of uncontrollable children', the bride-to-be also limited the number of bridal attendants to just one bridesmaid (her nine-year-old cousin, Sarah, daughter of Princess Margaret) and one pageboy (her younger brother, Edward, also nine). The Princess also asked her personal dressmaker, Maureen Baker of Susan Small, to make her wedding dress, eschewing a more high-profile designer such as Sir Norman Hartnell. Meanwhile, the wedding cake was made by the Army Catering Corps, rather than the traditional royal cake bakers at Lyons or McVitie & Price. But it was no less impressive than one of their creations. The towering masterpiece (which was as tall as Anne herself) weighed 145 pounds

and was made from no fewer than eighty-four eggs, twelve and a half pounds of flour and two bottles of brandy.

Despite the fact that no national holiday had been declared, crowds of avid spectators descended upon the capital to witness the occasion. Many had camped out the night before, braving the bitterly cold weather, and by dawn an estimated 47,000 people were lining the processional route. As well as the privilege of seeing the bridal party on their way to Westminster Abbey, they were also rewarded with a march past by one of the most impressive military gatherings ever seen at a British royal wedding.

When at last the crowds caught sight of the famous Glass Coach, they went wild, their ecstatic cheers ringing out all the way along the Princess's ride to the Abbey. As ever, the most anticipated part of the whole occasion was the bridal gown. All eyes were upon Anne as she stepped out of the coach and mounted the steps to the Abbey at 11.30 a.m. Reluctant though she had been to embrace the pomp and ceremony of a full royal wedding, her exquisitely designed dress evoked hundreds of years of tradition. With a high neckline, closely fitting bodice, medieval-style sleeves, and a full, semi-circular train, it was a perfect blend of traditional and modern; elegance and simplicity. Crafted from ivory silk and decorated with thousands of tiny pearls and mirror jewels, it was inspired by medieval and Tudor portraits. Continuing the historical theme, the Princess's hair was fashioned in a full, Edwardian style, bedecked by a beautiful diamond tiara, loaned by her grandmother, from which flowed a long white tulle veil. The bouquet she carried included the traditional sprig of myrtle. But the more eagle-eyed spectators would have noticed that there was also a reference to the fact that this was a military as well as a royal wedding, for an outline of epaulettes had been picked out in tiny pearls across the shoulders of Anne's dress.

Within hours, replicas of Anne's dress were being produced by bridal shops across the country. But Maureen Baker had consciously designed it to be one-off, confidently declaring: 'A chain-store couldn't possibly do it.' She was right. No matter how closely the scores of other dressmakers tried to copy it, the resulting gowns were all pale imitations of the original, which was far too costly to emulate, being made from one piece of silk with no seams.

As the organ struck up the processional hymn, Prince Philip accompanied

After signing the register, Princess Anne and Captain Mark Philips walk past the Queen, the Queen Mother and other members of the royal family, 1973.

his daughter along the blue carpet of the nave. Throughout the four-minute walk, the bride appeared relaxed and happy, and both she and her father were wreathed in smiles. The last time that she had made this walk at a royal wedding had been ten years earlier as a bridesmaid for her cousin, Princess Alexandra.

After the ceremony, the newlyweds emerged through the great west door of the Abbey to rapturous cheers from the crowds, and travelled in the waiting coach back to Buckingham Palace. In what was by then a much-anticipated part of royal wedding formalities, they later appeared on the balcony with the rest of the royal family, and waved to the thousands of spectators waiting below. Chants of 'Happy Birthday, Charlie' mingled with cries of congratulations to Anne and Mark Phillips, at which the bride urged her brother to take a bow. The party then retreated back into the Palace for the wedding breakfast, which was attended by 130 guests. This is traditionally the most informal part of any

royal wedding, giving the bridal party and the select coterie of guests a chance to relax and enjoy the occasion.

Princess Anne's wedding had done much to restore public confidence in the royal family, but within five years the situation had deteriorated again. Princess Margaret and Lord Snowdon were divorced in July 1978, and a month later Prince Michael of Kent courted further controversy for the royal family by marrying Baroness Marie-Christine von Reibnitz. Not only was the Baroness a Roman Catholic, but she had also been married before. In order to marry her, Prince Michael had first to obtain special permission from the Queen and renounce his right of succession to the throne (he was sixteenth in line) in accordance with the terms of the Act of Settlement of 1701. The couple were married in a civil ceremony at the Town Hall in Vienna on 30 June 1978. Marie-Christine (henceforth known as Princess Michael of Kent) became the first Roman Catholic princess for three hundred years.

Princess Anne and her new husband join other members of the royal family for the traditional appearance on the balcony of Buckingham Palace.

The question of who the heir to the throne would marry had been on everyone's lips for some considerable time, and with good reason. Not only would Prince Charles's wife be Queen one day, but their children would inherit the throne after them. The Prince himself heightened the speculation by once remarking that thirty was 'about the right age for a chap like me to get married'. That birthday (in November 1978) came and went with no sign of an engagement, although the Prince's name was linked with a string of different women, including an aristocrat (Lady Jane Wellesley), an actress (Susan George), a model (Fiona Watson), the Belgian Princess Marie Astrid, Camilla Shand (later Parker Bowles), and various other members of high society.

Among the latter was Lady Sarah Spencer, the eldest daughter of the eighth Earl Spencer and the Honourable Frances Roche. The Spencers shared a common ancestry with the royal family and could trace their descent to King James I. It was while visiting Lady Sarah at the Spencer family home of Althorp in 1977 that Charles first met her youngest sister, Diana. He later recalled her as 'a splendid sixteen-year-old'. Their meeting was unremarkable: it was certainly not a case of love at first sight, and the Prince (who was twelve years older than Diana) thought no more of the encounter until some time later.

The Prince's beloved great-uncle, the first Earl Mountbatten, had once counselled him on the subject of marriage. 'In a case like yours, the man should sow his wild oats and have as many affairs as he can before settling down', he told him. 'But for a wife he should choose a suitable, attractive, and sweet-charactered girl before she has met anyone else she might fall for.' The Earl was assassinated by the IRA in August 1979, and Charles was devastated. The following summer, he met Lady Diana Spencer at a friend's barbeque. As the pair were sitting on a bale of hay and talking, the Prince mentioned his great uncle's death, which prompted Diana to observe that Charles had looked sad and in need of comfort at the funeral. Her sympathy may have brought to mind Mountbatten's advice about a suitable bride. Diana seemed every inch the 'sweet-charactered', virginal girl that the Earl had recommended, and very soon Charles began to think of her as a potential wife.

The press were quick to spot the fact that the Prince had a new 'friend', and they began to hound Diana. She was regularly followed to and from the

London kindergarten where she worked by a swarm of photographers. One audacious reporter tried to break into the kindergarten through the lavatory window, while another dressed up as a road-sweeper in order to photograph Diana unawares. Disarmingly pretty with a shyness born of youth and inexperience, she was an irresistible subject for the tabloids. Nicknamed 'Shy Di' by the press, she rapidly became a figure of intense public interest. Even in those early days, it was obvious that she had star quality. Rumours about her blossoming relationship with the heir to the throne reached fever pitch in July 1980 when she was invited aboard the royal yacht *Britannia* at Cowes by Prince Philip. The following month, she was present at the Queen Mother's eightieth birthday celebrations, and soon after that she visited Balmoral – this time at Charles's request.

At last, on 24 February 1981, an announcement was made that put an end to months of frenzied speculation: the Prince of Wales was to marry Lady Diana Spencer. He had proposed on 4 February upon returning from a skiing holiday in Klosters. The couple gave a television interview, for which Diana wore the now-famous blue suit with blue and white blouse that was copied by high-street stores across the country. During the interview, Diana appeared shy, nervous and somewhat in awe of her future husband. Unlike him, she also seemed very much in love. In what has become the most replayed excerpt of the broadcast, when asked whether they were in love the bride-to-be immediately replied: 'Of course.' Charles merely remarked: 'Whatever "in love" means.' Those close to the Prince knew the truth behind this unguarded comment. He was marrying for duty, not for love.

From the moment that the engagement was announced, Diana became a national obsession. Although she moved into Clarence House so that she would be under the protection of the royal press office, there was little they could do to keep her out of the glare of publicity. Her clothes, jewellery and make-up were scrutinised by the press and public on an unprecedented scale. The engagement ring – a large sapphire set within fourteen diamonds, was copied by scores of high-street jewellers, although at a slightly lower cost than the £30,000 price tag of the original. Meanwhile, thousands of women across the country hurried to the hairdresser to ask for a 'Lady Di'. Sales of the eyeliner, lipstick and other make-up favoured by Diana rocketed. To be such an icon of style and fashion was a dizzying role for anyone, let alone a

nineteen-year-old ingénue, but Diana rose to the challenge admirably, aided by the scores of high-class couturiers who clamoured to dress this beautiful and increasingly elegant young woman. Meanwhile, her natural charm and lack of affectation rapidly won her a place in the hearts of the British people.

Every detail of the wedding was planned with meticulous care and was subject to endless scrutiny by the press. A decision that provoked some surprise was that the ceremony should be held, not in Westminster Abbey, the traditional venue for royal weddings, but St Paul's Cathedral. One of the reasons for the choice was that St Paul's offered more seating – an important consideration given that there were to be 2,600 guests. In contrast to Princess Anne's wedding, all the usual protocol for royal weddings was observed, so the guest list included the crowned monarchs of Europe and most of the elected heads of state.

As the wedding day drew closer, there was an unprecedented level of excitement, not just within the United Kingdom, but worldwide. Everyone, it seemed, had caught royal wedding fever. Thousands of visitors from overseas scheduled their holidays to coincide with the big day, and many thousands more flocked to the capital from across the country. The scale of the crowds that gathered in London on that hot July day (a national holiday) was staggering. An estimated 600,000 people lined the processional route so that they might catch a glimpse of Diana on her way to St Paul's – more than twelve times as many as for Princess Anne's wedding. Meanwhile, 750 million people in fifty countries around the world watched the wedding on television.

Few of them believed that Charles and Diana were anything other than the ideal match. What their story lacked in romance, the public (and press) made up for in their imagination. Charles was the Prince Charming of romantic legend who had been lured out of bachelorhood by the beautiful, virginal Diana, named after the Goddess of hunting. Their wedding was to be the glorious highlight of their relationship, after which they would surely live happily ever after. The knowledge of the tumultuous events that followed makes such predictions seem naively optimistic. But this was an era before the royal family was blighted by bitter divorce battles and public spats between warring couples. With the exception of Princess Margaret, recent history provided nothing but shining examples of successful royal marriages – none more so than Queen Elizabeth's own.

Only those within Charles and Diana's most intimate circles knew that there was any cause for concern. The Prince was already in a relationship with Camilla Parker Bowles. They had met a decade earlier, but the relationship (though close) had not developed, possibly because of an ill-timed overseas tour of military duties by Charles in 1972. He had allegedly asked Camilla to wait for him, but she had married Andrew Parker Bowles the following year. Reliable sources claim that she and Charles had renewed their relationship by the beginning of the 1980s. Diana knew about her future husband's affair with Camilla, but apparently believed that she could put a stop to it. It was later revealed that Charles had told her on the eve of their wedding that he was not in love with her. The fact that the wedding went ahead at all was thanks in no small part to the Duke of Edinburgh, who urged his son to 'do the right thing'.

Meanwhile, there was no hint in the press that anything was awry, and the excitement about the impending nuptials continued unabated. The public wanted a fairy-tale wedding and they were not disappointed. No expense was spared on this lavish occasion, which was billed as the greatest royal wedding of all time. It was certainly the most eagerly anticipated. By eight o'clock on the morning of 29 July 1981, the streets of London were already thronged with eager spectators. Union Jacks flew everywhere, and every street on the processional route was bright with banners and decorations.

Very soon after the Queen and other members of the royal family set off from Buckingham Palace, the bride left Clarence House in the Glass Coach. Although her dress was still mostly shielded from view, the seemingly endless fine silk tulle of her veil filled the coach and made her appear every inch the fairy-tale princess. When the coach drew up at the steps of St Paul's, Diana emerged to rapturous cheers from the crowds. At last they caught a long-awaited glimpse of the dress. A triumph of ivory silk taffeta, it was hand-embroidered with 10,000 tiny mother-of-pearl sequins and pearls and fringed with antique lace. Layers and layers of tulle under the skirt contrasted with the fitted bodice and puff-sleeves, and a twenty-five-foot-long train trimmed with sparkling old lace added to what was surely the most sumptuous wedding dress in history. There was even an eighteen-carat-gold horseshoe sewn into it for luck. The dress was the creation of Diana's favourite designers, David and Elizabeth Emanuel, who were said to have been influenced by Botticelli, Renoir and Degas, as well

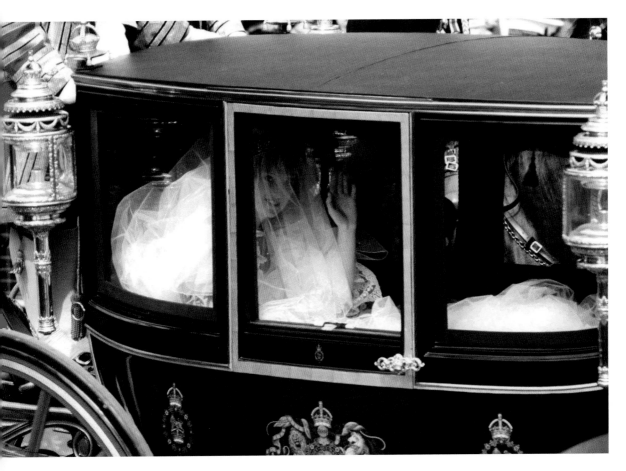

The crowds catch their first glimpse of Diana as she leaves Clarence House, 1981.

as photographs of some of the most romantic women in history – including Vivien Leigh in *Gone with the Wind*. To complete the ensemble, Diana wore the Spencer family tiara and her mother's diamond earrings.

Pausing on the steps of the cathedral so that two of her five bridesmaids might arrange her train, Diana then made the three and a half minute walk up the aisle with her father to the tune of the Trumpet Voluntary – already a popular wedding piece, but even more so after this occasion. Although she appeared every inch the joyful bride, she later revealed that she had considered turning back in view of the devastating confession her husband-to-be had made the night before. But she, like him, decided that duty must prevail.

When Diana reached Prince Charles, who was waiting beneath the magnificent soaring dome of the cathedral with his brothers, Princes Andrew and Edward, the couple moved forward together to stand before the Dean of

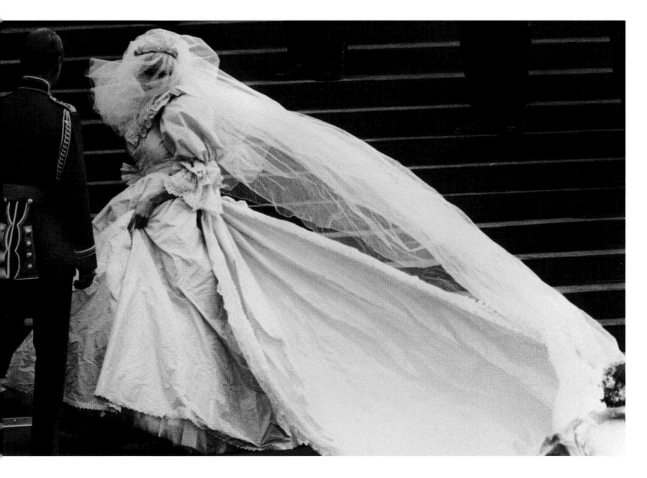

St Paul's, who began the service. The marriage ceremony was performed by the Archbishop of Canterbury, Robert Runcie. Diana's nerves briefly betrayed her when she famously mixed up her bridegroom's names, saying instead 'Philip Charles Arthur George'. She did not promise to 'obey' her husband as this traditional vow had been left out of the service at the couple's request, which caused some comment in the press.

At the end of the ceremony, the newlyweds emerged from St Paul's to a deafening welcome from the waiting crowds. They were driven back to Buckingham Palace in the open-topped 1902 state landau, which was a break with tradition because the carriage was more usually employed at the start of state visits to London or Windsor. Shortly after their arrival, the bride and groom, together with members of both families and the bridesmaids and pages, made the traditional appearance on the balcony of the palace. The

Lady Diana pauses on the steps of St Paul's as a bridesmaid arranges her train.

155

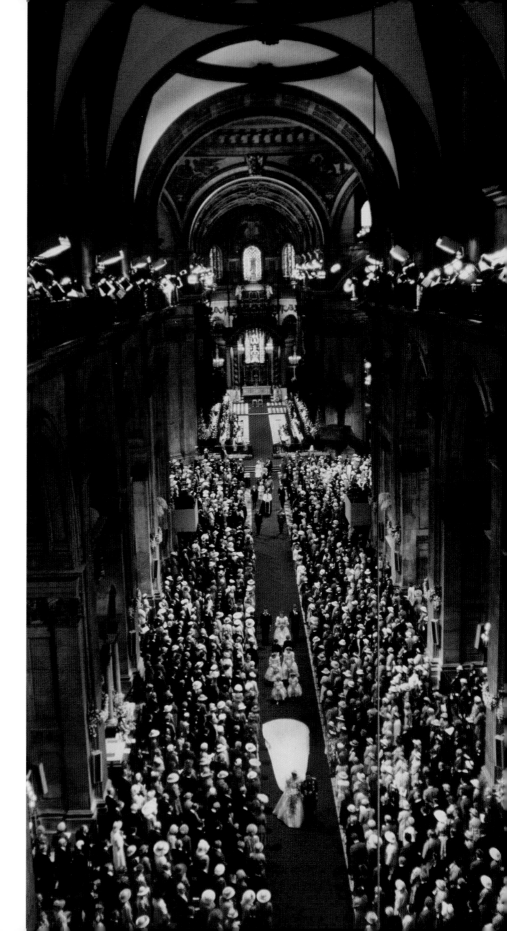

The Prince and Princess of Wales process back down the aisle after the ceremony.

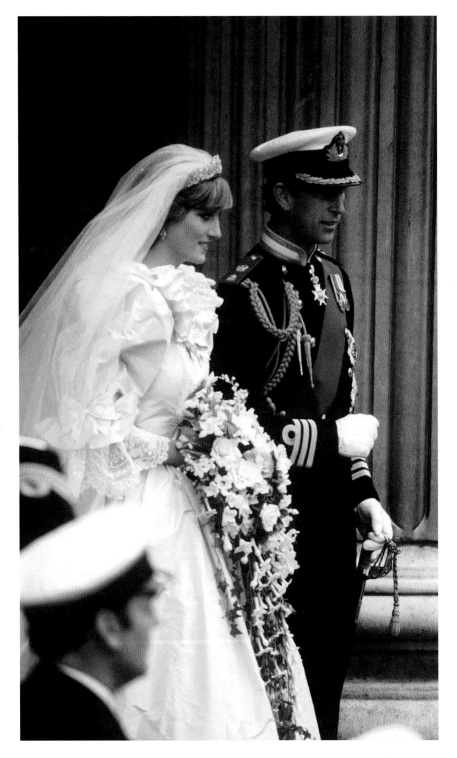

The newlyweds emerge from St Paul's to rapturous cheers from the waiting crowds.

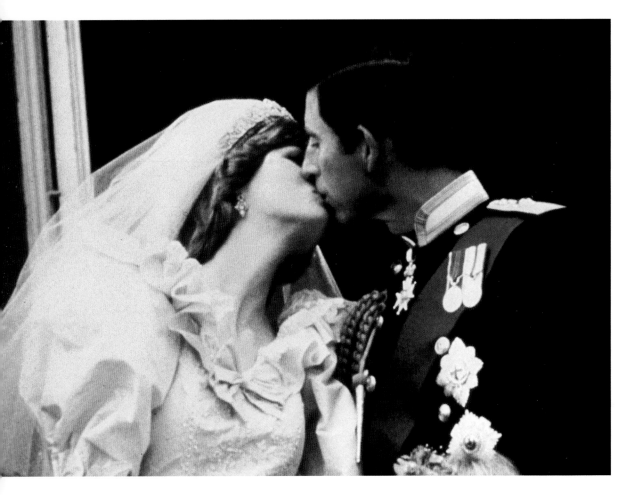

After persistent chants from the crowds below the balcony, Prince Charles at last kisses his bride.

thousands of spectators thronging around the statue of Queen Victoria and extending back up the Mall as far as the eye could see chanted for Charles and Diana, and then the Queen and Queen Mother, all of whom were obliged to return several times to the balcony to satisfy the crowds. Much to their delight, Charles eventually kissed his bride. It was the first time that members of the royal family had kissed in public.

After the wedding breakfast, which was attended by 120 guests, the married couple left Buckingham Palace in another open-topped landau (with a handwritten 'Just Married' sign pinned to the back by Princes Andrew and Edward) and were driven to Waterloo Station. From there, they caught the train to Romsey in Hampshire to begin their honeymoon at Broadlands, where the Queen and Prince Philip had also spent their honeymoon. Charles

and Diana then flew to Gibraltar to join the royal yacht *Britannia* for a cruise in the Mediterranean, before ending their trip at Balmoral.

The public's fascination with the Prince and Princess of Wales by no means abated after the furore of their wedding had died down. Within less than a year, Diana had fulfilled her duty by producing a son and heir, William, and two years later Prince Henry (known as Harry) was born. Press interest grew ever more intense, particularly in the Princess, who rapidly became the most photographed woman in the world. She was far more popular than the Prince, and when the newlyweds went on public engagements it was Diana, not Charles, for whom the crowds cheered the loudest. Compassionate, accessible and tactile, the Princess had the common touch her husband so obviously lacked, and she won praise and adoration wherever she went. This became a source of tension between the couple. If it had been the only one, it might have been overcome. But there were other – graver – problems in the marriage – not least the twelve-year age gap, which was exacerbated by the fact that they each had wildly different characters and interests. After a few short years it became obvious to all that the fairy-tale wedding had been just that – a fantasy that bore little relation to reality.

The unravelling of the Waleses' marriage was played out on a very public stage. Every detail that the press could glean about the cause of the split was dissected and debated at great length in newspapers, radio and television programmes. Each side was in turn cast as the victim or villain, and opinion is still divided on where the greatest fault lay. Charles and Diana formally separated in 1992, but this was by no means the end of the story as far as the press was concerned. While the Palace tried to play down the scandal, the Princess courted publicity. She secretly cooperated with Andrew Morton's book, *Diana, Her True Story*, which uncovered a host of shocking details about her marriage. Then, in November 1995, she took the unprecedented step of giving a television interview on the subject. In this broadcast, which was watched by millions worldwide, she talked openly about her husband's affair with Camilla Parker Bowles, but also admitted to infidelity herself. The following day, the Queen, realising the considerable damage that this acrimonious battle was inflicting upon the royal family, urged the Prince and Princess of Wales to seek 'an early divorce'. It would be another eight months before the decree absolute was issued.

Diana did not long enjoy her freedom. A little over a year after her divorce was finalised, she died in a car crash in Paris with her companion, Dodi Fayed on 31 August 1997. Few events in British history have prompted the scale of national dismay and bewilderment that followed. A sea of flowers appeared outside the gates of Buckingham Palace and Kensington Palace, laid by people desperate to express their grief. Thousands more queued for up to twelve hours to sign the book of condolence (which ran into several volumes) at St James's Palace. The news dominated every television channel as footage of the Princess leaving the Ritz Hotel in Paris on what would be her last journey was replayed over and over again. Grief turned to outrage as the Queen remained at Balmoral, where she and her family had been on holiday when the news arrived. Meanwhile, the press ignited the increasing public anger towards the royal family by declaring that the flag above Buckingham Palace ought to fly at half-mast, despite the fact that it was only ever raised if the Queen was in residence. Eventually, the Palace responded to the dangerously high level of public hostility, and the Queen made a television broadcast in which she spoke movingly of her daughter-in-law.

Diana's funeral eclipsed her wedding in the level of public interest that it generated. More than a million people lined the four-mile route from Kensington Palace to Westminster Abbey, while an estimated 2.5 billion watched the ceremony on television. This 'Queen of Hearts', as she became known, had swept away the formalities and traditions of the royal family, and people had loved her for it. Her influence would be felt long after her death. She had raised public expectations of the role the monarchy should play, forcing it to be less distant, less formal and more in touch with the needs of its people. Few could have predicted on that glorious July day in 1981 that the shy, nervous young bride would change the face of the British monarchy for ever.

The wedding of the Queen's second son to Sarah Ferguson in July 1986 was perhaps the most joyful and relaxed of all the royal weddings celebrated by the House of Windsor. Although Sarah could also trace her descent to James I and was Prince Andrew's sixth cousin once removed, the Fergusons were not noble by birth and she was therefore considered a commoner. Nevertheless, her

family moved in royal circles. Her father was Prince Charles's polo manager, and Sarah and Andrew had known each other since childhood. They had not met very often as adults, however, and it was only in June 1985, when they were both aged twenty-five, that they were pictured together at Royal Ascot. When Sarah was invited to join the royal family on holiday the following December, speculation began to mount that Prince Andrew's latest relationship had developed into something serious.

The paparazzi now followed Sarah Ferguson's every move, camping outside her flat in Clapham and chasing after her as she made her way to the graphic designers where she worked. She dealt with the intrusion with effortless grace, maintaining a cheerful, relaxed demeanour, and often joking with the pressmen. On one occasion, when a pair of journalists followed her and a friend into a restaurant, she sent over two flowers to their table with her compliments. Her humorous, confident and gregarious manner was like a breath of fresh air for the royal family, and she rapidly won popularity with the press and public alike.

On 19 March 1986, Buckingham Palace announced that Andrew and Sarah were to marry. The official interview followed shortly afterwards and was remarkably informal. The couple joked between themselves and were clearly very at ease in each other's company. They were also obviously in love and their responses to the questions were genuine and spontaneous, rather than the scripted, stilted responses that Charles and Diana had given. They kissed during the photocall, and the bride-to-be proudly showed off the engagement ring which she described as 'stunning'. Prince Andrew had no doubt been inspired by his wife's 'Titian' hair, for it was a large oval Burma ruby surrounded by ten diamonds.

The date of the wedding was set for 23 July, and preparations began in earnest. Royal weddings are classed as non-state occasions. As such, they are the responsibility of the Lord Chamberlain in his capacity as 'Impresario of Pageantry to the Queen'. Among the myriad and complex duties involved is the drafting of the guest list, and as Prince Andrew's — like that of his elder brother — would exceed two thousand guests, this was no mean feat. It is also the Lord Chamberlain's job to arrange the seating plan. This task is further complicated by the fact that only eight hundred of the two-thousand-strong congregation in Westminster Abbey are able to see anything of the procession,

Sarah
Ferguson and her
father, Major Ronald
Ferguson, are driven
to Westminster Abbey
in the traditional Glass
Coach, 1986.

and fewer still can catch a glimpse of the wedding ceremony. Any would-be royal wedding attendee should therefore take note: the better the view, the more important the guest. Andrew and Sarah's guest list included the usual mixture of royalty, politicians and celebrities. Among the latter were Sir Elton John, Nancy Reagan, Billy Connolly and his wife Pamela Stephenson.

As had become a tradition, the crowds flocked to London in their thousands for the big event, and many camped out overnight to secure the best views of the procession. At eight o'clock on the morning of the wedding, Buckingham Palace announced that the bridegroom had been created Duke of York in honour of his marriage. The last royal bride to marry a Duke of York had been Elizabeth Bowes-Lyon, the Queen Mother, who had stood in exactly the same spot in Westminster Abbey to exchange her vows with Prince Albert, the future King George VI, sixty three years before.

At eleven o'clock, the groom set off from Buckingham Palace with his brother Edward. Shortly afterwards, the crowds outside Clarence House raised a cheer as they caught their first glimpse of the bride – and, more importantly, her dress. Like Diana, Sarah chose a relative unknown (at least in royal circles) to design her wedding dress. Lindka Cierach was renowned for creating dresses 'with a sweep of costume drama about them', and she believed that a woman's dress should suit her personality. The royal wedding was by far her biggest commission to date, and she did not disappoint. The bride-to-be remarked on the eve of the wedding that there would 'never be a dress to match it'. She was not exaggerating. Made from heavy ivory duchess satin with extraordinarily intricate and elaborate beading, it was one of the most lavish royal wedding dresses ever created. The close-fitting bodice, full shoulders and billowing skirt flattered the bride's figure perfectly, and the seventeen-foot long train was embellished with exquisite beadwork. The thistles and bees of Sarah's coat of arms were intertwined with anchors and waves symbolising her groom's naval career, hearts were in abundance, and there was a large 'A' interwoven with two small 'S's, all picked out in tiny seed pearls and diamante.

The bride's veil was held in place by a headdress of flowers, but this hid a diamond tiara which was only revealed at the end of the ceremony to signify her transformation from commoner to Duchess of York. The very personal nature of Sarah's dress was reflected by her bouquet, crafted from cream and yellow roses, lilies of the valley, gardenias and lilies in the shape of an 'S'.

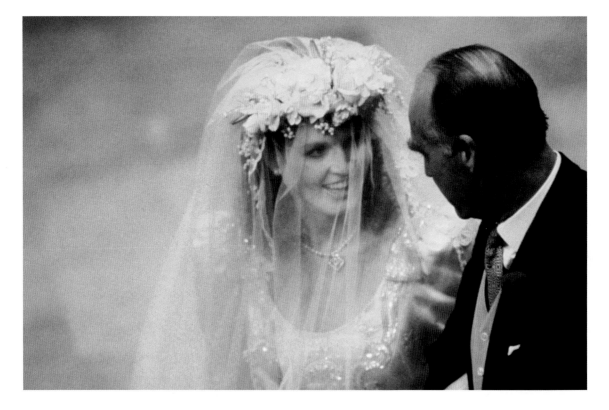

~~~ The bride and her father share an intimate moment before the ceremony begins.

Meanwhile, the awning outside Westminster Abbey was decorated with the bridal couple's entwined initials in cream flowers. The floral theme continued inside Westminster Abbey, which was a riot of colour with 20,000 roses, lilies, chrysanthemums, carnations and gladioli in pink, yellow, white and cream. The groom's landau was decorated with white roses, the symbol of the House of York, and when he arrived at the west door of the Abbey, the crowds gave an impromptu rendition of 'The Grand Old Duke of York'.

Although it adhered to the same rigid formalities and ceremonials of other royal weddings, the occasion had a sense of genuine joy and celebration. The bride had said that she intended to enjoy her big day, and both she and the Prince appeared relaxed and happy throughout. Their mood was infectious, and there was a carnival atmosphere among the thousands of people who had converged upon the capital to witness the occasion. Even the Queen appeared happy and at ease, and there are many photographs of her smiling and waving with almost as much enthusiasm as the bridal pair. Meanwhile, the four-year-old Prince William evidently forgot the strict decorum required of royal

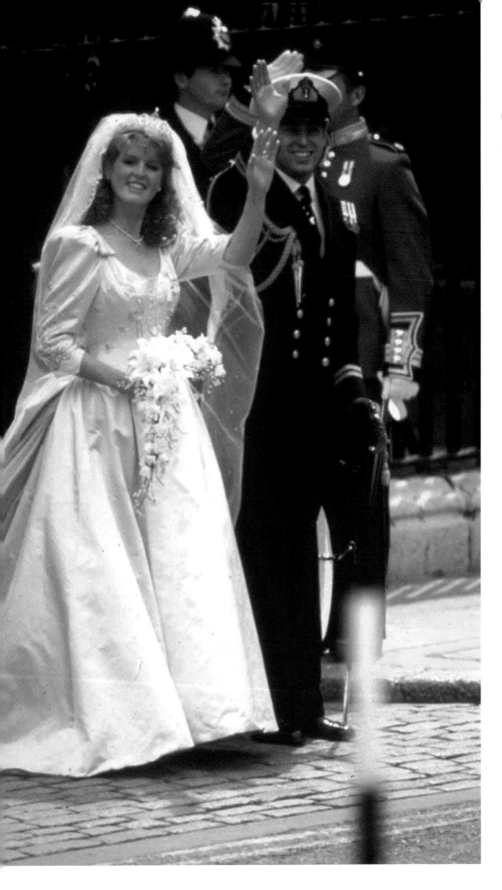

The Duke and Duchess of York, wreathed in smiles, greet the waiting crowds outside Westminster Abbey.

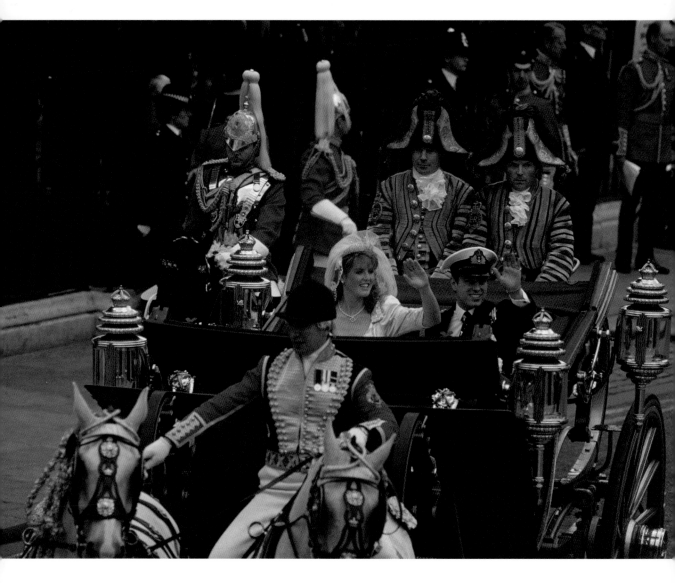

〰 The newlyweds make their way to Buckingham Palace in one of the traditional state landaus.

pageboys and was snapped by one sharp-eyed cameraman during the ceremony playing peek-a-boo with his order of service, yawning and sticking out his tongue at his companion, Laura Fellowes, who was one of the bridesmaids.

The light-hearted mood continued as the bridal party later made its appearance on the balcony of Buckingham Palace. As the chants of 'Kiss her, kiss her!' grew ever louder, the Duchess jokingly shouted back: 'Can't hear!' She and Andrew eventually obliged, and their kiss was altogether more heartfelt than that of their predecessors. The entire event had been a triumph, and there

was every reason to hope that this apparently well-matched pair would enjoy many years of happiness together.

Two years after the wedding, the Yorks' first daughter, Beatrice, was born. Another daughter, Eugenie, followed in 1990. But by 1992, the marriage was in trouble. The Duke's naval career necessitated long periods of time away from his wife, and the couple gradually drifted apart. Although Sarah had been hailed as a refreshing change from the stiff formality of the royal family, the press soon began to turn against her. When she was seen in the company of other men during her husband's absences, they were quick to point the finger of blame – not entirely without justification. Just six years after the jubilant scenes that marked their wedding, the marriage was over.

Boredom gets the better of Prince William during the ceremony, while Laura Fellowes dutifully reads the order of service.

The 1980s had witnessed an apotheosis of royal weddings. Charles and Diana's had excited public interest to unprecedented levels, and the dazzling spectacle of their big day had raised expectations for future occasions. Four years later, Prince Andrew and his bride had put on a show that was every bit as spectacular. But both marriages had ended in the same glare of publicity as they had begun. In March 1992, Prince Andrew formally separated from Sarah Ferguson, who had been snapped in the infamous 'toe-sucking' photographs with her 'financial advisor', Johnny Bryan. The following month, his elder sister Anne's marriage to Captain Mark Phillips ended in the divorce courts. In December that year, Anne married for the second time. Her new husband was Commander Timothy Lawrence, and it was the discovery of their relationship in 1989 that had sounded the death knell for her first marriage. In the same week as her wedding, it was announced that the Prince and Princess of Wales were to separate.

The result of all of this scandal and controversy was an altogether changed

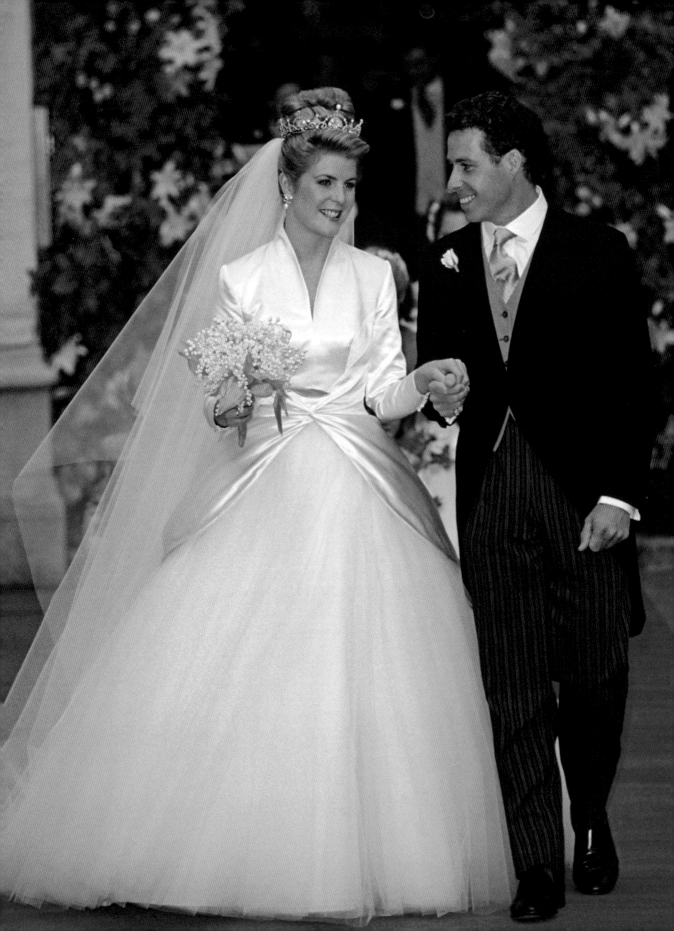

atmosphere by the early 1990s. The public no longer had the stomach for the ostentation and glamour of the royal weddings that had gone before. A quieter, more understated tone was called for, and this was exactly what the following two occasions achieved.

The semi-royal weddings of Princess Margaret's children, David and Sarah, took place within nine months of each other. On 8 October 1993, David Linley married Serena Stanhope at St Margaret's, Westminster. The church had been a popular choice for high-society weddings from Edwardian times to the 1960s, including that of Winston Churchill. This latest wedding owed much to Princess Margaret's own. Serena's dress was a very obvious tribute to her new mother-in-law, and her hair was similarly styled in a chignon, around which was set one of Margaret's tiaras.

Sarah Armstrong-Jones, who married her long-term partner, Daniel Chatto, on 14 July 1994, appeared no less stylish in an understated white gown designed by Jasper Conran. The venue was the church of St Stephen Walbrook in the City of London, designed by Sir Christopher Wren. This signalled the couple's desire for a quiet wedding, for the church holds just two hundred – a tenth of the capacity of Westminster Abbey. The ceremony was so brief that it caught the chauffeurs unawares, and several members of the royal family – including the Queen, Prince Philip and Princess Diana – were obliged to wait for their cars to arrive. It was an indication of how much things had changed in the space of just a few short years.

Although the weddings of Princess Margaret's children had been entirely in tune with the mood of the public, Princess Diana's death in 1997 prompted a devastating backlash against the monarchy. In the place of unqualified loyalty and adulation came hostility, cynicism and even derisory contempt. The last royal wedding of the nineties was seen by many as a chance for the royal family to rekindle at least some of the popularity that they had once enjoyed – and, perhaps, taken for granted.

The engagement of the Queen's youngest son, Prince Edward, to Sophie Rhys-Jones had been announced in January 1999, and marked the culmination of their five-year courtship. They had met at a charity real-tennis event at the Queen's Club in west London in September 1993 when Edward was twenty-nine and Sophie twenty-eight. Sophie had managed the publicity for the event and was unexpectedly thrust into the limelight when Sue Barker pulled out and she was obliged to step in for the photocall with Prince Edward. In

Serena Stanhope, wearing a dress that was reminiscent of her mother-in-law's, emerges from St Margaret's Church with her new husband, Viscount Linley, 1993.

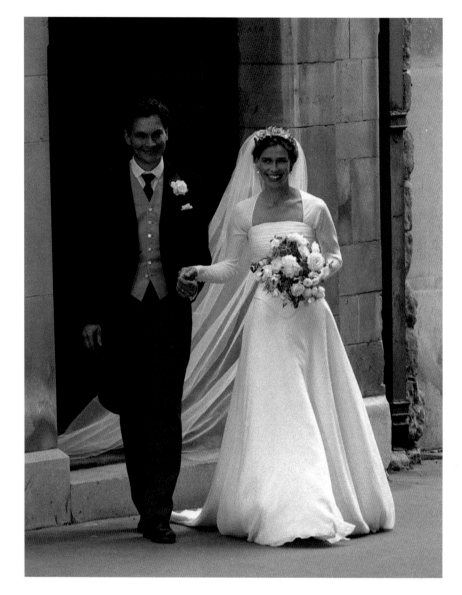

Lady Sarah Armstrong-Jones looking radiant at her wedding to Daniel Chatto, 1994.

contrast to other royal courtships, theirs began very discreetly and it was three months before the press got wind of it. When they did, the Prince – mindful of the damage that excessive press interest had inflicted upon the marriages of his siblings – sent an open letter to editors appealing for them to respect their privacy.

Although the blossoming relationship continued to attract attention in the media, Edward and Sophie were determined to conduct it with as much

discretion as possible. Only gradually did they begin to appear in public together, and the first royal occasion that Sophie attended was the wedding of Lady Sarah Armstrong-Jones in the summer of 1994. Speculation about an impending engagement was rife, but Edward refused to bow to pressure.

The much-anticipated proposal eventually came during a holiday in the Bahamas just before Christmas 1998. Before the engagement was made public, the Prince first had to seek the permission of the Queen, according to the terms of the Royal Marriages Act of 1772. She gave her enthusiastic assent, delighted that her youngest son had chosen such a sensible and intelligent bride, whom she hoped would enhance the royal family's public image.

Sophie, the first real outsider to enter the House of Windsor, had gained respect for her discreet and dignified behaviour during the five years of their courtship. A PR professional, she was an ideal match for the Prince, who was notoriously lacking in patience where the press was concerned and had had several well-publicised spats with journalists. Thanks to her successful career and stable, middle-class background, by the time of her engagement to Prince Edward she was a confident, well-travelled thirty-five-year-old. She was also the first royal bride to work full-time at her own profession, and continued to do so after the wedding.

Prince Edward's wedding was a much more low-key affair than those of his siblings, and it was described in court circles as 'a somewhat restrained celebration'. The lack of extravagance and ostentation was deliberate and reflected a new sensitivity towards the attitudes of the people, who felt a good deal less enthusiastic than when the first of the Queen's children had married sixteen years before. The message was clear: this, the last royal wedding of the twentieth century, would signal a new era for the royal family.

The date of the wedding was set for 19 June 1999. It was to take place, not in the customary splendour of Westminster Abbey, but in St George's Chapel, Windsor. A number of other significant traditions were discarded. Gone were the state landaus that had conducted the royal bride and groom to their destination for many years past. Sophie and her future parents-in-law arrived by Rolls-Royce, but other members of the royal family were transported to the chapel in a mini-bus. Meanwhile, Prince Edward and his elder brothers (who were his supporters) took an informal stroll through the precincts of the castle to St George's Chapel before the service began.

Looking relaxed and happy, Prince Edward and his two brothers stroll through the precincts of Windsor Castle before the ceremony.

A jubilant Prince Edward and his bride emerge from St George's Chapel.

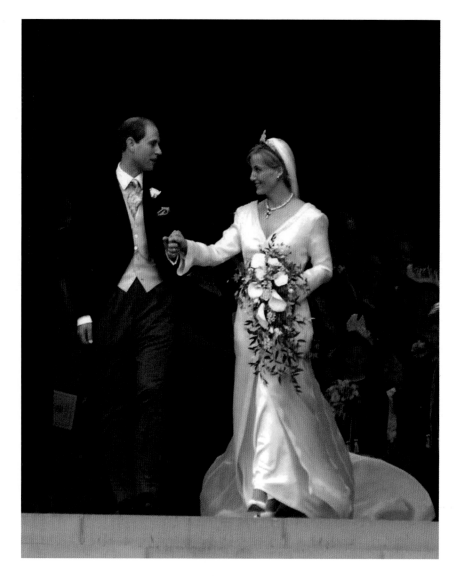

The ceremony was conducted not by the Archbishop of Canterbury, but the Right Revd Peter Nott, Bishop of Norwich. There was no guard of honour and only a minimal military presence. Prince Edward had given up his military career after a disastrous and short-lived experience in the Royal Marines, and he was the first royal groom in recent times to marry in morning suit, rather than military uniform. The 550 guests were drawn from the couple's family, friends and colleagues. There were no politicians and only a handful of foreign dignitaries. Two notable omissions were Prince Andrew's estranged wife,

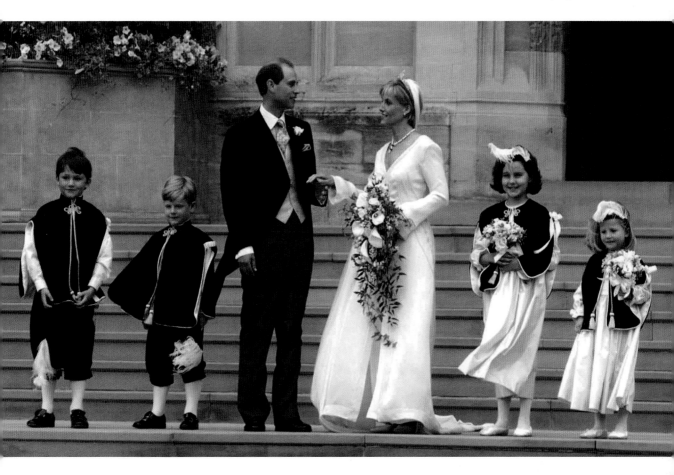

Sarah (with whom he nonetheless remained on good terms), and Charles's companion, Camilla Parker Bowles. The royal family clearly wished to avoid any negative publicity on a day that they hoped would signal a revival in their fortunes.

As a goodwill gesture, eight thousand members of the public (mostly from the local area) were permitted to enter the grounds of Windsor Castle. Many thousands more lined the streets of Windsor itself. They saw the Queen, apparently caught up in the informality of the occasion, looking happier and more relaxed than she had in years. There were loud cheers when the crowds first glimpsed the bride as she made her way from the Royal Lodge in Windsor Great Park to St George's Chapel. Although this was an unconventional wedding by royal standards, Sophie did uphold one age-old tradition by arriving late – albeit only by five minutes.

The newlyweds pose for photographs on the steps of the chapel, accompanied by their bridesmaids and pageboys.

The bridal gown, which had been kept as closely guarded a secret as others in the past, was as elegant and understated as the occasion itself. The design was a sleek, panelled long dress-coat of ivory silk, embroidered with sparkling cut-glass and pearl beads. The veil, which trailed down the length of the train, was held in place by a diamond tiara from the Queen's private collection. Sophie completed the ensemble with a black-and-white pearl necklace and cross designed by Prince Edward as a wedding gift. This matched the colouring of the bridesmaids' and pageboys' outfits, which comprised black velvet capes over ivory silk dresses and shirts.

After the ceremony, the newly created Earl and Countess of Wessex posed briefly on the steps of the chapel. Resisting calls for the traditional kiss, Prince Edward conducted his new wife to the open Ascot landau – a brief resurgence of tradition – which conveyed them to the reception in the State Apartments. This reception dispensed with many of the formalities of previous royal weddings: indeed, it replicated the weddings of thousands of ordinary couples across the country. In place of the traditional seated banquet was a buffet-style dinner, followed by dancing in the magnificently restored St George's Hall – a symbol, perhaps, of the royal family's renaissance after the devastating events of the preceding decade.

It is a testament to how far public attitudes had shifted that by the time Prince Charles finally married Camilla Parker Bowles, with whom he had been in a relationship – intermittently – since 1971, there was a sense of acceptance, even affection, towards the couple. And yet Camilla had once been described as 'the most hated woman in Britain'. She was the reason why, in Diana's words, her marriage to Charles had been 'a bit crowded', and she was seen by many as the chief architect of its demise. If Diana had been the fairy-tale princess, Camilla was the wicked witch. Not since Anne Boleyn had a rival to a royal wife been so reviled. Her unpopularity reached a nadir during the months following Diana's death, as the grief-stricken public cast about for someone to blame. Only gradually did the situation begin to change, thanks as much to Camilla's personal qualities as to a carefully planned PR strategy by the Prince of Wales's press office.

A fact that the press did not pay much attention to when the Prince of Wales first started dating Camilla Shand (as she was then) was that she was the great-granddaughter of Alice Keppel, the long-standing mistress of Prince Charles's great-great-grandfather, King Edward VII. They have, of course, made up for it since. This dubious claim to fame was something of which Camilla herself seemed rather proud. When she first met Charles in June 1970, she reminded him of the connection and playfully asked: 'How about it, Sir?'

Charles and Camilla were ideally suited: just eight months apart in age, they had a number of common interests. The Prince was said to have fallen head over heels in love with Camilla from the beginning, and even though they went on to marry other people, they remained close. When revelations about their affair hit the headlines in the mid-1990s, Andrew Parker Bowles, who had apparently been privy to his wife's infidelity for some years, finally decided to institute divorce proceedings. Their divorce came through in 1995, a year ahead of Charles's own. Any hopes that the Prince and Camilla could enjoy their relationship in the open were dashed by Diana's untimely death in August 1997. But after a courtship that had lasted more than a quarter of a century, the couple were used to the need for patience. In private, they had already started living as husband and wife, and as the public hostility gradually began to subside, Camilla appeared with Charles at official functions. Their much-publicised first kiss came at a high-profile event to mark the fifteenth anniversary of the National Osteoporosis Society in 2001.

Meanwhile, behind the scenes the Prince was holding talks with Palace officials about the possibility of marriage. The fact that Camilla was a divorcee presented a major obstacle, as Edward VIII had discovered when he declared his wish to marry Wallis Simpson. The situation was made worse by staunch opposition from the Queen Mother, but her death in 2002 proved a significant step forward. The Prince, who once described Camilla as 'my rock, my life' and the only woman he had ever loved, stepped up his efforts to gain his mother's approval for the marriage. The Queen was said to like Camilla on a personal level, and eventually she came to realise that she was essential to her son's happiness.

The engagement was announced on 10 February 2005, and the Queen gave her formal consent – again, as required by the Royal Marriages Act – at a meeting of the Privy Council the following month. The official press

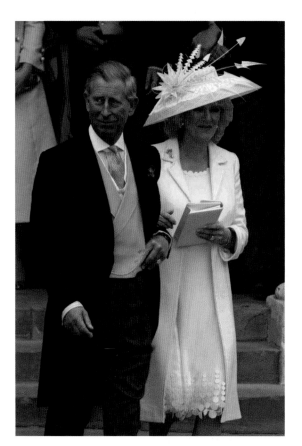

release indicated that the wedding would take place on 8 April at Windsor Castle. In fact, both the date and the venue would change. The funeral of Pope John Paul II, who had died on 2 April, was scheduled for the same day, so the wedding was moved to 9 April. Meanwhile, the difficulties of securing a licence for the Castle meant that the ceremony took place at the Guildhall in Windsor. This would be the first time that a member of the royal family had been married in a civil ceremony in England. It was a source of some controversy, with some experts claiming that the royal family was specifically excluded from the Marriage Act of 1834, which instituted civil marriages in England. This prompted Lord Falconer, Secretary of State for Constitutional Affairs and Lord Chancellor, to issue a written statement declaring the proceedings valid according to the terms of the Marriage Act of 1949.

Just twenty-eight guests gathered for the ceremony, which was modest by any standards, let

〰️ The Duke and Duchess of Cornwall emerge from their civil ceremony at the Guildhall, Windsor, to greet the waiting crowds, 2005.

alone the wedding of the heir to the throne. The Queen herself was not in attendance at the Guildhall, but she was at pains to point out that this was not a sign of disapproval; rather, that her presence would prevent the ceremony from being low-key as intended. A sign of her tacit approval of the union was the fact that Camilla's engagement ring was one that the Queen Mother had been given by King George VI to celebrate their daughter Elizabeth's birth.

Twenty thousand people lined the streets to catch a glimpse of the bridal party and guests. Camilla's son, Tom Parker Bowles, was a witness, along with Prince William, whose brother Harry was also in attendance. Their support was invaluable to Prince Charles and his fiancée and helped secure more widespread acceptance of their union. Charles and Camilla's outfits were tasteful and understated. The Prince wore a simple grey morning suit, in contrast to the full military uniform of his first wedding. Meanwhile, Camilla chose a cream silk overcoat and chiffon dress by the designers Robinson

 The Duchess of Cornwall arrives for the blessing of her marriage to Prince Charles at Windsor Castle.

The newlyweds looked relaxed and happy as they posed for photographs after the blessing.

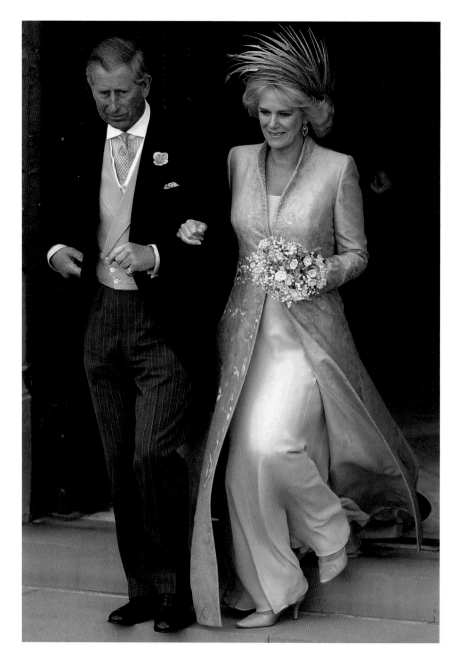

Valentine, complemented by a wide-brimmed hat with woven feathers by the celebrated milliner Philip Treacy. Prominently pinned to her coat lapel was a diamond-encrusted white-gold brooch in the shape of three feathers – the Prince of Wales's official insignia – a gift from her fiancé.

A ceremony of blessing was later held at St George's Chapel. This was a much grander affair, attended by the Queen and Prince Philip, as well as foreign royalty, politicians, religious figures and celebrities such as Sir David Frost, Rowan Atkinson and Stephen Fry. Camilla's first husband was also there, and she was seen to smile at him as she entered the chapel. She wore a shimmering, floor-length silvery blue and gold coat over a matching chiffon gown, set off to dramatic effect by a flamboyant spray of golden feathers in her hair.

A reception was held afterwards in the State Apartments, during which the Queen gave a speech that was unusually personal and humorous. Couched in horseracing terms – a sport for which she shared their passion – she remarked: 'They have overcome Becher's Brook and all kinds of other terrible obstacles. They have come through and I'm very proud and wish them well. My son is home and dry with the woman he loves.'

The newlyweds drove off in a car festooned in red, white and blue balloons. Charles's sons had written 'Just Married' across the rear window, and the words 'Prince' and 'Duchess' were sprayed on either side of the windscreen. The couple spent their honeymoon at Birkhall, the eighteenth-century hunting lodge in Scotland bequeathed to Charles by the Queen Mother. This was somewhat ironic, given his grandmother's staunch disapproval of the relationship. For Camilla, newly created Duchess of Cornwall, her marriage to Prince Charles marked the end of a life lived in the shadows.

On 16 November 2010, Clarence House announced the engagement of Prince William and Kate Middleton. A week later, the date of the wedding was set for 29 April 2011 (the year which would have marked the thirtieth anniversary of the wedding of William's parents) and the venue was confirmed as Westminster Abbey. The wedding was the first in six years to arouse significant public interest. Princess Anne's son's marriage to Autumn Kelly in 2008 and Lord Frederick Windsor's to Sophie Winkleman at the Chapel Royal, Hampton Court, attracted no more attention than the many 'celebrity' weddings covered by *Hello!* magazine. Likewise, the news that Zara Phillips was to marry her long-term boyfriend, international rugby

Prince William and Kate Middleton pose for photographs after their official interview following the engagement announcement, November 2010.

player Mike Tindall, in 2011 was eclipsed by plans for her cousin William's wedding.

William and Kate's relationship is perhaps the most 'normal' of any involving a member of the royal family – if that word can ever be applied to the life of the man who will one day be King. Kate is the eldest of three children born to Carole and Michael Middleton. She has no royal blood in her veins, and although her parents subsequently founded a multimillion pound company, their roots are firmly working class. The fact that an ordinary girl should be plucked from obscurity to become the future Queen of England appealed to a society obsessed with overnight celebrities.

William and Kate met at the University of St Andrews in 2001, where they were both reading History of Art. They later became flatmates, during which time their friendship developed into intimacy. In the official interview to mark their engagement, the couple recalled those early days at St Andrews with humour and affection. William had tried to impress Kate by cooking for her, but he admitted that his culinary endeavours had frequently ended in disaster. As well as a number of common interests, they shared the same sense of humour, which the Prince described as 'naughty'.

The relationship continued after the couple had graduated, and speculation grew that an engagement was imminent. The press began to plague Kate Middleton, just as they had previous royal girlfriends. It was not a welcome intrusion: she complained through her lawyer that she had done nothing to warrant such attention. Prince William and his father later supported her plea for privacy, and two of the United Kingdom's largest newspaper groups decided to stop printing paparazzi photographs of her. But this did little to dampen public interest, and when Kate celebrated her twenty-fifth birthday in January 2007, it was widely believed that the Prince (who was twenty-five in June that year) would soon propose. Bookmakers took bets on the possibility of a royal wedding, and the now-defunct Woolworths even produced memorabilia in preparation for the event.

In fact, the reverse happened. In April 2007, the *Sun* newspaper reported in a world exclusive that the couple had separated. There was intense speculation about the cause of the split, with some sources claiming that Kate was tired of waiting for William to commit. Nevertheless, they remained friends and it was not long before they were pictured together at royal events.

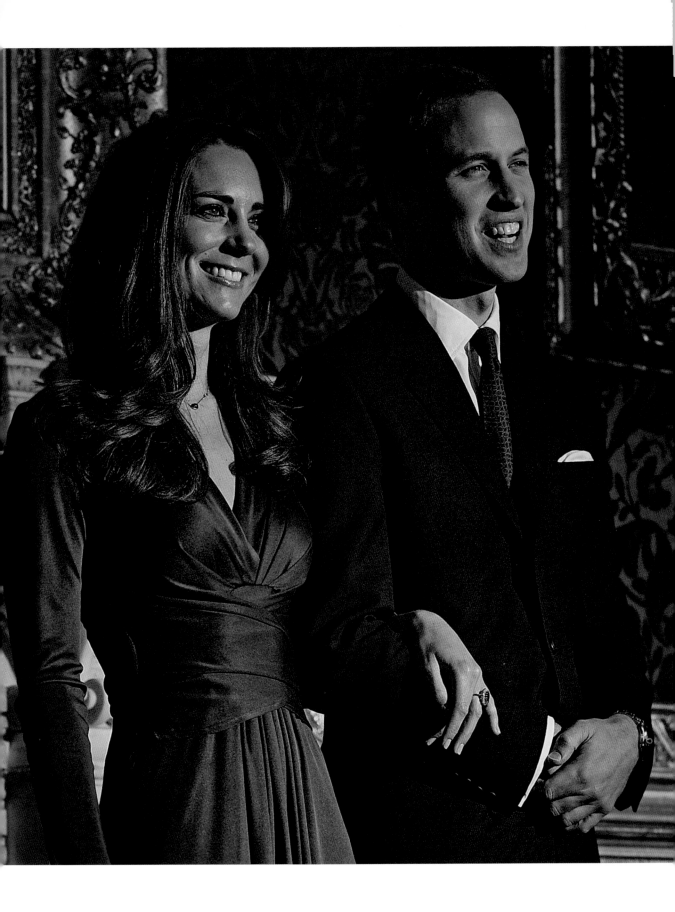

One of the official engagement photographs, in which the ring (which belonged to Princess Diana) can clearly be seen.

When Kate attended the wedding of William's cousin, Peter Phillips, in May 2008, it was as an official guest in her own right because the Prince had a prior commitment. Clarence House neither confirmed nor denied that a reconciliation had taken place, but it soon became obvious that William and Kate were together again.

Nevertheless, the Prince gave no indication that he intended to marry his long-term girlfriend, which prompted the press to coin the nickname 'Waity Katy'. In private, though, the couple had begun to discuss the prospect of marriage, and William later claimed that he had taken things slowly because he wished to give Kate the opportunity to find out what lay in store for her as a royal consort. This mature, common-sense approach would have benefited many of his predecessors.

Despite being prepared for the idea of marriage, Kate still described William's proposal as 'a total shock'. The couple were on holiday with friends in Kenya when it happened, and according to Kate the style of William's proposal proved that he is a 'true romantic'. The ring with which William proposed is one of the most iconic in royal history. It was the sapphire and diamond engagement ring that had belonged to Princess Diana. While this could be viewed as a bad omen, the Prince intended it as a way of keeping his mother involved.

Comparisons between Kate Middleton and her fiancé's late mother are inevitable, but in their official television interview William was at pains to point out that Kate is her own person and will not try to fill anyone's shoes. Kate herself described Diana as an 'inspiration', a tactful response that was typical of the consummate ease with which she and William handled the succession of probing questions. They appeared happy and relaxed in each other's company, displaying the humour and friendship upon which the Prince said their relationship was based.

Within a few weeks of the engagement announcement, the country was gripped by royal wedding fever. Royal commentators were drafted in to speculate upon the traditions that would be observed, as well as the innovations that this thoroughly modern couple might make. One of the earliest to be revealed was that Kate Middleton would travel to Westminster Abbey by car, rather than the traditional Glass Coach. In place of the usual intimate wedding breakfast was to be a buffet lunch, followed that evening

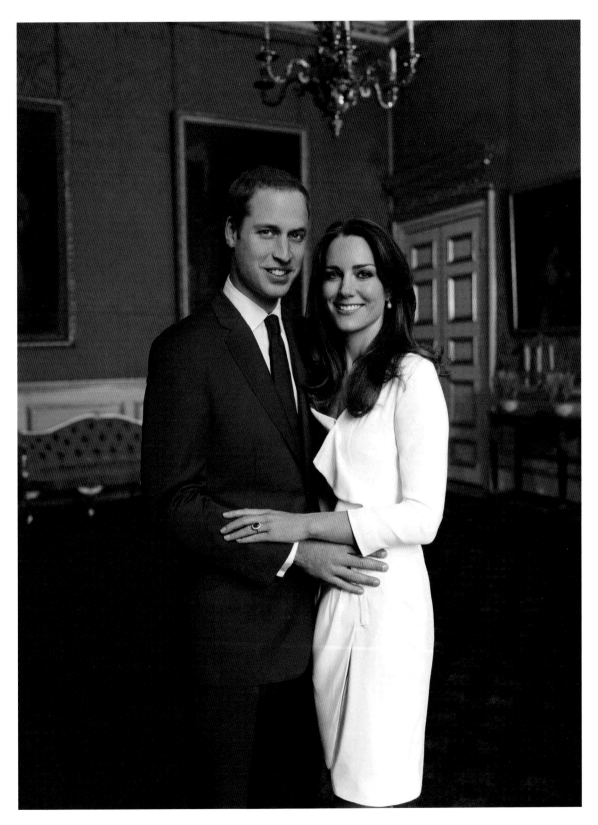

by dinner and dancing. A number of ducal titles were mooted by the press, including Duke and Duchess of Clarence, Cambridge, Sussex and Windsor. Others claimed that William asked the Queen not to confer any title upon him at all. And, as ever, the design of the bridal gown excited the most interest. Kate Middleton had already established herself as a fashion icon, and copies of her engagement dress sold out within hours of the interview. Expectations of her wedding dress were therefore higher than ever before. A national holiday was declared for 29 April, enabling thousands of eager spectators to descend upon the capital for the big day.

Despite the increasing disillusionment with the monarchy sparked by the marital crises of the eighties and nineties, it seems that the public has not quite fallen out of love with the idea of royal matrimony.

# PICTURE CREDITS

Page:

101. Hulton Archive/Getty Images
102. Topical Press Agency/Getty Images
104. Topical Press Agency/Getty Images
105. © Illustrated London News Ltd/ Mary Evans
107. Hulton Archive/Getty Images
109. Hulton Archive/Getty Images
111. General Photographic Agency/Getty Images
112-113. Haynes Archive/Popperfoto/Getty Images
114. R.Wesley/Fox Photos/Getty Images
116. Keystone-France/Gamma-Keystone via Getty Images
117. Central Press/Getty Images
120. Topical Press Agency/Getty Images
121. AP/Press Association Images
123. PA/PA Archive/Press Association Images
125. Central Press/Getty Images
127. PA/PA Archive/Press Association Images
129. Barratts/S&G Barratts/EMPICS Archive/Press Association Images
130. AP/Press Association Images
134. Barratts/S&G Barratts/EMPICS Archive/Press Association Images
136-137. Hulton Archive/Getty Images
138. Barratts/S&G Barratts/EMPICS Archive/Press Association Images
140. Barratts/S&G Barratts/EMPICS Archive/Press Association Images
141. Victor Blackman/Getty Images

Page:

142. Loomis Dean/Time Life Pictures/Getty Images
145. Popperfoto/Getty Images
148. Popperfoto/Getty Images
149. Anwar Hussein/Getty Images
154. Princess Diana Archive/Getty Images
155. AFP/Getty Images
156. Tim Graham/Getty Images
157. Anwar Hussein/Wire Image
158. Anwar Hussein/Getty Images
163. Bob Thomas/Popperfoto/Getty Images
164. Tim Graham/Getty Images
165. Hulton Archive/Getty Images
166. Bob Thomas/Popperfoto/Getty Images
167. PA/PA Archive/Press Association Images
168. Tim Graham/Getty Images
170. Martin Keene/PA Archive/Press Association Images
172-173. Phil Noble/AFP/Getty Images
174. John Stillwell/AFP/Getty Images
175. John Stillwell/AFP/Getty Images
178. Peter Tarry/AP/Press Association Images
179. Anwar Hussein/EMPICS Entertainment/Press Association Images
180. Odd Andersen/AP/Press Association Images
183. Ben Stansall/AFP/Getty Images
185. Copyright 2010 Mario Testino /Clarence House Press Office via WireImage

# THE HISTORY GIRLS

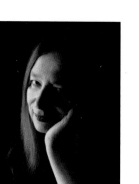   

ALISON WEIR        KATE WILLIAMS        SARAH GRISTWOOD        TRACY BORMAN

We are so used to hearing what men have to say about other famous men.
Now it's time for the other side of the story. The History Girls – Alison Weir, Kate Williams,
Sarah Gristwood and Tracy Borman – are all about history with attitude.

The History Girls are best-selling, critically acclaimed and engaging historians whose
expertise spans more than a thousand years of history.

They focus on famous names and major events, but always come at them from a new angle,
with human stories and fascinating detail, revealing a new insight into the lives of those who
lived history; both the high and mighty, and the ordinary people of the past.
In their writing and events, The History Girls interact to look at key historic figures
and moments from an insightful and lively female perspective, offering a timely
investigation of the vital roles that women have played in history.

# ACKNOWLEDGEMENTS

We should like to extend our warmest thanks to Paul Sidey, our editor at Hutchinson, for all his patience, creativity and prompt professional advice. We'd also like to express our sincere gratitude to the fantastic team at Hutchinson for producing this book at such short notice. We are indebted to Julian Alexander, the agent for The History Girls, for his unfailing enthusiasm for this project, and his tenacity and patience in bringing it to fruition. Special thanks go to Sophie Hartley and Fiona Greenway for their hard work on picture permissions, Richard Collins for copy editing, Managing Editor Joanna Taylor, Richard Ogle for the jacket and Peter Ward for the beautiful book design. We are greatly indebted to our friend and fellow historian, Christopher Warwick, author of *Two Centuries of Royal Weddings*, for his very generous advice on, particularly, the marriages of the twentieth century. Sincere thanks are also due to Samantha Brown of Historic Royal Palaces for very kindly arranging for us to launch the book at Hampton Court Palace. Lastly, we want to thank our fellow authors (and friends) for making this such an enjoyable project. A good book is the sum of many parts!